# THE BANG-BANG CLUB

# THE BANG-BANG CLUB

## SNAPSHOTS FROM A HIDDEN WAR

Greg Marinovich

and

João Silva

Basic Books
A Member of the Perseus Books Group

Published by Basic Books,
A Member of the Perseus Books Group

First published in the United Kingdom by William Heinemann

ISBN 0–465–04412–3 (hc.); 0–465–04413–1 (pbk.)

# ACKNOWLEDGMENTS

We want to thank our endlessly patient and insightful editors Elizabeth Burrows and Johanna McGeary, and especially Suzanne Daley who pulled our chapters together.

Jonathan Diamond and Christine Tomasini, our agents and friends, who had passionate faith in the book when it was just a bunch of notes and anecdotes. Abner Stein in London. The editors Ravi Mirchandani at William Heinemann and Tim Bartlett at Basic Books.

Impimpi: Jerry, Joan, Julia and Mitchell Balich, Howard Burdett, David Brauchli, Kevin Carter's parents – Jimmy and Roma, Tom Cohen, Gisella Cohen, Robin Comley, Kathy Davidson, Jude Domski, Horst Faas, Denis Farrel, Louise Gubb, Themba Hadebe, Joyce Jenetwa, Bafana Khumalo, Carolyn Lessard, Julia Lloyd, R&P, Nancy Lee, Scott MacLeod, Peter Magubane, Chris Marais, Judith Matloff, Brian Mkhize, Monty Montgomery, James Nachtwey, Juda Ngwenya, Mike Nicol, Patrick de Noirmont, Mike Persson, Gilles Peress, Rodney Pinder, The Rapoo family – Maki, Sandy and Reginald (Boytjie), Heidi Rinke, Vivian Silva, Tina Susman, Paul Velasco, John Wills, Chuck Zoeller.

Monica Hilton-Barber and *The Star* for allowing us to use Ken's pictures, and Guy Adams for his picture of Kevin.

Jerry Marobyane for the 'Songs from the Struggle' and Dr Onen of Gulu, Uganda for the Acholi songs.

# CONTENTS

# FOREWORD

By Desmond M. Tutu, Archbishop Emeritus
of Cape Town, South Africa

Nearly everybody made the most dire predictions about where South Africa was headed. They believed that that beautiful land would be overwhelmed by the most awful bloodbath, that as sure as anything, a catastrophic race war would devastate that country. These predictions seemed well on the way to fulfilment when violence broke out at the time of the negotiations for a transition from repression to freedom, from totalitarian rule to democracy. At the start of the 1990s, the most awful bloodletting began to seem endemic. What appeared to be random killings were taking place on the trains, massacres were happening when township residents were pitted against the hostel dwellers who led an unnatural existence in single-sex hostels and were being alienated from the more stable community-life in the black urban townships. People were dying like flies and dying gruesomely, through the notorious necklace when a tyre filled with petrol would be placed around a victim's neck and then set alight. Whenever the daily statistics of casualties were published and they said five or six people had been killed in the previous twenty-four hours, most of us would sigh with relief and say, 'Only five or only six' – it was that bad.

Conventional wisdom declared that most of this bloodletting was due to the bloody rivalry between Nelson Mandela's African National Congress (ANC) and Chief Mangosuthu Buthelezi's Inkatha Freedom Party (IFP), fighting for political turf to establish unchallengeable supremacy. That seemed a plausible explanation until one pointed out certain odd features in this whole gory rivalry. The massacres seemed almost always to take place just when the negotiations for transition had reached a delicate stage, and it was an odd coincidence that the

negotiations were put at very great risk at a critical point in the discussions.

It would seem that the train killings were a part of the rivalry between political foes, but this view was made untenable by the fact that the killers shot and killed people at random. They said nothing; they did not ask the passengers to declare their political affiliation. How would they, therefore, know that they were not murdering their own fellow members?

The explanation of inter-political party rivalry was even more difficult to accept as accounting for the drive-past shootings, which were a feature of the volatile pre-election period. It made more sense to see that it was all designed to fill township dwellers with panic and to get them saying that the ANC was unable to protect its members, and thereby erode its considerable support in the black townships. Increasingly, therefore, many of us spoke about a sinister third force somehow linked to the apartheid government and its security forces, which was intent on fomenting so-called black-on-black violence, enabling the apartheid government and many whites to crow about how these blacks were clearly not yet ready for democracy and political power. I have always been intrigued by this obsession with so-called black-on-black violence, as if black-on-white violence was somehow more acceptable. And why had no one ever described what happened in Northern Ireland or in Bosnia, Kosovo, et al. with its vicious brutality as examples of white-on-white violence? There it was just violence – then why black-on-black violence?

The apartheid government and its cohorts denied any such involvement in fomenting this gruesome and gory violence. They were to be proved liars, through for example the Goldstone Commission. Pieces began to fall into place – for instance, that explained the silent killers on the trains. Most of them, it was to be revealed, came from outside South Africa – from Angola, Namibia, etc., and could not speak the local languages. They would have given themselves away had they opened their mouths. It had in fact, nothing to do with political rivalry and everything to do with people who wanted to cling to power at all costs, at the cost of some of the most awful bloodletting.

And the world needed to be told this story. We were greatly blessed to have some of the most gifted journalists and brilliant photographers. They helped to tell the story. They captured some riveting moments on film, such as a gruesome necklacing, and the barbaric turning on a helpless victim by a baying crowd from one or other side of the conflict. Some of these professionals won high honours, such as the Pulitzer Prize, for their work, one for his picture from the Sudan of a vulture stalking an apparently dying child. It was a picture that stunned a somewhat complacent world. We were often amazed when we saw their handiwork. Just how could they have managed to capture such images in the midst of so much frenzied mayhem? They must have been endowed with extraordinary courage to work in death zones with so much nonchalance and professionalism. And they must have been remarkably cool, no, even cold-blooded to look on it all as being part of a day's work.

Now we know a little more as the veil is lifted on the ways this remarkable breed operated, how frequently they had to be callous, to the extent of trampling all over corpses without showing too much emotion, so that they could capture that special image which would ensure that agencies would want their work. Now we know a little of the cost, the constant gambling with death, of being part of what they call, with macabre humour, the Bang-Bang Club. And we know a little about the cost of being traumatized that drove some to suicide, that, yes, these people were human beings operating under the most demanding of conditions. Yes, this is a splendid book, devastating in what it reveals about the lengths to which we are prepared to go to gain or to cling to power, and searingly honest about the high cost, as it brings to public view what has for so long been out of sight. We owe them a tremendous debt for their contribution to the fragile process of transition from repression to democracy, from injustice to freedom.

It is the work of two outstanding artists; no wonder one of them won the Pulitzer Prize for his photographic depictions of the Hostel War of which this book is the written account.

# PREFACE

We faced a number of struggles in writing this book. Clouded memories, our reluctance to revisit what was a very difficult time, and how best to deal with the complexity inherent in telling the story of four people who, despite being bound together professionally, had very different lives and experiences. In the end, we decided that it was a story best told in a single voice, Greg's. Had we not collaborated, this book would not have been possible. One person never sees enough to be able to pull together a book of this nature, and certainly, the researching and writing of the book helped us understand so much more about our friends, ourselves and the times. We can never hope to know what goes on in the minds of even the closest of intimates, but we have made an honest attempt to penetrate the fog surrounding our friends and ourselves in that time of pain.

We had never intended to write a book about that period. And when we finally did start to write it in 1997, it was more a journey of discovery than a fevered attempt to chronicle what we considered an already established truth. We were to discover that the questions about what we did and how we handled it were much more complex than the way in which we had compartmentalized the issues in our heads. There is a lot of anger and bitterness from those times that cannot be banished – it is a part of us, and of the country. But there is also an amazing amount of forgiveness, grace and humanity that emerges. That mix of emotions is much like the South Africa we know.

The Bang-Bang Club of South African photojournalists was much written about in the period of violence that marked the end of the apartheid regime in South Africa. The name gives a mental image of a group of hard-living men who worked, played and hung out together

pretty much all of the time. Let us set the record straight: there never was such a creature, there never was a club, and there never were just the four of us in some kind of silver halide cult – dozens of journalists covered the violence during the period from Nelson Mandela's release from jail to the first fully democratic election.

We discovered that one of the strongest links among us was questions about the morality of what we do: when do you press the shutter release and when do you cease being a photographer? We discovered that the camera was never a filter through which we were protected from the worst of what we witnessed and photographed. Quite the opposite – it seems like the images have been burned on to our minds as well as our films.

We had friendships that linked the four of us, but it was not some kind of joint, mutual friendship, but rather individual bonds that sometimes overlapped. But there certainly was a common denominator – we all covered the shattering events of the 90s with a sense of history and purpose, and we can see how to the outside eye, that easy moniker came to be regarded as factual.

We have used many terms that are uniquely South African, some in a version of English and others in one of the nine African languages and Afrikaans, as well as the township slang called Tsotsitaal. We explain some within the text, and some are self-evident, but there is a glossary at the back of the book that will give some of the texture of the terms that have particular resonance among South Africans – as well as a timeline of South African historical events that we felt were helpful in understanding what has happened since white colonists first established themselves on the southern tip of Africa.

# THE WALL

If only I could reach
The homestead of Death's mother
Oh, my daughter
I would make a long grass torch . . .
I would destroy everything utterly utterly . . .

<div style="text-align: right">Traditional Acholi funeral song</div>

*Thokoza township, South Africa, 18 April 1994*
'Not a picture,' I muttered as I looked through my camera viewfinder at the soldier firing methodically into the hostel. I turned back towards the line of terrified, unwilling and poorly-trained soldiers taking cover alongside the wall next to me. Their eyes darted back and forth under the rims of their steel helmets. I wanted to capture that fear. The next minute, a blow struck me – massive, hammer-like – in the chest. I missed a sub-moment, a beat from my life, and then I found myself on the ground, entangled in the legs of the other photographers working beside me. Pain irradiated my left breast and spread through my torso. It went far beyond the point I imagined pain ended. 'Fuck! I'm hit, I'm hit! Fuck! Fuck! Fuck!'

As automatic fire continued to erupt from along the wall, Joao and Jim desperately dragged me by my camera vest closer to the wall, seeking shelter next to the soldiers and out of their line of fire. Then an anguished voice broke through the cacophony: 'Ken O is hit!' I struggled to turn my head through the tangled cameras and straps around

my neck. A few yards to the right, I could see a pair of long skinny legs that were unmistakably Ken's protruding from the weeds flourishing against the concrete wall. They were motionless and at an improbable angle to each other. Jim ran over to where Gary was clutching Ken, trying to find a sign of life. The sporadic crack and rattle of high-velocity automatic gunfire reverberated through the air around the huddle of journalists and soldiers trying to flatten themselves against the wall.

Blood seeped from the gaping hole in my T-shirt. I clamped my hand over the hole to stop the bleeding. I imagined the exit wound of the bullet as a deadly, gaping hole in my back. 'Look for an exit wound,' I said to Joao. He ignored me. 'You'll be OK,' he said. I reasoned that it must be bad if he didn't want to look, and as though this was all happening in some feeble movie, I asked him to give a message to my girlfriend. 'Tell Heidi I'm sorry . . . that I love her,' I said. 'Tell her yourself,' he snapped back.

Suddenly a sensation of utter calm washed over me. This was it. I had paid my dues. I had atoned for the dozens of close calls that always left someone else injured or dead, while I emerged from the scenes of mayhem unscathed, pictures in hand, having committed the crime of being the lucky voyeur.

Jim returned, crouching under the gunfire and murmured softly in my ear, 'Ken's gone, but you'll be OK.' Joao heard and stood up to rush over to Ken, but others were already helping him. He lifted his camera. 'Ken will want to see these later,' he told himself. He was annoyed that Ken's hair was in his face, ruining the picture. Joao took pictures of us both – two of his closest friends – me sprawled on the cracked concrete clutching my chest; Ken being clumsily manhandled into the back of an armoured vehicle by Gary and a soldier, his head lolling freely like that of a rag doll and his cameras dangling uselessly from his neck. Then it was my turn to be loaded into the armoured car; Jim had my shoulders and Joao my legs, but I am large, and Heidi's pampering had added more kilos. 'You're too fat, man!' Joao joked. 'I can walk,' I protested, trying to laugh, but strangely indignant. I wanted to remind them of the weight of the cameras.

After four long years of observing the violence, the bullets had finally caught up with us. The bang-bang had been good to us, until now.

Earlier that morning we had been working the back streets and alleys of Thokoza township's devastated no-man's-land that we — Ken Oosterbroek, Kevin Carter, Joao and I — had become so familiar with over the years of chasing confrontations between police, soldiers, modern-day Zulu warriors and Kalashnikov-toting youngsters as apartheid came to its bloody end.

Kevin was not with us when the shooting happened. He had left Thokoza to talk to a local journalist about the Pulitzer Prize he had won for his shocking picture of a starving child being stalked by a vulture in the Sudan. He had been in two minds about leaving. Joao had advised him to stay, that despite there being a lull, things were sure to cook again. But Kevin was enjoying his new-found status as a celebrity and went anyway.

Over a steak lunch in Johannesburg, Kevin recounted his many narrow escapes. After dessert, he told the journalist that there had been a lot of bang-bang that morning in Thokoza, and that he had to return. While driving back to the township, some 16 kilometres from Johannesburg, he heard on a news report on the radio that Ken and I had been shot, and that Ken was dead. He raced towards the local hospital we had been taken to. Kevin hardly ever wore body armour, none of us did, and Joao flatly refused to. But at the entrance to the township, before reaching the hospital, Kevin dragged his bullet-proof vest over his head. All at once, he felt fear.

The boys were no longer untouchable, and, before the bloodstains faded from the concrete beside the wall, another of us would be dead.

# 'AH, A PONDO – HE DESERVED TO DIE'

Death has killed the happiest
Death has killed the happiest
Death has killed the great one that I trusted.

Traditional Acholi funeral song

|||

*17 August 1990*

On a sunny spring afternoon in 1990, at the age of 27, I am making the 25-minute drive to Soweto, where politically-motivated fighting has broken out, and feel the as yet gentle tightening of my throat and the thrill of tension that runs from my belly and along my arms as I tighten my grip on the steering wheel. The sensation makes me slightly nauseous; it is like waking from a nightmare whose details are obscure but for the lingering emotions. It's an indistinct fear: I am abstractly scared that I might be killed, scared of what I might see in the civil conflict that has exploded in the black residential ghettos, but I do not really understand the fear. I also have no idea that this is the start of a new life for me.

I had woken – as always – in a leafy, well-kept suburb of white South Africa, washed in a white-tiled bathroom and shaved with hot water. My house was cleaned by a black woman, and at the petrol station it was a black man who pumped my fuel and washed my windscreen,

hoping for a few cents tip. It had been this way all my life, despite my intellectual opposition to apartheid and my peripheral involvement in the politics of the Struggle. While growing up, my life had, in most ways, been typical of an English-speaking white South African boy.

There had been a very popular advertising jingle in the 70s that was virtually the theme song of my high-school days: 'We love braaivleis, rugby, sunny skies and Chevrolet/They go together in the good old RSA: braaivleis, rugby, sunny skies and Chevrolet!' This ditty perfectly captured the confidence of South Africa's whites, snug in the paradise that they had created for themselves, despite the international sanctions campaign designed to isolate our country and force our minority government to recant its apartheid ways. White South Africans had retreated into a defensive laager, spending huge amounts on the trappings of self-sufficiency and enjoying extravagant material rewards for being a compliant electorate.

I cannot say that the jingle ever offended me while I was growing up. I loved playing rugby and the thrill of its controlled aggression. I also took the sunny skies and my privileged life for granted when I lay on the steaming tiles around the public swimming-pool next to our home in suburban Johannesburg – I had no thoughts of black teenagers in overcrowded slums with no access to swimming-pools. And there was always plenty of grilled meat left over after the customary weekend braaivleis, or barbecue.

My mother's parents were Catholic Croats who had emigrated from Yugoslavia in the 20s, and my father had come out to South Africa in the 50s. I was brought up in an all-white, English-speaking community and attended English medium schools. Our only contact with blacks was as service people – domestic workers, 'garden boys' and 'rubbish boys'. I never used the word 'kaffir' – the Moslem term for 'non-believer' that, with centuries of mangled interpretation, had become South Africa's most emotive racial insult. I never dreamed of going kaffir-bashing on Friday nights – a practice where gangs of drunken white kids looked for lone blacks to beat up. I knew there was a sickness in our society, but then, I did not realize the extent of it. I took the

pleasures of apartheid for granted. Like most of my contemporaries, I had failed to register the situation of black South Africans, had never been to see how different a township school was from my own green-lawned preserve, had no inkling of starvation in the homelands – ethnically-based reserves to which black people were forcibly moved out of 'white' South Africa. My mother had instilled in me a sense of justice and fairness that would probably ensure that I grew up to be a 'nice' white: one who did his military service, paid taxes and bought defence bonds, and might vote for a less racist, relatively liberal party in an effort to appease his conscience. I would have been one of those blind deaf-mutes who ensured South Africa made enough money to pay for apartheid, without ever getting my hands dirty in directly oppressing anyone.

I was just 16 when I enjoyed my first holiday away from my parents, experimenting with rum and mampoer moonshine along the beautiful coastline of the Natal South Coast that was reserved for whites. It was during that summer holiday that I fell for an Afrikaans farm girl whose mashed toes began my education in the racial ugliness underpinning our society.

My buddies and I were playing beach soccer when a lean, long-legged girl with hazel eyes and flowing hair joined the game. Her name was Michelle and she played like a boy. As the game slowly petered out, just the two of us were left kicking the ball around. Michelle told me she had learnt to play soccer with the children of the black labourers who worked on her father's farm. She showed me her toes, crooked and misshapen from playing barefoot on uneven patches of farmland. It was with an aggressive irony that she referred to her black playmates as kaffirs. I was shocked, but then understood that her use of the word was comparable to the way black Americans had appropriated the word 'nigger' to blunt its sting. She had grown up with black kids in one of the most brutally racist sectors of white society. As a child, she had been allowed to play with black kids, but now that she was growing up, she was expected to leave her black friends behind. The whites' biggest fear was that one of their girls would sleep with a black man. Michelle was a

teenager rebelling against her environment and a society mired in racism.

I was startled and attracted by her anger, intrigued by the sense of social injustice that vaguely lurked outside my suburban world. But my life was filled with school, sport, experimenting with alcohol and learning about those mysterious creatures called girls.

By the time I left for university in Pietermaritzburg, far from home, in the eastern province of KwaZulu-Natal, I had become involved in socialist politics and was tutoring black schoolkids from nearby township schools as they prepared for their final school exams. From them, I learned the then-banned hymn and liberation anthem, 'Nkosi Sikelel' iAfrika'. The all-white university was awash with poisonously right-wing students, many of them fleeing black rule in newly independent Zimbabwe, the former Rhodesia to our north. South Africans called them 'when-we's' after their habit of whining about how good things used to be: 'When we were in Rhodesia . . .' They were generally distinguishable by their clothes: short-sleeved shirts, rugby shorts, long socks and desert boots. From them I first heard the term 'oxygen-wasters' applied to black people and it shocked me. Before long I was involved in several brawls and other ugly confrontations. After the April Easter break, I learned that I had been chosen to play rugby for the province's under-20 side. Though I very much wanted to play in that team, I had already decided to quit the sport – the racism endemic in rugby depressed and angered me too much. I even began to root for any team that played against the South African national side – the Springboks, resenting their victories.

No bright advertising jingle could ever sum up the other, darker formative forces in my life. My parents shared a horrendous marriage, full of quarrels, beatings and loathing. They were divorced when my brother and I were very young and my childhood days were never as happy as when they were separated. I lived with my mother, Franka, while my brother stayed with my father, Mladen. It was a great time: she and I would renovate furniture into the early hours of the morning, and, when I would be too tired for school, she would supply false sicknotes.

But my parents reunited some years later, and the quarrels and fights began again. There were weeks when things went well, but then my mother would turn to the whisky, and that was all she needed to be transformed from a loving woman – generous, caring and fun – into someone who could not resist a fight. My father was a money-obsessed bully who drank too much all the time and who verbally and physically abused his wife. Whenever the signs were there that a fight was about to begin, I would feel the fear build in my stomach, a sickening dread of violence beyond my emotional capacities to handle. I remember vividly the first time I managed to overcome my fear of him. I was about 14 or 15. It was on a weekend, and they were both drunk. I had not heard the beginning of the argument, but it had been going on for some time – and then he began to hit her. I was frightened and angry, but determined to intervene. To Mladen, this was a threat to his manhood – he would not tolerate being questioned by a 'pip-squeak'. After much screaming and pushing, I somehow ended up with a butcher's knife in my hand, warning him that unless he left my mother alone, I would stab him. Even through the drink, he realized that I was serious and backed down.

During my last year of school, 1980, when I was 17 years old, doctors discovered my mother had cancer. It had started as lung cancer, but had spread through her organs. She had given up cigarettes eight years earlier, so it came as a shock that her effort had come too late. For me, her illness seemed like some kind of cosmic misunderstanding.

After she learned of the cancer, she began to keep a diary in a small leatherette pocketbook. It had not been her habit – at least not that I was aware of – to keep a diary, though she was a prodigious collector of the most obscure and useless things. The first entry was in a medium blue ballpoint, though she loved writing with a nibbed ink pen, the curves of her convent school handwriting flowing smoothly word after word. There was no mention of her sickness, no prayer for her recovery committed to paper. The pens changed, one that stuttered, a lighter blue, then a fine tipped blue. And the handwriting of which she was so proud degenerated into a cramped, harsh scrawl. And she was writing

much more, as if she felt the disease taking over, compelling her to say more. But she did not manage more than to give overly detailed descriptions of the house and our daily life, naming every family member or friend who visited. She noted that she had baked a turkey and a walnut loaf for Christmas lunch.

The diary then began to mention the pain waking her in the early hours, when the drugs wore off; having to change the bedclothes because she had sweated through them. She was now confined to bed most of the day, and only occasionally got up.

10 December 1980 was the first time the diary mentioned death – it was her last entry: 'At 16.30 had appointment with Dr Homan for morphine injection. During conversation he told me he was a Christian. Spoke about lack of fear of death. No charge for consultation.'

When I read the journal, I understood the early, mundane entries as her attempt to deny the cancer, to hold on to life. Towards the very end, the drugs she had been prescribed were not enough to keep her completely pain-free, and Mom knew she was too far gone for a cure. Every day, when the pain grew too great, she would ask me to run a hot, hot bath for her. Since she was too weak to bathe herself I would help her undress and lower her into the steaming water. She would gasp from the heat, but it would help to ease the other, mortal pain. I found this experience very hard to handle: my mother was helpless and in immense pain, yet I was embarrassed by her nakedness and it was difficult to accept that this fiercely independent woman could not even dress herself. I cannot recall what her face looked like at that time, but I clearly remember her plump belly in the water.

In the last months of her life, my parents stopped fighting. My brother Bart, who was two years older, could not deal with her illness and he went for hours-long runs to rid himself of the anger he felt. I understood cancer only imperfectly: I knew it could kill you, but I also knew it was curable. Mom had undergone chemotherapy and radiation treatment and I was confident that would cure her. More importantly, God was going to save her. What I did not know was that my mother

knew she was going to die, that her apparent faith in a miracle cure was really for our benefit. The rest of us believed she would pull through. I had recently become as religiously devout as my mother, uncles and aunts. We all prayed day and night, believing the Lord would spare her.

Despite all that love and faith, she did die, on a hot summer night. We were all around her bed in the small yellow room. Mladen was reading some photo-romance comic in another room and had to be called to the deathbed. That was the end of any feelings I had for him, except contempt and hatred, though it would take a year of our trying to keep together as a family 'for Franka's sake', before a rancorous and violent fight finally ended all pretence. To me, he was no longer my father. It took even less time for my naïve belief in God to wither away.

So nine years later, on Friday, 17 August 1990, I found myself, a godless, scared and confused white boy in his late twenties, leaving the comfort of white Johannesburg to venture into black Soweto, armed with nothing but a couple of obsolete cameras. I had taken up photography a couple of years previously as a means to explore other people's lives, the more different from mine the better. I had discovered that there is nothing like a camera to grant a licence for curiosity. But I was so far out of the news loop that six months earlier, instead of attending the biggest South African news event of my life – Nelson Mandela's release after 27 years in prison – I had chosen to photograph people coming to pay their respects to the Rain Queen, in the far north of the country, after the death of her daughter. The Rain Queen, or Modjadji as she is known, is a traditional chief who, it is believed, is able to control the rains in a land prone to drought. I had spent a lot of time there and was building up an interesting body of pictures.

Besides such anthropological work, I had been doing stories on people living under apartheid, mostly rural stuff. But after Mandela's release it was clear that a new era had begun and apartheid was ending. The radio began to carry a steadily increasing number of news reports of burning barricades and deadly clashes in Sebokeng, Thokoza and then Soweto – South Africa's largest black city, just 15 kilometres from

my home, and a place I was at least familiar with, as opposed to the other, even more ominous names. My uneasy stirring of excitement and fear increased as each hour's broadcasts told of a widening of the conflict.

There were no visible borders around the townships, no sentries to warn the ignorant, no signs saying 'Keep Out: Battle Zone'. But there was a war going on inside those ghettos, as residents who supported Nelson Mandela's non-racial African National Congress (ANC) were pitted in a struggle against the police and migrant rural Zulu nationalists, based in the workers' hostels that dotted every township. Those hostels, sprawling blocks of single-storey workers' dormitory buildings, were being turned into Zulu strongholds under the banner of Inkatha, the chauvinist Zulu movement that had been formed as a cultural organization in the 70s, but swiftly became political. I – like most people – did not understand the exact roots of the war and was confused by the seemingly indiscriminate acts of violence. The easy and commonly accepted answer, supplied by the white government, was that the ANC was locked in a battle for power with Inkatha – no more, no less. But many years later, all the half-clues and evidence would finally be put together to show that the euphoria of Mandela's release had been accompanied by a sustained campaign of brutal killings and terror, covertly planned, funded and executed by government security units and the police. Policemen and soldiers assassinated political figures, community leaders and also hired gangs to spread terror in the townships. The white government wanted to disrupt the ANC's support base ahead of an election that would allow black, coloured and Indian South Africans to vote in a one-person-one-vote scenario for the first time. Inkatha collaborated with the white state in attempting to crush the ANC and secretly received weapons and military training from the security forces. These Zulu nationalists, with dreams of secession, wanted to retain the autonomy of their KwaZulu homeland, which in the future would surely be subsumed into an ANC-led South Africa.

As I approached the entrance of Nancefield Hostel, deep inside

Soweto, I was confronted by dozens of armed, belligerent Zulu warriors for the very first time. They wore red headbands and were armed with a variety of machete-like pangas, clubs and improvised spears as they stood on the raised railway tracks next to the hostel, shouting insults and threats across an overgrown graveyard. On the far side of the cemetery was a large group of residents, presumably ANC supporters. Among them were several journalists. I did not see much point in going across there; even if I did get pictures, they would be tough to sell to newspapers who had their own, probably more proficient, photographers on the scene. I knew enough to know that the Zulus were seen as the villains of the piece by most of the second- and third-generation township residents from a dozen other South African tribes. I also knew that the massive, decrepit dormitory complexes housing tens of thousands of migrant workers from the rural, tribal homelands across the country were undergoing a brutal purge of all non-Zulus.

The conflict was more complex than just Zulus versus The Rest. In 'Zululand', a civil war between Inkatha-supporting Zulus and ANC-supporting Zulus had been raging for a decade, before it moved to the cities and towns around Johannesburg – the Reef, as it is known. Inkatha worked hard at portraying themselves as the sole representatives of the Zulu people, a lie that was propagated by the government and sympathetic media. But I was entirely innocent as to what these facts meant in reality; they were just words in news reports and I naïvely decided to try and get pictures from the Inkatha side.

The warriors were surprised to see me there and not with the other journalists, but seemed to decide I was no threat. They continued to do their mock charges, leaping up and down, as their traditional war cry of 'Usuthu!' rang in my ears. After a few minutes, the warriors tired of taunting their enemies and returned to the hostel. I followed the men into one of the long dormitory blocks, where we sat on cement benches at a cement table in the communal kitchen and eating-room. The tangy smell of the traditional sour grain beer being passed around in a plastic jar added to the acrid stench of the cramped quarters. The windows

were grimy, and except for some scoured aluminium cooking pots, everything seemed dirty.

The hostels had been designed for temporary occupation by black migrants from the rural areas, whose movement, employment and rights to residence were controlled by a series of laws enacted from the 1920s onwards. Hostels were for single men. This is not to say that the men who lived there were necessarily unmarried, but simply that they were not allowed to bring their wives or families to live with them. The laws of apartheid allowed them to stay in urban areas only as long as they were gainfully employed. When their labour was no longer needed, they had to return to their homelands. Under the pass laws more than 17 million black people were prosecuted from 1916 to 1981. The apartheid dream was to force most blacks, 80 per cent of the population, to be legal citizens of the nominally independent ethnic homelands squashed into 13 per cent of the nation's territory, so that the rest of South Africa's vast, rich lands could be enjoyed by a white minority that conveniently employed blacks from the captive labour pool in the homelands.

The hostels were austere structures, neglected by the municipality and by tenants alike. Their architecture imposed a claustrophobic proximity within, and isolation and distance without.

They were basically dormitory quadrangles with contiguous single-storey concrete-block lodgings forming the outer perimeter. Enter a typical one, and the dirt and neglect assaulted your senses. Raw sewage from blocked and broken pipes spilled on to the ground. Uncollected garbage and dead dogs rotted unattended.

The communal ablution blocks were not maintained and broken toilets rose from reeking pools in stalls that had never had doors. The cold-water showers had no doors either, so that those shitting could pass the time by watching those washing. There was no heating, even though temperatures dropped below freezing in winter. In summer, the poorly ventilated rooms were stifling and the stench unbearable.

Each hostel had only one entrance that led to the dormitories. Few windows had glass panes and many were covered with plastic,

cardboard or corrugated iron. To each side, a door led into an open-plan sleeping-room meant to be shared by four men, but often as many as 16 were crammed in. Each person had perhaps 1.8 by 1.5 metres of space in which to sleep, but even that was often shared as the beds were occupied in turns by shift-workers. Clothing hung from a length of wire strung above the beds; grey steel lockers stored food, pots and a few smaller items. There were no ceilings, just the underside of a corrugated iron or untreated asbestos roof, often in disrepair. When the fighting forced the township Zulus who were loyal to Inkatha to seek refuge in the hostels, entire families crowded in, worsening the hostels' already unhygienic conditions.

No provision was made for entertainment, unless you counted the ubiquitous beer hall run by the municipality. Enterprising residents usually set up a rough stall to sell parts of an animal slaughtered somewhere in the hostel, while others tried to make a living by converting their rooms into shebeens – informal, often illegal, taverns – where clear beer in quart bottles and sorghum beer in paper cartons was sold and consumed. Drunkenness was commonplace, and the Inkatha men that I was sitting with inside the hostel were getting drunk.

Suddenly, a piercing, excited whistling echoed from somewhere deep in the massive hostel complex. Everyone jumped up and many began running towards the noise. 'What's happening?' I asked.

'Nothing, it's nothing,' a man answered, as he ran towards the sound, carrying sharpened iron rods and a cardboard shield. I followed another man carrying a piece of steel piping, white paint scuffed and peeling off in places. He paused now and then to blow into the pipe, emitting a thin trumpet-like sound. Was this a call to battle, I wondered? We came to a halt outside an undistinguished dormitory, where a score of men armed with sticks, assegais (spears), sharpened rods and pangas gathered before a white-painted steel door. Some tried to peer cautiously through the windows, shying back as the curtains twitched. 'Vula! Vula!' They were demanding that whoever was inside open the door. But there was no response. When they tried to force the door open, it remained stubbornly shut. The door seemed not to be locked, but the

person inside appeared to be holding the handle up to prevent the men outside thrusting their way in.

The mood outside the door seemed strangely jovial. The men did not seem too aggressive, except when they shouted, 'Vula!' with an explosive expulsion of breath on the first syllable. They smiled at each other and at me: 'There is a Xhosa inside. He has been shooting at us,' explained one. I had not heard a single gunshot in the time I had been at the hostel, but I felt that this was not the time to point this out.

Slowly, the game turned serious. The men crowded at the door, trying to force their way in. The door gave and swayed slowly inwards, only to be jammed shut again. The contest was slow and deliberate, the strength of the men outside equalled by an unseen force within, as if the door had a powerful spring holding it shut. Eventually the door was pried open long enough for one Zulu to squeeze in. The door slammed shut after him. What was going on inside? The door continued to resist the men outside, but then another warrior managed to slip through. Once again, the door slammed shut after him. Then another warrior managed to slip in. The man inside was clearly weakening. A fourth man pushed through, yet there was still only silence from within.

What grim battle was taking place inside, I could hardly imagine. Then the door was pulled open from the inside and a tall man with a woollen scarf wrapped like a turban around his head raced out, waving a broom. His eyes were wide open and wild, looking directly into mine, from just feet away, but there was no comprehension, no connection, just a desperate attempt to escape. His shoulders were pulled straight back and his knees pumping high as he burst through the men outside the door. 'Maybe he can make it,' I thought.

The Zulus and I took off after him, a pack hunting its terrified prey. After just a few dozen steps he went down, but I did not see why or how. The attackers were instantly around him in a tight, voiceless circle, stabbing, slashing, hitting. My ears picked out the slithering, whispery sound of steel entering flesh, the solid thud of the heavy fighting sticks crushing the bone of his skull. These were sounds I had never heard before, but they made sickening sense, as if this were

exactly the noise a roughly sharpened, rusty iron rod should make when pushed deep into a human torso. The victim's body quivered each time he was hit and jerked spasmodically when a jagged spear blade was tugged from the resisting flesh.

I was one of the circle of killers, shooting with a wide-angle lens just an arm's length away, much too close. I was horrified, screaming inside my head that this could not be happening. But I steadily checked light readings and switched between cameras loaded with black-and-white and colour, rapidly advancing the film frame by frame. I was as aware of what I was doing as a photographer as I was of the rich scent of fresh blood, and the stench of sweat from the men next to me.

Some time during those minutes, the man on the floor passed from living to dead and the blows slowed from the frenzy of killing to a sadistic punishment he could no longer feel. Not everyone was silent; the man with the home-made horn I had followed through the hostel blew monotonously into his pipe, emitting a coarse, unearthly sound. It was not a call to battle, I now understood, but a celebration of death.

'Mlungu shoota!' one of the dozen killers exclaimed as they finally took note that I was taking pictures. The men sprang away, but within seconds they would surely realize that I was a defenceless witness to the murder. Fear swept over me. I prepared myself to do anything to survive: I thought of kicking the dead man and calling him a Xhosa dog. I was even prepared to spit on the corpse. I knew I would be capable of desecrating the body to survive.

'Lungile, ai problem!' I called out in pidgin Zulu, surprised that my voice sounded calm as I tried to reassure them. Their attention returned to the body and in desperation I tried to ingratiate myself: 'Who was he anyway?'

'He was a Xhosa, he was shooting at us, a spy!' said one of the men. I readily agreed, quick to seize this chance to justify the killing, to save myself. The killers were now treating the corpse with what I would later realize was the customary delicacy that Zulus display around dead bodies – to touch the dead is to be spiritually polluted. One of them

struggled to go through the dead man's trouser pockets using the tips of two spears. He fished a green identity book out of a side pocket and opened the pages. Two or three others gathered over the worn book that would reveal the dead man's tribe, and − in their minds − his political allegiance: 'Ah, a Pondo − he deserved to die,' one said.

The dead man was not, after all, a Xhosa, not a member of the ethnic group that dominated the political leadership of the ANC. He was a Pondo, whose ancestral homeland lay between that of the Zulus and the Xhosas along South Africa's east coast. Many were culturally more Zulu than Xhosa, and some supported Inkatha. But all that mattered was that he was not a Zulu (and in this instance, read 'Zulu' as 'Inkatha-supporting Zulu') and therefore an enemy. My mind was in turmoil, I tried not to think of what I had seen or what I had done.

The killers rapidly lost interest in the corpse and drifted away. I began the long walk out of the hostel compound. Inside the dormitory where the terrified Pondo had hidden, several Zulus were searching for the gun, but there was none to be found. Two men with red headbands presented themselves to me, posing shoulder to shoulder, and demanded: 'Shoota, baas, shoota us!' I took the picture, gave a queasy grin and walked on. I feared I couldn't maintain my calm any more, sure the shock was too apparent on my face for my safety. I concentrated on the well-established poplar trees that lined the road as I walked out. They were beautiful in the late afternoon light.

I went to a newspaper office where I had friends and asked the darkroom technician, Rudy, to process the films for me − I thought I was too upset to do it properly. But shocked as I was, I was mindful of the importance of the pictures. No words would bring home the horror of what was happening in the townships as clearly as that set of brutal pictures could. I was also aware of the commercial value of those shots. A friend at the paper advised me to take the pictures to the Associated Press, the US wire service. When I got to the AP's downtown Johannesburg office, I pressed the photo editor for a favourable deal and even persuaded him to put me on to one of the big-selling French

picture agencies as a part of the bargain. I was learning fast. This was my chance to make a mark in the world of photojournalism and, I hoped, to break out of the ranks of the perpetually broke freelancers. I was able to do so because of a man's savage death.

# 'f5.6 SHOULD BE RIGHT'

(JOH-106)SOWETO, SOUTH AFRICA, SEPT. 15 –
HUMAN TORCH – A small boy runs past as a youth clubs the
burning body of a man identified as a Zulu Inkatha supporter
and set alight by rival African National Congress supporters,
Soweto, South Africa, Saturday morning.
(AP ColourPhoto) (mon71224/str. SEB BALIC) 1990
EDS. NOTE: – COLOUR CONTENT: ORANGE/RED
FLAMES – PERSONS IN SILHOUETTE, VERY LITTLE
DETAIL.

<div align="right">Associated Press photo caption</div>

|||

*15 September 1990*

There aren't many trees in Soweto. The gang-ravaged neighbourhood
of White City has particularly few, but that morning it had lost several
more. Some of the scarred thorn trees along the main through-road had
been roughly chopped down and dragged into the street to provide
obstacles to possible attacks by hostel Zulus and police. I slowed my car
to a crawl, negotiating the newly felled trees, kerbstones and burning
tyres that imperfectly barricaded the way to the rows of Jabulani
Hostel's dormitory blocks. The sun was not yet up, and the highveld
chill kept fogging the windscreen. It was a month after my first foray
into the hostels and I had been back in the townships almost every day
since then. Today I was with Tom Cohen, a reporter with the AP who
had been posted here from the US just days before. We were planning

to do a feature on the hostels as flashpoints of violence. I had established a good relationship with the AP. They didn't have anyone regularly getting them conflict pictures and they were all too willing to pay me day-rates or to buy pictures from me.

In the month since I had photographed the Pondo's death in Soweto, I had become completely absorbed by the news and hadn't touched the larger format view camera that I normally used for softer documentary stuff. Each day I tried to control my fear and sought out access to the township clashes – I was becoming hooked on the adrenaline and the notion that I was photographing the final push for liberation as it was happening.

As Tom and I inched along the road, two teenage boys emerged from the inky blue shadows and padded up to my window. They wore knitted woollen caps pulled down low over their foreheads and baggy slacks with hems shortened to leave a gap of a few inches above their loosely-laced canvas takkies – the informal uniform of petty township thugs, tsotsis.

'Heytada,' I greeted them in tsotsietaal, the township vernacular. 'Hola,' they responded with the Spanish greeting that ANC militants had brought back from guerrilla training camps throughout socialist Africa, where most of their military instructors had been Cuban. Tsotsies liked to be considered comrades – full-blooded ANC guerrillas or activists; they wanted to be a part of the ANC-aligned neighbourhood militia that came to be known as 'self-defence units'. Law-abiding residents duly addressed the tsotsis by the abbreviation coms, but snidely called them comtsotsis behind their backs.

'What's going on, coms?' I asked. The boys always knew where things were happening, but it was 50/50 as to whether they would tell you. 'It's bad,' they said. 'All night, nyaga–nyaga with the fokken amaZulu.'

'Is it quiet now?' I asked, as I glanced nervously towards the hostel that dominated the low hill some 300 metres in front of us. 'Tsk,' was the dismissive reply. 'Give us petrol, mlungu.' I smiled weakly, trying to think of a way for this whitey to get around the demand. I knew they wanted the fuel for Molotov cocktails.

'Leave them. They're journalists, they can't,' another youth commanded from the side of the road. I looked over at him, but could not make out his features in the near dark. He was probably a real comrade, a trained ANC fighter, commanding the thugs' respect. The comtsotsis turned sullen and began to move away from the window, but then one leant forward and whispered: 'Give us your gun.'

'I don't have one,' I said. This was easier to handle than the demand for petrol, since I had never owned a firearm. He looked at me in disbelief; it was clear to me that he subscribed to the widely held notion that every white man owns a gun. 'Straight, com,' I said. 'You can search the car.'

The thugs exchanged words in a language I didn't understand and then drew back. I eased the car into gear and left the barricades behind, driving slowly on to a bridge that crossed the railway line running alongside the hostel's fortress-like eastern edge. There were three men in long overcoats on watch at the gate that cut through the red brick perimeter wall, defaced by badly executed graffiti proclaiming it Inkatha territory. They stared at us as we approached, the long coats doubtless hiding shotguns or assault rifles. Instead of turning into the entrance, I said to Tom, 'I don't feel too good about this, let's keep driving.' He readily agreed – we were both scared to go into a hostel following a night of conflict. We caught up with a car ahead of us, recognizing a couple of fellow journalists inside: Simon Stanford and Tim Facey, a television crew for the BBC. We exchanged waves, then followed them as they skirted the south side of the hostel. It was a comfort to be with other journalists, an illusion of safety in numbers. And maybe they had information about something hot that was going on.

Leaving the hostel behind, we looped around Jabulani stadium and turned east again to recross the railway tracks. Simon and Tim were driving slowly, clearly just cruising, but we decided to stick with them in any case. After a kilometre we turned left and followed the tracks up to Inhlazane train station, the closest stop to Jabulani Hostel. We were just a couple of hundred metres short of the corner where the comtsotsis had demanded petrol ten minutes previously, but we found that the

stretch of road that would have allowed us to complete our left-handed circle was blocked by several makeshift barricades.

Groups of residents, ANC sympathizers, watched us approach as the early light gradually erased the smudgy darkness. I parked and we got out to speak to the combatants. We introduced ourselves as journalists. The men and youths were aggressive, agitated. They had obviously been up the whole night, skirmishing with their Inkatha enemies from the hostel across the railway tracks. They were not keen to have us around.

'We work for the foreign press, AP and BBC,' I said. But one of the men was suspicious. 'You're from the *Citizen*,' he insisted, referring to a disreputable racist daily that had been set up by a covert government propaganda fund. Every black person I knew hated the paper's political reporting and editorials, but it nevertheless had a massive black readership drawn by its comprehensive horse-racing results and excellent punter's guide.

'Not the *Citizen*, mjita (my friend), I promise,' I protested. This was more than a little disingenuous, since all the local papers subscribed to the AP and often used the wire pictures to further their own particular bias. But the partial truth enabled us to stay.

A shrill whistle galvanized the comrades and someone yelled a warning that the police were coming: 'Poyisa!' Tom and I followed on the heels of the boys fleeing for shelter behind the station ticket office next to the road. Within seconds an armoured military personnel carrier, a tough, heavy Casspir designed for the bush war in Angola but now used in the townships by the police, careened up the road. The Casspir's massive wheels simply crunched over the rocks and rubble barricade the residents had erected in a vain attempt to control access to their area.

The police fired randomly from inside the towering behemoth as it sped by, rocking from side to side on its rigid springs. What cowboys, I thought: it would have been stupid bad luck if any of us had been hit. As soon as the Casspir rounded a corner, the coms emerged from cover and tried to drag a big garbage skip into the road to make a more

effective barrier. It was like watching a game. The residents could not match the heavily-armed police with their rocks and the rare firearm; but equally the police could not quell the unrest by racing through the township, firing wildly.

The coms grew more at ease with our presence. The shared excitement had broken down some of the mistrust, so we could take pictures more freely. Within a few minutes, shooting broke out again, this time at the bridge leading over the tracks. I ran up the slope of the embankment that bordered the line. A handful of older ANC supporters crouched behind the heavy iron plates edging the bridge. Thirty feet below us were the sunken tracks and the austere concrete platform of Inhlazane station. I ducked down beside a man wearing a soft cloth cap and carrying a revolver. We crouched below the bulwark at the entrance to the bridge. 'No pictures, you hear?' he said, glaring fiercely at me. I reluctantly lifted my hands off the cameras to show my acquiescence. He peered over the top, across the railway lines. Several other coms lifted their heads, not wanting to miss out if the gunman hit anything. He cautiously lifted the revolver above the edge and fired, then dropped down on to his haunches again to cheers and admiring calls from the women down behind us at street level. Return fire from the Inkatha side occasionally whistled comfortably high above our heads, but we all ducked reflexively.

A train stopped at the station. The driver was either ignorant or uncaring of the clash going on above him. Some of the young combatants ran down to meet the train, in case there were Inkatha members on it, or to guide their own to the safe side of the tracks. I watched them re-emerge at the top of the wide concrete stairs, pushing and pulling a tall man in a blue workman's coverall jacket. He was at least a head taller than the boys, but he did not resist as they tugged and drove him towards ANC territory. He could have been returning from a night shift or making an early start to visit friends, but he had unwittingly disembarked into our insignificant little skirmish.

At first, I was not sure of what was going on, but as soon as they had him off the bridge and out of sight of the Inkatha members opposite,

they began to stone and stab him. I watched as he fell to the ground, then tried to crawl under a door propped up across the dented steel drums of a street vendor's stall. I was terrified that I might again witness a murder like the brutal killing at Nancefield Hostel a month before. It had been the first time I'd seen a person killed and I could still not shake off the feeling of guilt that he had died so close to me that I could have reached out and touched him, yet all I had done was take pictures. As much as I wished that I could have had another chance to try to stop his death, that Saturday morning seemed too soon to be offered a chance to redeem myself.

The coms dragged the silent and unprotesting man they had identified as a Zulu to his feet and down the path to the street below. More people gathered around, mostly teenage boys, but there were one or two older men and a handful of even younger boys as well. They crowded around the bloodied Zulu and the assault intensified. A youth ran in and leapt high to deliver a kind of kung fu kick. Another slapped the Zulu hard across the face, a demeaning blow usually reserved for obstinate women and disobedient children. A man in a long-sleeved white shirt hauled out a massive, shiny bowie knife and stabbed hard into the victim's chest. I was in the midst of the crowd, separated from Tom and the other journalists. My heart was racing and I had difficulty taking deep enough breaths. Stepping across the chasm from my presumed role as a detached observer to that of a participant, I called out: 'Who is he? What's he done?' A voice from the crowd replied, 'He's an Inkatha spy.' I tried to see who was speaking, to make contact with an individual amid the killing fervour.

'Are you sure he's a spy? How do you know?' I asked. Another voice answered: 'We know.' It was the man in the white shirt, absolute certainty in his flat voice. But he had stopped the attack for the moment and was looking at me. He seemed to be the leader, though I did not see him command or direct the action. Perhaps it was just that he was older.

'What if you're wrong?' said. 'I mean, last month I saw Zulus, Inkatha, kill a Pondo because they thought he was Xhosa. Just here, at

Nancefield Hostel. Maybe he is Zulu, yes, of course he is, but maybe he is not Inkatha. He could be ANC. Just make sure.' The man nodded while I talked, watching me shrewdly. Despite the garbled way it came out, he understood. But what I had to say did not matter. He and the others knew their decision had already been made.

The attack resumed and it looked as if the Zulu was now in a state of shock. Maybe the boys had demanded that he give the ANC nicknames for the neighbourhood streets, or someone had shown him a one-rand coin and he had identified it as 'iLandi', betraying the rural Zulu dialect that characteristically changed 'r' to 'l'. That would have been enough to secure his death sentence. But I never actually heard the man utter a single word throughout his ordeal. He did not appeal for mercy, nor even look to me for help. He seemed not to recognize what was happening. I wondered if he was mentally deficient, drugged, or just dumb with terror.

My questions had attracted attention from the coms and some of the assailants began an ominous hissing. 'No pictures, no! Fokoff!'

I managed a fleeting defiance: 'I'll stop taking pictures when you stop killing him,' but the attack simply went on moving down the street as the Zulu stepped slowly and ponderously forward. Now, one person after the next took turns to inflict an injury on the defenceless man. It was as though this was a rite that had been played out before, and everyone but me knew the liturgy.

I noticed odd details. The sun had cleared the single-storey houses and shone with the extraordinary clarity of a spring morning. It would be a hot day.

I saw a young man with a wisp of a beard step forward and stand on his toes to thrust a knife into the Zulu's chest. His victim just stared dumbly ahead as the knife plunged in, while I released the shutter and wound on the next frame. A part of me did not want to be a photographer just then, but as with the killing in Nancefield Hostel, I smoothly exchanged camera bodies to shoot slide as well as colour negative, ensuring I had material for both the AP and the French agency, Sygma.

The progress down the street halted when the Zulu collapsed into a sitting position on the pavement. Most of the mob was edging away by then and others had slipped behind me, probably to avoid being photographed. The man in the white shirt moved in again; I had a camera in front of my face as I shot and cranked the advance on my shabby Nikkormat. I took a few steps back, driven by a nervous impulse, some vague sense of unease about the spot I was occupying. Afterwards, Simon, the BBC cameraman, would say: 'Jesus, did you see that guy try to stab you?'

For those crucial minutes, it was as if I lost my grasp of what was going on. I was present, but nothing entering through my senses registered. The pictures I kept mechanically taking would later substitute for the events my memory could not recall.

By now, the victim was lying on his side, propped up on one elbow, facing away from me. A teenager with one arm in a plaster cast used his good hand to throw a rock at his helpless target. In the picture, the victim seems to be looking directly at his assailant while the rock, captured in mid-air, is hurtling towards him. Did it hit him? I can't recall and as my cameras were without motordrives, there is no photographic memory; no next moment. Another image is of the man in the white shirt stabbing his knife down into the top of the Zulu's head as he sits on the road, almost absent-mindedly reaching up towards the source of pain. I don't know if I noted that either.

My awareness gradually returned. The victim was now flat on his back some yards in front of me. All around him, the street was empty. The man in the white shirt was standing next to me, my left shoulder brushing his right. He lifted his right hand, the one he had used for stabbing, to look at a little cut he had sustained and drew his breath in sharply under his teeth: 'Ththth,' like a child letting it be known he has hurt himself on the playground.

I peered down at the cut at the base of his thumb; he held it out to ensure I saw. There was a thin line of red along a shallow incision in the soft pink-brown skin of his hand, no deeper than a clumsy shaving cut. I felt we were both acutely aware of how grotesque this instant of

bonding was. The moment was broken when a boy, no older than 13, walked across the deserted tarmac to the inert man and unscrewed the cap of the Molotov cocktail he was carrying. I was relieved that I had refused to earlier allow the comtsotsis to siphon petrol from my tank – what if it were fuel from my tank that was poured over that victim? The boy carefully doused the Zulu with the petrol. Then he walked over to where I was standing with the man in the white shirt. The kid knew what must come next, but he would not, or could not, do it himself. I watched him surreptitiously slip a box of matches into the older man's left trouser pocket, on the far side from me, and whisper in his ear. The man in the white shirt tried to make out that nothing unusual was happening, that I had not caught this grim interchange.

The hissing and cursing around me had grown louder, more menacing. But I was determined not to leave the scene. I had failed to prevent the man's death, but fuck them if I was going to leave and let them burn him too. I stood my ground next to the man in the white shirt, both of us staring at the body, pretending to be oblivious of the matches in his pocket. I heard the urgent calls from Simon, unnerved by the sight of me just standing next to one of the killers. 'What's happening?' he demanded. I could not answer. 'What did they say?' he asked. His words seemed to break the spell and I moved away, reluctantly, but also with relief. I felt as if a giant spring was wound up inside me, desperate for release. We agreed to leave, but then an excited shout went up from near the railway tracks. Onlookers drawn by the drama and participants in the killing ran up the embankment and we followed them. I was panting, though the sprint was brief. A handful of residents were trying to attack a man in a blue shirt, but their assault lacked the conviction of the earlier mob, and when one of those who had taken part in the first attack stretched out his arms protectively to ward off the blows, the attackers backed off. I didn't know why, but it seemed that he knew the man was not Inkatha; or perhaps he just had been sickened by the previous murder.

There was a low brick building, the ticket office, between me and where the Zulu lay in the street. Suddenly I heard a hollow whoof and

women began to ululate in a celebration of victory. I ran towards the edge of the elevation. The man I had thought dead was running across the field below us, his body enveloped in flames. Red, blue and yellow tongues licked the clothing and skin off his body. It was a stumbling, urgent run as he tried to escape the pain. I lifted the long lens camera. The human torch slowed and dropped to a squat. As I focused, I noted that the early sun was right behind the burning man. The camera's light meter did not work and so I twisted the aperture wide open: f5.6 should be right. I depressed the shutter, then pulled the camera away from my face for a second to advance the crank and frame my next exposure. A bare-chested, barefoot man ran into view and swung a machete into the man's blazing skull as a young boy fled from this vision of hell, from an enemy who would not die.

I lurched down the slope and stood over the prostrated body that crackled and smouldered. I tried to breathe without allowing the pungent, acrid smell to penetrate my lungs. I shot a few pictures, but I was losing the battle to suppress my emotions. I left while he was still twitching, moaning in a low, monotonous, most dreadful voice. Nearby, Tom was interviewing someone about the killing and I had trouble controlling my own voice as I said: 'Tom, let's go.'

'Yeah, OK.' He seemed in shock too, but wrapped up in talking with one of the killers. 'Let's go, now!' I repeated, raising my voice, and he took in the danger of the situation; the crowd could turn on us at any time and we had more than we needed. We walked to the car without exchanging a further word.

We got in the car, I started the engine and we drove off. Tom was looking at me, not sure of what to say, not even sure of what he had just seen. Around the first corner I pulled over and, closing my eyes, began to beat the steering wheel with my fists. Finally I could scream.

Only from the following day's newspapers did I learn the man's name: Lindsaye Tshabalala. I will never forget it now, but when I was so close to him, he was only an anonymous, unlucky Zulu who should never have caught the train that morning.

The pictures of the fiery death of Lindsaye Tshabalala set off a series

of events that I could never have imagined. On the other side of the world, in London, it was a sunny Saturday, and the AP's day photo editor 'Monty' Montgomery was alone on the morning shift. He prepared for the day by checking through the inter-bureau messages, domestic and international news copy and the pictures that had come in overnight. He scanned the newspapers to see how the previous day's AP pictures had fared against their rival wire services – Reuters and Agence France Presse. He noted that the major stories of the day were the growing Gulf crisis, a coup in Sudan, the Mohawk siege in Canada, the Aquino murder trial in the Philippines and Princess Diana due to appear on the balcony of Buckingham Palace for the celebration of the 50th anniversary of the Battle of Britain.

Not long into his shift, Monty got a call from Denis Farrell in AP's Johannesburg office. Denis told him that a stringer had arrived with film of an event in Soweto, but he thought the pictures too graphic to run on the wire. What he really meant was that they were probably too graphic for the US newspapers. There was an unspoken rule that overly graphic pictures of violence should not move on the wire, and the US had a lower tolerance for violent images than the rest of the world. Monty asked Denis to pick out the best images and let him see them.

Monty had a lot to do that day and the new technology then in place was cumbersome, slow and needed constant coaxing. When the first picture appeared on his screen, he muttered 'Holy shit!' to himself in the deserted office. He was used to seeing thousands of pictures but he had rarely seen anything like this. He wondered if I was black and if I was with the ANC.

In those days, the AP was using the Leafax, one of the first machines that scanned directly from the negative, as opposed to scanning from a print. The negatives had to be selected and scanned, cropped, toned and captioned, one at a time; and then transmitted to London on a phone line. Before digital technology made everything faster and easier, a black–and–white transmission took seven minutes, while colour transmissions took three times longer.

In Johannesburg, Denis struggled with the backlit, difficult 'Human

Torch' negative. The Leafax was an imperfect machine, and so to get better quality he made a print of the picture in the darkroom, sending it with the old-fashioned drum transmitter. The pictures came in slowly, dependent on 'clean' phone lines. Every time there was a crackle or noise on the line, it left a mark, or a 'hit', on the image that arrived at the other end and the separation would have to be resent. The process of getting pictures to the AP's newspaper and magazine clients was an intricate, slow and painful procedure.

Chief photo editor Horst Faas, wire veteran and two-time Pulitzer Prize-winner (1965 Vietnam and 1972 Bangladesh), came in shortly after the first pictures had landed. He took one look at them and despite his view that a story needed just one or two key images, he sent a customarily terse note to Johannesburg on the message wire: 'jobp/ pho/lonp Send all pictures. faas/lonp.'

Faas, Monty and Denis feared that the notoriously sensitive New York desk would kill the pictures because they were too gory. But on that weekend the London people convinced their cautious counterparts across the Atlantic to let all the pictures move on through to the newspapers. Their fears were well founded: by Monday morning there was an outcry from some of the newspaper editors and publishers who own the AP. They objected to such brutal pictures running on the wire. One editor complained that he ran a family paper, and castigated the AP for putting out such pictures. It was not as if the existence of pictures on the wire obliged anyone to print them; only a fraction of any day's production are ever published – hundreds of pictures are routinely ignored.

But Monty and Faas believed that the pictures of Lindsaye Tshabalala's death should be seen. To censor pictures that are too strong, indecent or obscene was to make decisions for the reader that were not theirs to make. They held that it should be shown that people were inflicting terrible violence on other people. In fact, some news-papers in the US did pull back from publishing the pictures, though many papers around the world ran them.

In South Africa, the violence of the photographs had an explosive

effect. The South African government saw Lindsaye Tshabalala's death as a perfect opportunity to portray the ANC as killers who could never be entrusted with leading the country. Within days, police approached the AP Johannesburg bureau to see if I would hand over my pictures to enable them to identify the killers. It would also be necessary for me to appear in court to validate the authenticity of the pictures so that they could be submitted as evidence. The police had not contacted the AP or the local newspapers about my photographs of the Inkatha warriors killing the alleged ANC supporter the previous month – it was presumably not in the interests of the South African state to prosecute their allies. Luckily, the police were trying to find one Sebastian Balic, the pseudonym I had adopted for my by-line, consisting of my middle name and my mother's maiden name. I had done this to avoid being detected by the military police, who were haphazardly searching for me to complete my military service. During my initial two years of compulsory national service in the army I had refused to carry a weapon. I had been allowed to get away with that little defiance because they needed me to translate Russian – something I just managed to do with a pile of dictionaries as the language is similar to my parents' mother tongue: Serbo-Croat. But by the time I was called up for camps, as the extended military call-up was known, I knew that even without carrying a gun, I would be playing my part in supporting apartheid.

Despite my horror at the brutal murder and the desire that the killers be prosecuted for it, there was no way I was going to testify. I had been allowed to stay during the clashes because I had convinced the ANC supporters that I was a journalist and not a police informer. If I did testify, journalists covering the war would almost certainly be targeted as soon as word spread. And once in court, Seb Balic would be revealed as Greg Marinovich. After I refused, the prosecutor issued a 205 subpoena, a court order used to force journalists, doctors and others to testify. The AP lawyers ascertained that the state would press ahead with charges against me if I refused to testify – with a maximum sentence of ten years for contempt of court and several more for avoiding military

camps. I decided to leave, rather than try my luck with the courts. So, within 24 hours, I was on a plane to London, leaving my housemates to deal with the security branch and plains-clothes policemen who would occasionally appear at the door.

Once in London, I felt that the AP and my magazine photo agency Sygma were less than helpful in finding me work. I unrealistically expected them to care about what I was going through; I understood the business associations as a form of friendship, rather than just an exchange of dollars for my pictures. I felt betrayed that neither agency took me under its wing in that strange city. I was in a troubled state of mind, shocked at what I had seen and depressed at having had to leave South Africa. I kept in touch with very few people back home, and most of my calls were to the Johannesburg AP office, trying to find out when I could return. Money was not really an immediate problem, as the British affiliate of my journalists' union back home gave me some money and let me stay in the union apartment in the city whenever it was free. When it was occupied, I would spend time at my aunt and her husband's house in the country, where I was made to feel completely at home. But they lived far from London and it was expensive and time-consuming to commute from there all the time. Camera Press, a picture agency, let me chase their unpaid bills and shoot local events: it was a job and I could survive on it, but I did not want to cover press conferences, rugby matches or London demos.

I had lots of feature ideas that nobody would assign. I was swiftly learning the dictum of journalism: if it bleeds, it leads. Papers would pay for photographers to go to war zones a lot quicker than they would spring for an essay on gypsy life in Eastern Europe. And so I decided that a good war was what I needed to take my mind off South Africa and to stop me wallowing in self-pity. After two months, Stuart Nicol, a former freelancer who had become the picture editor on the *European* newspaper, looked through my portfolio and sent me off on my first ever international assignment. He simply gave me a plane ticket and a wad of traveller's cheques. I assumed I would have to sign some kind of undertaking to work for them until the Second Coming, but Stuart

waved me off with an amused smile. My assignment was to cover the student riots in the streets of Belgrade and the possible collapse of Yugoslavia; but, by the time I arrived, the police had already beaten the opposition into submission and there was nothing to photograph. I stayed in progressively cheaper hotels and finally in youth hostels to save the paper's money – I was so green that I did not yet know that it is a foreign correspondent's duty to stay in the most costly hotels and run up impressive expenses.

Belgrade in November of 1990 was dark, cold and full of miserable people. I skulked around the region doing inconsequential features, hoping for distraction. One afternoon, I lay on my hotel bed wistfully aroused as I listened to the noisy sex of an anonymous couple on the other side of the thin wall.

Then the paper sent me to Hungary to do a story on the revival of Judaism – a happy story and a chance to escape the Slavic wretchedness of Yugoslavia. The Hungarian capital, Budapest, even in mid-winter, was full of beautiful women and excellent ice cream. But all I could think about was South Africa and my depression grew so severe that I became obsessed with thoughts of suicide. One cold evening I went for a walk and found myself on a bridge over the Danube. I was staring down into the swirling, icy waters: as if I were being drawn down into the current, tugged towards the water. The thought crossed my mind that the river might not be deep enough: what if I plunged off and landed in waist-deep water, cold and embarrassed? I reassured myself that the mighty Danube had to be deep, but the distracting thought made it all seem ridiculous. I pulled back, angry with myself that I could give up so easily. Right then, I decided to go home. Despite my paranoia, the police were not waiting at Johannesburg airport to arrest me.

The Hostel War was going on much as it was when I had left and I easily slipped back into the grisly routine of covering the violence. I again took up stringing for the AP, Sygma and others where I had left off three months earlier. One day, the police came in to the AP office to try to pressurize the bureau chief, Barry Renfrew, into giving them

Seb Balic's address. I was in the newsroom and watched him courteously let them out after telling them that he did not have an address for me, but would let them know when he did. It was all a charade, but it kept my stress levels pretty high. I then began to get phone calls about awards the Lindsaye Tshabalala photographs were winning; the pictures had been submitted for awards from institutions I had never heard of without my even knowing about it. While visiting my uncle and aunt on their mango farm outside Barberton, a rural farming area 450 kilometres east of Johannesburg, Renfrew called to tell me in reverent tones that I was a finalist for a Pulitzer Prize, and, as I had a one-in-three chance of winning, I should stick close to the phone that night. I made an appropriately awed response, but I really was not very excited as I had no idea what this Pulitzer thing was. After putting the phone down, I went and looked it up in the encyclopedia.

# FAME AND FRIENDSHIP

Kafirs? [said Oom Schalk Lourens] Yes, I know them. And
they're all the same. I fear the Almighty, and I respect His
works, but I could never understand why He made the kafir and
the rinderpest.

'Makapan's Caves', from the collection of short stories entitled
*Mafeking Road* by Herman Charles Bosman, Central News
Publishers, 1947

### April 1991

The phone rang at about ten that night, waking me from a deep sleep.
I heard the distinctive click of an overseas line. It was the AP photo
boss, Vin Alabiso, to tell me that I had won the Pulitzer Prize for Spot
News. Less than four months after turning away from the Danube's
frigid waters, I had joined that journalistic elite – I was a Pulitzer Prize-
winner, but right then I did not have a clue as to its significance. I
wondered if there were money involved, but I was soon to discover
what all the fuss was about. The next call was from the Johannesburg
office – they needed pictures of me celebrating as soon as possible. They
had the champagne ready. A sense of the importance of the prize was
taking shape: they had not asked for pictures of me when I had won any
of the other prizes. I became excited as I got dressed to drive to
Johannesburg through the night.

My new-found fame was awkward. The fact that I was winning
prizes for shooting Tshabalala's gruesome death troubled me, but when

I passed a huge newspaper billboard proclaiming 'SA Lensman Wins Pulitzer', I could not but feel a surge of pride. While a few photographers resented my quick success, most seemed genuinely pleased for me. We had a party to celebrate the prize at the new home I shared with my old housemates. The house was packed with friends and journalists, some of whom I had never met before. I was already drunk when photographer Ken Oosterbroek stood on a table in the living-room and gave a speech. Ken was taller than anyone else in the room anyway, but he wanted to make sure people paid attention. He was like that: when he wanted to be noticed, he would straighten out of his normal, easy-going slouch and get a stern, commanding air about him. I recall Ken recounting how, three years before, I had come up to him in the daily newspaper *The Star*'s newsroom and complimented him on a picture that had been splashed across the front page. 'I wish I could shoot pictures like that!' I had said. The picture that I so admired had won Ken South Africa's leading photographic award in 1989. Ken, truly a very talented photographer, and a perfectionist, had also struggled to gain a foothold in the industry. He had gone from paper to paper trying to get a job on the strength of pictures he had illegally taken of his fellow-conscripts during his military service.

He had kept a diary while serving as a soldier in southern Angola, where the South Africans were fighting against Angola's socialist government and southern African guerilla armies from their bases in the then South African colony of South West Africa. When I read those diaries years later after his death, I was appalled that Ken came across as a typical English-speaking white South African who easily referred insultingly to blacks as peckies. On 16 June 1981, for example, he had spent a long time looking at the bodies of six guerrillas that were lying piled in a heap. Ken had been fascinated by 'the kill'. One fighter had been shot right in the centre of his forehead. Ken assumed that he had been the first killed, shot by a sniper. They were all wearing People's Liberation Army of Namibia (PLAN – the armed wing of the banned Namibian liberation movement SWAPO, South West African People's Organization) uniforms, except for one who was naked. The naked

guerrilla's legs had been hacked by pangas. Some of them looked young, perhaps no more than 15 or 16, Ken estimated. The scene bothered him, but he rationalized that they had chosen to don guerrilla uniforms: 'they slipped up', he wrote. The next day he added a further note in his journal, one which suggests a much more unpleasant scenario. 'I have been thinking about the terr (terrorist) who was shot in the centre of his forehead. He had wire wrapped around him, which puzzled me. Tied up against a tree and shot?' In yet another entry he described, with neither reservation nor distaste, how his unit had wired up a young Angolan villager to a field telephone and tortured him for information. As for the vast majority of whites, it was 'them' against 'us' for Ken.

When I had first met Ken, I knew nothing about his border experiences or his politics, but the newsroom abounded with snide jokes about the chip on his shoulder. He was defensive and had a brittle arrogance. He was always very aware of his appearance – he had quite beautiful brown eyes and a charming smile, though he usually had a serious, intense look on his face. He was very aware of how he looked in pictures and I had never seen a photograph of Ken in which he was not mindful of the camera. Pictures taken of him over the years show a tall, thin man with long hair, inevitably wearing jeans and T-shirt, sometimes a droopy bandito moustache. He had perfected the image of the biker-rebel he so wished to cultivate.

Years after his stint in the army, Ken would return to keeping an occasional journal. When he achieved his first success as a photographer in 1989, he wrote: 'I won the Ilford Award (South African Press Photographer Of The Year) on Wednesday the 19th of April, exceeding my wildest expectations but fulfilling my ultimate ambition.

'One excellent night followed, full of cheers and smiles and congratulations & all, and a cheese slice (-shaped) trophy . . . i didn't put the thing down for hours. And then in the morning this kind of emptiness or what-now feeling and it just wasn't so important anymore.

'I've got it, it's history, it's on record and now my head is free of a single-minded one-stop goal. Now i can really let rip. Will somebody please give me a gap to let rip?

'BUT, give me a break to shoot the real thing. Real, happening, life. Relevant work. Something to get the adrenaline up & the eyes peeled, the brain rolling over with possibilities and the potential for power-house pictures. I am a photographer. Set me free.'

By the time we were celebrating my Pulitzer in April of 1991, Ken had had his wish come true. The country was awash with real pictures – passion, excitement and dreadful violence – and Ken had been named South African Press Photographer of the Year for the second time. Once he was the photographer he had dreamed of becoming, he matured into a generous and self-possessed man. His professional life was on track and he was in love with a vivacious journalist, Monica Nicholson. They had just returned from a working holiday to Israel, where they had spent the first two months of 1991 covering the Iraqi Scud-attacks on Israel. One night he and Monica were in bed in their Jerusalem hotel room when they were interrupted by a Scud-attack warning. Before going off to the shelters, Ken took a picture of himself and Monica. The photograph shows his hand reaching for Monica's exposed breast; they are both wearing gasmasks. He scrawled a note about the incident on hotel notepaper: 'A moment of passion and love – destroyed by War 23/01/91. A moment's tenderness. The first few moments of shared warmth. The opening joy, the quiet love felt as we lie together, giving over shared love to the physical. The promise of more, closeness, com-mitment and co-passion. The moon rising, sirens around us, the hostile hint, grim realization as speakers blurb a Hebrew emergency order.'

Ken and Kevin Carter, another young photographer, had become friends when they first started working for newspapers in the mid 80s. In that period, Kevin had witnessed the first known public execution by necklacing. Necklace was township slang for the barbaric practice of killing a person by placing a tyre filled with petrol around the neck and setting it alight. Maki Skosana, whose necklacing Kevin witnessed and photographed, had been accused of being a policeman's girlfriend. Her necklacing was the ritual, public execution of a person who had betrayed the community, a punishment reserved for those who collaborated with the state, traitors.

Kevin had watched and photographed as the mob kicked and beat her, and then they poured petrol on her and set her alight. She was still alive and screaming, but eventually she did die. Kevin wrote about that horrific incident years later: 'I was appalled at what they were doing. I was appalled at what I was doing. But then people started talking about those pictures; they created quite a stir. And then I felt that maybe my actions hadn't been all bad. Being a witness to something this horrible wasn't necessarily such a terrible thing to do.'

The state had its own form of the necklace, ritualized murder no less barbarous for its legitimization by law. The death penalty was frequently used against political opponents – hanging was the white regime's ultimate display of power. Both were equally abhorrent to me. The necklace was a warped symbol of liberation, and became known as shisanyama or burnt meat, three cents, which was then the price of a box of matches, and finally, savagely, Nando's after a popular flame-grilled chicken franchise.

Kevin's childhood had been difficult. His parents had found his moods and outbursts impossible to deal with. Years later, he wrote about what he felt then, during the years he lived at home with his parents, Jimmy and Roma Carter, in their middle-class white neighbourhood. The occasional police raids, to arrest blacks who were illegally in the whites-only neighbourhood, was the closest Kevin, as a child, got to seeing apartheid being implemented: 'We weren't racist at home of course, coming from a supposedly "liberal" family. We were brought up in a Christian way, to love our neighbours, and that included all humans, but I do now question how my parents' generation could have been so lackadaisical about fighting the obvious sin of apartheid.'

After high school, Kevin made a stab at studying to be a pharmacist but soon dropped out and was drafted into the army. He hated it, and to escape from the infantry he rashly signed up for the professional air force. He soon realized that four years in the military – even in the air force – was a serious mistake, but he was trapped. In 1980, after an incident in which he was badly beaten up by fellow soldiers for

defending a black mess-hall waiter who was being insulted, he went
AWOL and tried to start a new life as 'David', a radio disc-jockey in the
coastal city of Durban. But he soon ran into difficulties, as he could not
open a bank account in the false name he was using. He gave up this
plan within a month and became increasingly depressed. He felt
trapped; years later he would write about that dark period of his life.

'Somewhere along the line, suicide became the option. I began to
think of it more and more, and the more I thought of it, the more
appealing it sounded. It was only a question of how really, and when. I
had decided to do it. I wandered from chemist shop to chemist shop,
accumulating a large quantity and variety of sleeping tablets and
painkillers. For the cherry on the top I bought some rat poison, and I
took the stash to my room. Then I went out, and spent my very last few
Rands on a Wimpy burger and a milkshake.

'Back in my room I went ahead with my plans. I remember being
amazed by the calm I felt. I had a two-litre bottle of Coke in the room,
and I proceeded to wash down the tablets. There must have been
hundreds in total. Down they went, four or five at a time, until they
were all gone. I lay on the bed, waiting to die. I looked forward to it as
an upcoming relief, a total escape from my solution, my problems, and
the mess I felt I had made of my life. Why had I failed so miserably?

'Hell, I didn't believe in heaven or hell. I couldn't believe I was
about to stand judgement on anything. Either it was all about to end
abruptly, and that's that; or I was going to achieve a new form, free of
physical restraint, and with a far higher understanding. Free of earth and
free of money, free of need and pain, and free of people's expectations.

'Thinking of dying, however, I began to wonder why I wasn't
feeling sleepy or drowsy, which I wasn't, and which was really strange
under the circumstances. I decided to go down to the beachfront, and
take a walk around. The world seemed very surreal to me that night. I
went into one of those amusement arcades, and played a few video
games with what were really now my last few coins.

'Slowly I was becoming aware of the drowsiness. Now it started to
seem real. I was ready to die, or was I? Staggering back to my room, I

passed a hotel, and in a total daze I walked into a phone booth. I wanted to say goodbye to someone. I don't know why it only occurred to me then, but I couldn't die without saying just one goodbye.'

But Kevin did not die and came to in a hospital ward. For him, surviving may have been the worst of that awful episode: 'I shall never forget facing my mother again. It is living through a suicide that is the hardest part.'

Soon after the suicide attempt, Kevin decided he had to see his military commitment through without creating more trouble. One Friday afternoon in 1983, while on guard duty in Pretoria, he spotted a car recklessly turning across four lanes of traffic; he wrote: 'It came screeching to a halt in the loading zone outside the Air Force headquarters, it didn't even straighten out. The front doors sprang open, and two men leaped out. They were hardly out of the doors when my eyes were blinded by an intense explosion of blinding light, and I was hit by a blast of tremendous force, that hurled me off my feet into the window behind me.'

The ANC had detonated a car bomb outside one of the military headquarters buildings and as soon as his initial panic subsided Kevin began to assist the dozens of wounded. It was only afterward that he realized that he too had been injured by flying glass and shrapnel. The incident was one of the ANC's most successful attacks on a military target. Kevin's sense of being involved in history at that point seems to have given him the idea of wanting to record history. He decided to be a news-photographer.

By 1984 Kevin had worked himself in to a staff job at *The Star*. While he was photographing outside the Johannesburg Supreme Court he met a striking, wild-haired photographer named Julia Lloyd and immediately asked her out. Within two weeks of their meeting, they were living together. Julia was soon pregnant. Kevin wanted them to get married, but Julia refused – she had been married twice before and did not want another husband. On the night his daughter was born, Kevin recalled the awe he felt at witnessing Megan's birth, at being allowed to cut the umbilical cord. Megan became the focus of all that was best

about Kevin – loyalty, intense passion, infectious enthusiasm and love. But he and Julia soon broke up and Kevin found himself missing his daughter terribly.

I had met Kevin before I had any plans to be a photographer, through my older brother Bart, who was a sports writer. I would see Kevin when I visited Bart at work, and at parties. Kevin was a tall, thin and good-looking guy, with a quick and winning smile. He had a rakish, mischievous way about him that many women found quite irresistible. He usually wore his hair long and had a diamond stud earring; he usually dressed in jeans and a T-shirt and wore leather-thonged Jesus-sandals. He always seemed pretty crazy to me, up and down like a yo-yo, but I liked him. By the time I took up the same line of work in 1990, he had become chief photographer at the anti-apartheid *Weekly Mail* newspaper. Kevin was one of the few people in the business that I knew and I would see him regularly in the townships. We began to team up to lessen the dangers of working alone.

It was some months later that I first met Joao Silva. In March of 1991, a lot of fighting was taking place in Johannesburg's Alexandra township. Alex is a tiny crowded slum just one kilometre square that had survived several forced removals, and, unlike all the other townships, is next to the heart of white Johannesburg. It was an unique place, where the lively South African music style kwela had originated: Alex had soul. But it was also a place teeming with criminals who preyed on the wealthy white areas that surrounded the township; a risky place to work.

I was walking up a road in Alex when I saw a helmeted rider getting off a motorbike. I had heard about this guy who was working in the townships on a bike. I had also heard that he was shooting hot pictures. It was dangerous enough working in the townships in a car, but doing it on a bike was not a good idea – the guy had to be a little crazy, I thought to myself. I smiled as I approached and he reciprocated with a friendly greeting. He was dark-skinned, unshaven and short, and he wore glasses, but he seemed sane enough to me. I was taller than him and heavy-set, with a marked physical presence – typical of a sportsman gone slightly to seed (it would get worse). In those days, I still had a

mop of dark-brown curly hair. We met in Alex again a week later and worked together. We got on well and a warmth immediately developed. From that day on, Joao was my first choice as a cruising partner. It would not be long before I would discover Joao's predominant characteristics: he was tenacious and could be pretty aggressive, but above all, his watchword was loyalty – a friend would later say of him that when the ship went down, the last thing you would see would be Silva's glasses.

For Joao, photography started out simply enough: he wanted to cover war. He was living in the coal-and-steel industrial town of Vereeniging, south of Johannesburg, where his father was a welder. In his second last year of high school he told his parents that he was dropping out of school. School had nothing more to teach him, he felt. Joao had come to South Africa when he was nine years old. Before that, he had spent ten months in Portugal with his godfather after his parents had sent him out of war-torn colonial Mozambique. Once his parents had re-settled in South Africa, they sent for Joao. He was put into an English-medium school, but spoke only Portuguese. He did not fit in at first and felt intimidated, but eventually started making friends by drawing dragons on his classmates' arms – that only got him into trouble with his teachers. He entered his teens angry and rebellious. After leaving school, Joao went from job to job, lying about having completed his military obligations, and made up details of where he had served. He and his parents had used a grey area in the law with respect to immigrants to avoid the army, but that was not something to admit in the rabidly patriotic atmosphere then prevailing in white South Africa. During the day he worked as a signwriter and at night he worked clubs, but nothing satisfied Joao.

In late 1988, a friend of Joao's had to take a series of pictures on motion for a course on graphic design and he joined Joao when he went to watch motor car racing at the track. Even then, Joao was an avid motor-sport fan; a speed junkie. The idea of taking pictures appealed to Joao, and he used his friend's camera to shoot a few rolls of his own. He was immediately hooked. He gave up the club job as well as the

signwriting and bought a camera, studying black-and-white pho-
tography at night school. A year later, in late 1989, he moved to
Johannesburg and began to establish himself as a photographer.

Joao remembers that the first time he saw Ken – at Thokoza's Phola
Park squatter camp towards the end of 1990 – was also his first
experience of photographing violence. By then, he had already landed
his first job shooting car-crashes and Rotary meetings for a small
newspaper in the industrial town of Alberton, east of Johannesburg. It
didn't pay much. The only reliable working camera he had was the
*Alberton Record*'s beat-up old screw-mount Pentax, which had an
annoying little hole in the cloth shutter, that left a white dot burnt on
to all his pictures, in the top left corner. Joao tried to frame his pictures
in a way that he could crop the dot out later.

Joao had convinced the paper's news editor to let him cover the
escalating violence in nearby Thokoza, arguing that the township was
right next door to Alberton, the white town which the newspaper
served. At Phola Park squatter camp, he had photographed some Xhosa
warriors wrapped in blankets and holding sharpened steel rods. They
were sitting on their haunches, staring at three corpses lying beneath
grey blankets. The warriors directed Joao and his increasingly nervous
Afrikaans reporter-colleague toward a cluster of shacks. The two of
them had to step carefully to bypass a shrouded corpse in a narrow alley
and entered a dark shack to find another covered body. The squatter
camp had been attacked earlier that day by Inkatha hostel dwellers in
one of the massive assaults that marked the beginning of the Hostel
War. His colleague was urging him to return to the office and Joao
reluctantly agreed.

As they emerged from the shacks, they ran into another
photographer. Joao immediately recognized Ken Oosterbroek, the fast-
rising photographer with the distinctively long hair and lanky frame,
from articles he had seen in newspapers and magazines. Ken looked at
Joao, a short, unknown photographer carrying an outdated camera, and
dismissed him with a disdainful nod. 'What an arsehole,' Joao thought.

While driving out along Thokoza's main road, Khumalo Street, Joao

spotted a group of women chasing another, younger woman. She was bleeding from her head and losing ground fast. In seconds they had caught her, hacking at her with whatever weapons they had, including a sickle. Joao leapt out of the still-moving car and ran towards the crowd. The low cries of pain from the woman on the dirt pavement were almost drowned out by the attackers' triumphant ululating. Joao was scared, confused. This was not the kind of war photography he had imagined himself doing – this was too weird, but he shot off frame after frame as he retreated. Just then a man walked into the right-hand side of his frame, patronizing the female killers with a broad smile. Joao instinctively felt he had the shot as he pressed the shutter, for once heedless as to where the little black spot would appear on the negative.

That night he had to cover the Alberton Rotary Club's annual general meeting. It was the last meeting before Christmas and like everyone at the dinner table, he had a cracker to pull. Inside Joao's was a toy machine-gun. He saw it as an omen; within weeks he put together a portfolio of his best pictures and approached Reuters, Britain's global wire service, persuading them to let him submit pictures on spec. For a few months he balanced the two: shooting the dull pictures that earned his salary at the paper and covering the burgeoning township war after hours and on the weekends, selling the pictures to Reuters. One day, the *Alberton Record*'s editor called him in to ask why the paper's car had been seen in Soweto. Realizing he could no longer balance both jobs, Joao quit the paper to freelance full-time for Reuters.

Joao's pictures on the wire were earning him a name as a conflict photographer, but a new picture editor for Reuters was coming in and the word was that he was going to get rid of the present stringers to set up his own network. Joao took his portfolio in to *The Star* to try to get a full-time job. While the Sunday picture editor was rather distractedly paging through the prints, Ken came over and looked over his shoulder and on seeing the picture of the woman being attacked in Thokoza, said, 'Hey, I heard about that!' though he seemed not to recall bumping into Joao on the day that the picture had been taken. Joao began to string for the *Sunday Star* and was still selling pictures to Reuters.

In August 1991, Ken was named chief photographer at *The Star*; one of the first things he did was hire Joao, the hotshot young photographer who was bringing great pictures back from the war in the townships. It had taken Joao just nine months to move from covering Rotary meetings to being *The Star*'s most exciting photographer. Ken and Joao became close friends as Joao became Ken's ally in his struggle to improve the paper's moribund photographic department.

Joao's beat was almost exclusively the political violence in the townships. His eager recklessness to go into any situation for a picture and his custom of not shaving for days on end, as well as treating management and danger alike to his 'fuck you' attitude, ensured he fitted the part of conflict photographer well. But he maintained a certain equilibrium. He had made a home with an acerbically witty girl three years his junior – Vivian Innes. She was just 17 when they first met in a nightclub where he was a bouncer. She had come from her matric party and looked sexy in a short black sleeveless dress. Some time later, Joao received a Valentine's card from Viv. He sent her flowers a few days later; from then on they were a couple and she moved in with him some time after he moved to Johannesburg. Over the years, they had accumulated a collection of orphaned cats which they both doted on. A friend once described Joao as 'Mr War-photographer who just melts all over his cats.'

Johann Greybe ran a small hole-in-the-wall camera shop in Hillbrow. Because he was always willing to give good prices and technical advice to struggling young photojournalists, we all ended up buying second-hand cameras from him – the cameras that I had used to shoot the execution pictures came from him. Johann remembers Joao as the most enthusiastic young photographer he has ever met; extremely energetic and driven to have his picture on the front page. Ken was the ultimate professional. The camera dealer's impression of Kevin was that he was too sensitive for this world: 'He was one of the photographers who got nightmares and saw spooks.' And me? I was level-headed, he said, the one who had his shit the most together.

# BANG-BANG

I lament with sorrow and cry because the boys are finished. The boys are finished

<div align="right">Traditional Acholi funeral song</div>

|||

We were all white, middle-class young men, but we went to those unfamiliar black townships for widely differing reasons and with contrasting approaches; over the years, we would find common ground in our shared experiences and develop friendships.

Ken, unlike the rest of us, was not at ease with black people, and in the beginning I avoided working with him too much because of that. Not that I can recall Ken ever saying anything racist: it was just a difference in response, in empathy. Perhaps he was as uncomfortable with me and my open support for blacks in a country where identity was deeply, indelibly based on the colour of a man's skin and how tight his hair curled. But Ken's experiences as a photographer slowly changed his attitudes and had rid him of that native, unthinking racism.

While Ken was undergoing that process, Joao and he became close friends. The hours spent processing and printing pictures in each other's company created a lot of time to learn about each other. They mostly just chatted or gossiped, but the claustrophobic processing cubbyholes at *The Star* were ideal for intimacies and sharing secrets. It was in Ken's

cubicle that he showed Joao the contents of a photo-paper box he treasured. Inside were pictures of a little girl: Tabitha, his daughter from a previous relationship. Ken's wife, Monica, had forbidden him to see his daughter and had even made him promise in writing to not visit the child. For someone who worked so hard to keep things in hand, there were parts of Ken's life that were definitely out of control. Monica's jealousy was so intense that Ken would ask Joao and others at the newspaper to lie to her when he went to see Tabitha. Ken hid those pictures, fearing Monica would destroy them if she ever found them.

On Joao's birthday in 1992, he was in his darkroom cubicle processing film when Ken came in to see how the job had gone. After some time, grinning broadly, Ken handed him a large brown envelope. Joao opened it, expecting a card, but instead it was a black-and-white photograph of a train smash and written on the bottom of the picture was 'Happy birthday Joao!!' Joao wondered why Ken had given him that picture. 'That's what happened the day you were born!' Ken explained. He had gone to the newspaper archives to see what had been on the front page on 9 August 1966, unearthed the original negative and made an 8' by 10' print. 'A lot of people die?' Joao asked. 'Lots,' replied Ken, who had been born on Valentine's Day. 'On my birthday, they had some girl with flowers; on yours there has to be a disaster!'

By 1992, Ken had turned *The Star*'s photo department around. That year Joao won the national Press Photographer's award, Ken was runner-up and *The Star* photographers dominated all the categories. It was through Joao that I got to know Ken better. There were individual friendships between the four of us, as well as a growing common bond. Our girlfriends and wives became friends, and we would get together for meals and to discuss and edit the pictures when one of us had done a big story.

When there was a lot of violence, we would team up for 'dawn patrols' – waking before dawn to be in the townships by first light. It was a ritual that we had each done singly at first and then later two or three of us would sometimes cruise together. The companionship meant I did not feel so alone when the alarm jerked me awake to face

the next day of witnessing the violence. Sometimes when the days had been really bad I would wake seconds before the alarm and try to find excuses for staying in that warm bed, but the thought that the others were waiting somewhere would help me to get up.

From 1991 to 1993, South African political players were embroiled in protracted negotiations towards a transition to the 'New South Africa', and the ongoing violence was being used as a negotiating tool. It was impossible not to notice how the number of inexplicable massacres and attacks surged whenever the talks were at a critical stage. Even though we each in our own way were deeply motivated by the story, pictures and politics, cash also had its part in getting us up before the sun. The dawn was the transition between the chaos of the night and the occasional order of day – when the police would come in to collect the bodies.

I had become known as a conflict photographer. I could ask for assignments to almost any place, as long as people were killing each other. But it had taken me a while to learn how to make use of that reputation. When I had gone to New York in August of 1991 to collect the Pulitzer, I had asked if I had to wear a tux to the ceremony, not knowing that tuxes are not worn to lunchtime affairs. I also naïvely thought that the award would be a great opportunity to say something about what was happening back home. I spent days working on a speech and it was in my jacket pocket when my name was called and I walked up to the dias at Columbia University. But all the man did was shake my hand and give me a little crystal paperweight with Mr Pulitzer's image engraved on it before ushering me away.

The other winners received their awards with equal haste and then there was a luncheon. It was the 75th anniversary of the prize and all living winners had been invited. It was an absurdly ideal place to establish contacts with many of the most important picture editors and the world's greatest photographers. I made a wan effort to meet people, but I was in no frame of mind to do it effectively and left soon afterwards.

Despite my ineptitude in handling the business side of photography

and in marketing myself, by late September of 1991 I had convinced the AP to assign me to cover the war in Croatia, and within days I was in the front-line village of Nustar. It was autumn, cold and wet, and the roads had been churned into muddy trails by the tanks. It was my first time in a 'real war' with tanks, artillery and machine-guns. I had no clue of what was reasonably safe and what was insane, yet somehow I survived those first weeks without getting myself or anyone else killed. I found that I liked war. There was a peculiar, liberating excitement in taking cover from an artillery barrage in a woodshed that offered no protection at all. Two other journalists shared that particular woodshed with me: one was a young British photographer called Paul Jenks, who huddled in a steel wheelbarrow because it made him feel safer as the massive detonation of nearby shells mingled with the scream of others passing overhead. He would be killed months later by a Croat sniper's bullet: Paul had come too close to discovering the cause of the death of another journalist who had been strangled by a member of a motley unit of international volunteers to the Croat army. My other companion was Heidi Rinke, an Austrian journalist with long black hair, beautiful green eyes and a wicked sense of humour. I lent her my flak jacket as she did not have one and so began a romance that would keep us warm through the long winter months of covering the Serbo-Croat war.

Because of my Croat parentage, I spoke a passable pidgin Serbo-Croat and this sometimes gained me good access. So, in December of 1991, Heidi and I were the only journalists accompanying a troop of Croatian soldiers as they took village after village in the Papuk mountains. The Croats met only token resistance from geriatric villagers firing old hunting rifles at them, since the Yugoslav army and the Serb militia had already retreated, having seemingly decided that the area was bound to be lost sooner or later. It was eerie to see house after house burst into flames as we advanced on foot. In addition to putting Serb homes to the torch, many of the Croat soldiers were looting everything they could find, especially the local plum moonshine, slivovic. They also murdered many of the old folk who had been left behind. Deeper in the mountains, a soldier and I helped an old lady to the safety of her

neighbour's farmhouse after her house had been torched. The Croat commander, a decent enough man in charge of a bunch of murderous drunks, promised that the women would be safe. A few hours later, I stopped by to check on them, but the barn and house had been burnt out. My heart was in my mouth as I searched for the two women. I found only one and she was lying dead in the frozen mud.

In another hamlet, on another day, a conscience-stricken Croat soldier whispered to me that there was an old man still alive in one of the partially burnt farmhouses. Heidi and I tried to be nonchalant as we walked up the drive where blood spilled on the mud gave urgency to our search. We found nothing in the house, not even a corpse. I came back down to the road and surreptitiously asked the soldier where the wounded man was; he was terrified that his comrades would see him talking to me and whispered, 'In the barn.' I went back up past the blood and to the wooden barn, but saw only piles of hay. I started pulling at it, prepared for the worst; but I still got a fright when confronted by the grey, bloodless and unshaven face of an old man at the bottom of the pile. He was alive, but in a bad way. He had been shot and left under the hay to die. I tried to tell him to be calm, that we would get help. While Heidi was staunching the old peasant's bleeding leg, I bent closer to hear what he was saying. I had my ear next to his mouth before I understood what it was that he kept repeating: 'Don't let the pigs eat my feet, don't let the pigs eat my feet!' It was not a crazy fear – pigs will eat anything, and on a few occasions I had seen pigs feeding off human corpses.

It was a strange war. One day I discovered a white-haired Serb lying dead in a ditch with his ears cut off. An unshaven, grinning Croat soldier with rotten teeth came up to me as I was taking pictures and he gleefully told me that he had killed and mutilated the old villager. His commander had a standing offer that anyone who brought him a pair of Serb ears could go home for four days. My Croatian surname allowed me to witness one side of the intimate brutalities of the civil war, but it precluded me from seeing the even greater toll of Serb atrocities up close.

Despite the horrors and my ancestral links to the country, the war did not have the same emotional impact on me as the events I had witnessed in South Africa – it was not my country and not my struggle. I was definitely there as a foreign journalist. In February of 1992, I returned to South Africa with Heidi. We lived together in the house I'd bought shortly after winning the Pulitzer. I had taken out a mortgage in order to buy it, as for the first time in my life I felt financially secure, after years of living hand-to-mouth. I was perpetually amazed by the turnaround in my circumstances – just one year previously I had been on the run from the police, but I now reckoned that there would be an outcry if they arrested South Africa's only Pulitzer Prize-winner. I began to use my real name as a by-line. But in reality, the environment was changing, and 'crimes' such as mine were being ignored, as were draft-dodgers and conscientious objectors – whereas they had previously been hunted to ensure there was no 'moral rot' among whites. But even the Pulitzer could not change the effect that witnessing such searing events had had on me; on my return I found that I was almost immediately emotionally and politically ensnared by the events in South Africa. Unlike in the former Yugoslavia, I could not keep a distance from this story, nor from the people I photographed.

I remember a Sunday morning just weeks after coming back. In the street outside my house I was cleaning my car. Several neighbours also had hosepipes and buckets out as they cleaned and polished their cars – a Sunday ritual in my working-class neighbourhood. We greeted each other – they recognized me from interviews on television and in the papers. What they did not know was that I was not getting the car spruced up for the weekend, but that I was grimly trying to wash someone's brains out of the cloth upholstery of my back seat. The previous afternoon, while most of South Africa was grilling meat on the braai or watching sport on television, I had been racing through the streets of Soweto trying to get to the hospital before the rasping, noisy breathing of the young man lying on my back seat ceased. The comrade's girlfriend cradled his head in her lap and Heidi, sitting alongside, was telling me not to bother speeding, that it would make no

difference. Brain-matter and fluid bubbled freely out of a gunshot wound in his head and he was not going to make it. At the hospital they pronounced him dead.

So, despite the cheery greetings from my neighbours, I resented them cleaning simple street dirt off their cars. This was something that I could not explain to them, nor to anyone else. It was as if they were occupying a different planet to me. It was precisely this that helped draw Joao, Ken, Kevin and me close to each other. When we tried to discuss those little telling details from incidents in the townships with people who had never experienced them, the usual response was either disgust or uncomprehending stares. We could only really talk about these matters to each other. Kevin had once written about his feelings on photography and covering conflict in an article which expressed thoughts that we had all, on occasion, shared: 'I suffer depression from what I see and experience nightmares. I feel alienated from "normal" people, including my family. I find myself unable to relate to or engage in frivolous conversation. The shutters come down and I recede into a dark place with dark images of blood and death in godforsaken dusty places.'

It was from this sense of being outsiders from the society we had grown up in, and of being insiders to an arcane world, that we developed into a circle of friends prompting a local lifestyle magazine, *Living*, to dub some of us 'the Bang-Bang Paparazzi' in a 1992 article. Joao and I were so offended by the word 'paparazzi' that we persuaded the editor of the magazine – a friend called Chris Marais – to change it to 'the Bang-Bang Club' when he wrote a follow-up piece that was about the four of us. We were a little embarrassed by the name and its implications, but we did appreciate being acknowledged for what we were doing. No matter what they called us, we liked the credit.

Articles like the Bang-Bang Club piece made us minor celebrities in media circles. As a result, several young South African photographers were motivated to try their hand at documenting the violence. One of these was a young man called Gary Bernard, who had always wanted to be a professional news-photographer. He kept seeing our pictures in the

papers and he eventually signed up at a non-profit photographic workshop, where he attended classes in the evening while working as a printer during the day. Gary's decision to be a news-photographer coincided with Ken's becoming *The Star*'s chief photographer. From being a notoriously self-absorbed egotist who cared only for his career and awards, Ken had become a champion of aspiring photojournalists. Gary was one of a group of interns Ken had taken on at *The Star* in a programme to recruit talented young photographers from the work-shop into the newspaper. Gary would go out with us to learn the ropes and he became a friend. He wanted to be a bang-bang photographer. Despite his desire to cover conflict, Gary was far too sensitive to deal with the violence, but he kept his feelings to himself. On the surface he seemed to handle the emotional aspect of the violence OK. We had no idea about his dysfunctional family past and how he blamed himself for not having been around when his father committed suicide. Sometimes I would catch myself looking at Gary and wondering what was going on in his mind, but I was too preoccupied to follow up on any of the small signs that might have indicated a real problem. It was only later that we understood the full effect that the accumulated trauma was having on him.

The stress from what we were seeing and the at times callous act of taking pictures was making an impact on all of us. Ken was waking up in the middle of the night sweating and screaming about things he had seen. Joao had become quiet and withdrawn, and I sank into a deep depression that I only clawed my way out of years later. Kevin was the most outwardly affected and that meant that life as his friend could be demanding. He seemed to have no borders, no emotional boundaries – everything that happened to him would penetrate his very being and he let all that was inside him just pour on out. The highs of boundless energy and infectious joy would inevitably crash and then we would get the despondent midnight calls. Joao, Ken and I all had our turns at spending hours talking to a weeping Kevin until he had been soothed or grown exhausted enough to sleep. But through it all, Kevin had a way about him, an openness to pain, a generosity with his time and

affection which meant it was easy to overlook those lapses and become even closer friends.

Maybe it was because his emotions were always right up front that Kevin was the most candid of us all about the effect that covering the violence was having on him. He was having a beer at a pub opposite *The Star* one Saturday afternoon when Joao came in after covering an uneventful political funeral. They listened to a radio report that three people had died in clashes following the burial. Joao wanted to go back to the township, but Kevin said it was getting dark and talked him out of the idea. After several more beers, Kevin recounted a recurrent nightmare that was plaguing his sleep. In the dream, he was near death, lying on the ground, crucified to a wooden beam, unable to move. A television camera with a massive lens zoomed closer and closer in on his face, until Kevin would wake up screaming. Kevin thought that the dream meant it might be time to leave photography.

When Kevin told me about the same nightmare some time later, he described the feelings of helplessness, the anger, the fear he lived though in that dream. It was all that he imagined our subjects must feel towards us in their last moments as we documented their deaths. The dream had variations: sometimes Kevin was the photographer, not the victim, and in that version, the 'dead' man would roll over and grab him by the ankle, holding him captive with bloody hands.

Some weeks previously, in a lawless Sowetan shanty town called Chicken Farm, Kevin and I had been following armed policemen as they ran through the shacks, plunging downhill along rough tracks muddy with raw sewage. At a clearing near a stream, we saw a woman in rural Zulu dress wailing in grief, her hands clutching her head. In front of her, a middle-aged man was lying on his back, his arms stretched out on either side of him along a thick wooden beam. It looked as if he had been crucified. His earlobes, pierced and enlarged in the traditional Zulu fashion, were filled with blood from several head wounds. There is no question that a professional thrill ran through me: it was a scene that could be an icon of the civil war. Kevin and I descended on the corpse, but once we started to photograph, I found

myself struggling and failing to capture this image of the crucifixion properly. I was unnerved, jittery, my hands were shaking involuntarily. Perhaps it was because of the woman wailing or memories of childhood religion, of Christ on the cross. I looked at Kevin; he looked stunned. Suddenly the corpse groaned and rolled on to its side. We leaped back in terror – we had been so certain he was dead. I will never forget that moment of horror, but unlike Kevin, I had no nightmares; at least none that I could recall in my waking hours.

An American consultant hired in November of 1992 to revamp the look of *The Star* was convinced that Joao was suffering from post-traumatic stress syndrome, similar to what he'd seen among photographers in Vietnam. Management agreed and, despite protests from both Ken and Joao, he was told to stop going to the townships. South Africa's isolation from the world during the apartheid years meant that any foreigner was automatically granted expert status and respect, often beyond their due. Joao was assigned to cover the effect of pollution on a pond in a wealthy white suburb of Johannesburg. While walking disconsolately around the sad pond, he noticed a duck waddling unsteadily towards him. The duck collapsed and died at his feet. Back at the newspaper, he printed the series as a montage with the mischievous caption 'Going, going, gone' and presented it to the photo desk. The consultant was appalled and urged the newspaper to get Joao psychological help.

Late that same night, a 'press alert' came across on the pager. An entire family had been in slain in Sebokeng, a sprawling black township south of Johannesburg that was plagued by mysterious killings and massacres and drive-by shootings. Kevin and Joao exchanged calls with Heidi and me, and despite the heavy rain and our anxiety about the fact that it was well after dark, we decided to go. The common wisdom among journalists was to never enter conflict zones after dark: things were different at night; people behaved without restraint. And we would have to use our flashes to get pictures – risky as the bright light going off spooked people and could attract gunfire.

The rain was bucketing down as we raced south in Kevin's little

pick-up. Heidi and I huddled against the cold in the fibreglass canopy on the back, bracing against each other as the car aquaplaned unpredictably every time it hit a patch of standing water on the road. We were uncertain about the wisdom of the foray: rumours of white agents provocateurs taking part in killings in the black townships meant that whites were increasingly treated with hostility. Sebokeng was probably the most dangerous township for journalists to work in, but we were determined to try to expose what was going on. When we got there, the dark streets were deserted. We had no way of finding the house as there were few street signs and residents had taken to painting over their house numbers for fear of being targeted for attack. The killings were so indiscriminate that people had devised convoluted theories as to who might be the next target – a situation which made wandering strangers seem to be a potential threat.

Usually we could ask people for directions or follow our noses to the right place, but the rain and the fear of being out at night meant that there was no one around to help. We started to regret our decision: to the armed self-defence unit members that kept watch, we must have looked like killers ourselves, cruising around looking for victims. We crept fearfully along the main streets, hoping to stumble on to the right house, until we saw a police armoured vehicle lumbering along, the deep growl of its engine breaking the silence. They were surprised to see whites there, but agreed to let us follow them to the house. While we waited for the detectives to finish their investigation, we found shelter from the wet with the survivors in a back room. The rain drummed on the tin roof, leaking through holes. Under the dim glow of a naked light-bulb, 21-year-old Jeremiah Zwane related how two men had burst through the front door and thrown a tear-gas canister into the room, then gone from room to room shooting everyone they found. His father and his brother had been gunned down in one bedroom. Jeremiah's sister, Aubrey, just seven years old, had tried in vain to hide in her parent' bedroom closet. She lay on her back in a pool of blood alongside her dead mother. Shot in the face and chest, her little body was a deeply shocking sight even after the many gruesome images

we had photographed over the previous two years. A visiting teenage cousin had been shot dead in the lounge. Another teenage sister had died on the way to hospital, but her two-day-old baby had somehow survived the attack unhurt. The house looked like a scene in a horror movie, but this was real. The smell of blood was heavy in the damp air.

The four of us were the only journalists out in Sebokeng that night, despite the fact that every news organization and most journalists had received the message of the killing on their pagers as we had. We were convinced that the only way to stop such killing was to show what those deaths looked like, what those daily body counts actually meant.

*The Star*, which had suggested Joao lay off covering township violence, ran the story he had reported and two pictures, one on the front page. I transmitted pictures to the AP and *The New York Times*. Without our pictures, the only source of information on the massacre would have been spokesmen for the police and the political parties. Editors from most domestic and foreign media organizations still took police reports as factual even though the police were clearly a part of the problem. I remember many infuriating discussions with Renfrew, who was then still the AP bureau chief, about police and military involvement in the killings – he would patronizingly accuse me of being politically biased and naïve, but the AP and almost every other news organization chose to believe the government's propaganda. The public would have been given information about yet another massacre from the people who were actually involved in many of the killings, as would be proved years later. It seemed that the international and domestic public were all too ready to believe that people who sometimes dressed in skins and could not speak English properly must be barbaric, while the white politicians and officials who spoke so logically and kept the trains running on time could not possibly be implicated in the murders. And yet despite our attempts to tell the truth, through our reporting and in our captions, our pictures played an unwitting part in the deception – our images from Sebokeng that night showed horribly dead black people and white policemen in uniform taking the bodies away, investigating their deaths. The impression was

of the police helping the victims. Our pictures could not show that they had arrived hours after the emergency calls for help: they could not show the absolute certainty of the survivors that security forces had been involved in the attack.

# A SHORTCUT TO HEAVEN

We do not want to remember those times, they break our hearts.

Soweto resident, Sandy 'Tarzan' Rapoo

|||

By 1992, I had seen a lot of dead bodies. I had once tried to count them in an attempt to properly acknowledge their existence, but it was hopeless. Strange objects, dead bodies. Some were as bereft of any sign of having been human as a dead dog on the highway; others appeared to be asleep, no sign of death about them at all. Then there were dead bodies that were so dreadful that they made me fear death itself.

It was difficult to remain unaffected by all those dead people; but it was equally difficult to keep from switching off my emotions. I could not withstand the repeated impact of having a complete emotional response to every corpse or injured person I came across – I would need to have been a saint; but nor did I wish to do what more seasoned photographers seemed to do – shut off completely. In my first weeks of working for the AP, my car was stolen in Soweto and so the next day I got a ride with a colleague in his car. The morning was quiet and at midday we went to get a meal at a fast food outlet. We had just received our meals when my colleague got a message that there was trouble in a

suburb of Soweto called Central Western Jabavu. We jumped into the car and raced to the address given; it was nearby, and we had not yet finished eating when we arrived at the scene. There were a handful of police and residents on a dirt soccer field and, next to the goalposts, was the object of their attention: a corpse on its back, burning. The flames had burnt most of the clothes off the body and were now through to the skin. I hurled my food away and began to photograph. After a minute or so, I turned to see what my colleague was doing. He was still eating his burger. I was shocked and thought him a callous pig; it was much later that I realized the extent to which his machismo was a defence against feeling too much.

In June of 1992, it was another dead body that drew me to Soweto's Meadowlands Zone One suburb. But it was through covering the death of what was, at first, just another anonymous tragedy that I came to know a family that would symbolize ordinary black people's struggle for liberation. I first met Sandy 'Tarzan' Rapoo, his wife, Maki, and his father, Boytjie, on the night of Johannes Rapoo's death. They were in pyjamas in their kitchen when I cautiously entered their house on Bakwena Street. Tarzan was a powerfully built man with a shaven head and an eight-inch scar running up the side of his face and skull. That night, his dark eyes were unblinking and frightening. In the yellow light of the single bulb, I saw the family as hard, uncompromising and angry people. Tarzan's nephew, Johannes, had been killed by police earlier that day, an unprovoked and pointless death that was symptomatic of the time.

Johannes and some neighbourhood friends had been pushing a wheelbarrow containing a car-engine when they were confronted by the police. They ran away. The police opened fire from inside their armoured vehicle. Johannes died on the way to hospital. The police claimed he was stealing the engine. Later, it was discovered that the engine was not stolen at all. Nobody knew why Johannes ran from the police, other than an all-too-common fear of arbitrary arrest or abuse.

I did not yet know the bitter memories that news of a death in that kitchen evoked. Nor did I yet know the easy laughter and generosity

that lay behind those masks of anger. As I returned to cover the funeral of Johannes and other incidents of violence in their conflict-wracked area, I would slowly develop a friendship with the Rapoo family.

Most relationships that I had with black people were either with those my own age that I could relate to, or with people that I met in a very limited, specific way – who could put me in a frame in their minds, and me them, so that any extraordinary behaviour could be ignored or accommodated. I met a lot of people as a journalist, most of them black, and got to know many beyond the usual superficial requirements of the work – but there was always a gulf that was difficult to cross. The cultural differences between a white boy from the suburbs and someone brought up in a township were massive. We shared no common linguistic shorthand – we even spoke different dialects of English. Key or code words they took for granted had to be spelled out to me. If they told me something, I was not sure that I understood the full context of it; and vice versa. But the Rapoos were patient of my ignorance, and with a lot of laughing and teasing they helped me to learn about what was important in their lives. Despite the success of apartheid's social engineering, we were to become close friends.

More than a year after Johannes's death, I was visiting his family. It was a quiet afternoon, people were out enjoying the sunshine, chatting with neighbours, children laughing and shrieking as they skipped rope and played tag with a plastic ball. A bearded black man wearing a blue cotton workman's jacket appeared at the end of the street. He had a quick, uneven gait and his right arm swung stiffly as he moved. He made his way unnoticed into the middle of the street. The first loud bang sent people scurrying off the street. I pressed myself against a garden wall and looked up – I watched the man calmly fire a large revolver into the street where parents screamed for their children in the panic. More shots rang out, but no one was hit. Then the street's self-defence unit boys began hurling rocks, bottles and curses at him. The bearded man turned and lurched swiftly down the street towards the open veld beyond the last houses. The boys, none older than 18, took off after him, armed with a pitiful assortment of weapons – an axe, a

knife and a kwash – a home-made zip-gun of metal pipes, pins and tightly pulled red rubber that could only fire one round at a time.

As we ran, the man kept turning and waiting, taunting the boys to come closer. They told me that he was a notorious Inkatha gunman from the neighbouring hostel, known as 'Pegleg' because of a disability that gave him the unusual gait, but he was deceptively fast and my chest was burning from the effort of keeping up with the chase.

The boys failed to catch Pegleg and we returned to a street disturbed and fearful after an incident that exposed the residents' vulnerability to random violence. The area was protected by youths and ANC comrades who relied on a few shared guns to defend the neighbour-hood, though on occasion well-armed self-defence units from other areas would come in to help launch attacks on the hostel. Later that day, I wanted to take pictures of the looted and burnt houses along the street that ran between the brown brick hostel buildings and the neighbour-hood the Rapoos lived in. The street was the front-line between Zone One and the Meadowlands Hostel, one of the eight Soweto hostels that had become Inkatha fortresses. On seeing me preparing to drive down that eerie road in the dead zone, a neighbourhood man burst out laughing and leaned into my open car window: 'If you take that road, you will never come back; it's a shortcut to Heaven!'

Over time, I learned of the Rapoo family history. Boytjie, the patriarch of the family, sitting in his customary place on a weathered log in the shade cast by a pair of gnarled peach trees, would watch the neighbourhood go about its business. There, under the fruit trees, he told me how the Rapoos had come to Soweto. Boytjie was born Tshoena Reginald Rapoo in 1920, but the white girls he used to play with called him 'Boytjie' and the name stuck. The young Boytjie, unlike his own children and grandchildren, played childhood games with whites because he lived in Johannesburg, then a young city that had areas that were racially mixed. But that was before the government trucks and bulldozers made Johannesburg white.

Boytjie's father had moved to the city from the farm where his family had bred cattle and grown crops for generations. Johannesburg was a

new and rough city growing rapidly around the fabulously rich veins of gold that lay under the grassy veld. The mines were desperate for labour and taxes were imposed to force the largely self-sustaining black peasant farmers to enter the labour market. Black families had to send men to the mines in order to earn the cash needed to pay poll-, hut- and even dog-taxes. Boytjie had just begun his life as an adult, he had a job and had fallen in love with a girl called Johanna. He approached his parents, telling them he had met the girl he wanted to marry. They felt he was in too much of a hurry, that he should wait as he had only known her two weeks. But Boytjie was stubborn and took the 500-kilometre journey to Kimberley to visit Johanna's parents: 'I took a train all the way, but it was an easy job, thinking about Johanna.'

They soon married and their first child followed shortly. One day his mother's friends came to visit and saw the infant lying naked on the bed – just a couple of months old. One of Johanna's friends joked, 'Oh, be careful, he is naked!' and the other replied, 'Don't worry, that one is Tarzan.' The name stuck. By the time Tarzan was named, the flood of hundreds of thousands of black men and women flocking to the cities had turned a labour deficit into a surplus. Boytjie had to register and be given a pass book – the tool by which the government effected laws that kept blacks out of the cities unless they were gainfully employed. 'The old pass was just a piece of paper. It had no photo, so we could borrow someone else's,' Boytjie remembered, but the pass laws became more sophisticated and more difficult to evade: 'The new book had a photo in it, the dompas, we had to carry it under our arm, because it was heavy and tore our pockets.' The dompas was indeed a heavy burden. It was on the basis of his racial identity, indelibly fixed in the identity book known as the dompas, that Boytjie, his wife and his son, Tarzan, and thousands of other non-white residents of the Johannesburg suburbs of Newclare, Sophiatown and Crown Mines were identified for forced removal to Soweto in 1955.

When the order came for them to leave, they tried to defy the police; they stoned the government trucks that came for them, but the army was eventually brought in and the forced removals proceeded. 'Once in

Meadowlands, they gave us a pint of milk and a loaf of bread for supper. The white official would ask: "How many children do you have?" If you answered "Six," the reply was "Two loaves for you." If you had no marriage certificate, they would push you off to the hostel. I had a friend at the council office so he and I went out to look for a better house than the one I had been allocated. There were trains and matchboxes. The trains are all in a line. The brown train. The corner house – a matchbox – had four rooms and the inside ones had three rooms.' Meadowlands had little appeal for the city-loving Boytjie. 'There were no fences, no streets, just a jungle with houses. People got lost.' The little houses were poorly built, the roofs were untreated asbestos, without ceilings. 'You could see through the bricks, watch people walk past outside. People would lean against an inside wall and it would just collapse. I did not plan to stay.'

But stay the Rapoos did, generation after generation, as apartheid tightened its grip. But it was also in that matchbox house that they had their first taste of liberation. On a summer day in 1990, Soweto spontaneously declared a public holiday and the streets were jammed with people singing, dancing and banging dustbins: the authorities that had kept Mandela incarcerated for 27 years had finally allowed him to walk free. The Rapooos were among millions of South Africans celebrating the release of Nelson Mandela, symbol of the struggle to be free from white minority rule. For decades, simply being in possession of a picture of Mandela tempted arrest, yet on 11 February 1990 the apartheid state dedicated hours of television time to cover the walk to freedom of the world's most famous prisoner. The task of talking viewers through the historic event fell to an Afrikaans presenter; he made a valiant effort, but decades of demonization of the ANC and Mandela had left him ill-prepared to inform the nation about the legendary prisoner, especially as Mandela's release was running hours late, live. In the years preceding his resignation in 1989, then State President P.W. Botha had kept a hotline through to the television studio in order to instantly kill any news piece he disliked. On more than one occasion a newscast had been abruptly cut and an offending item dropped. Those days were over, but

white South Africans, and the presenter, were not prepared for a Mandela who had the status of a demi-god.

But decades of strife and loss separated that happy time from the day in 1955 when Boytjie had fatefully chosen a house near the hostel. It was the student uprising of 1976 that laid the ground for the tragedies that would beset the Rapoos. On 16 June, thousands of schoolchildren took to the streets of Soweto to protest against the compulsory use of Afrikaans as a medium of education. Afrikaans was regarded as the language of the oppressor, the language of the Boers, used by police, magistrates and prison warders in the administration of apartheid. The enforced use of Afrikaans stuck in the craw of the teenagers who were coming of age under a system where their skin colour determined that they be regarded as perpetual children, members of an inferior race. Within the warped version of Christianity moulded and followed by the white Nationalist regime, Afrikaners were the chosen people spoken of in the Bible, and blacks were the Canaanites, hewers of wood and carriers of water. They were to have an education that befitted their caste – that of labourers and servants. While Boytjie had grown up speaking English in addition to his African home language, many of the children of '76 were barely literate in English.

By 1976, Meadowlands was a well-established part of Soweto, now a massive dormitory township, a sprawling ghetto some 17 kilometres long by 11 kilometres wide. Soweto's population was equal to, or greater than, most white South African cities, but it had been deliberately deprived of the necessary amenities and local political autonomy to be a city in its own right – it had to remain dependent on white cities. It has no industrial area, no central business district, no large stores. Like all townships, it was designed to be a place where black people who worked in neighbouring white areas slept. On the other hand, it did not share a common tax base with Johannesburg – as it logically should have, since its people generated wealth and taxes there – so it was entirely reliant on government hand-outs to survive. Not one of the large supermarket chains had a store in Soweto, and so its residents had to shop in white areas unless they wanted to pay the

inflated prices that small neighbourhood shops charged. Real money was not circulated in Soweto itself and Sowetans helped fund their own oppression through the various income and sales taxes they paid to the white regime.

As Tarzan approached Soweto on his way home from work in Johannesburg that June evening, he got his first glimpse of the unrest that would continue intermittently for the next two decades: 'The whole place was full of smoke. On every corner you saw people running. They were demolishing everything that belonged to the government – the beer houses, the council buildings. Others were looting, I saw a fat lady running with three cases of beers. That was June the sixteenth.' June 16th and 1976 became milestones in the Struggle, especially among schoolchildren, as they had initiated the uprising.

There were running battles in the streets, police guns facing stones. Dozens of children were killed, none more famously than Hector Petersen, the first to die. His death became an icon of the burgeoning revolution in South African newspaper photographer Sam Nzima's wrenching photograph of Petersen's young body being carried away by crying schoolchildren. The riots continued for six months, through to the end of the year. By 1977, the schoolchildren – now the blooded and initiated standard-bearers of the revolution – decided on a work stay-away in an attempt to export the township's pain to white business and commerce. Gangs of militant, self-righteous children aligned with the ANC or the PAC (Pan-Africanist Congress) manned bus and train stations to ensure that people did not go to work.

Tarzan recalled that the rallying cry of the youth was 'asigibeli, asigibeli,' a call to not ride to the towns – to stay at home. The children enforced the stay-away. The Zulus in the hostels, however, refused to be dictated to by youths: 'These comrades will not tell us what to do. They are just small children.'

The social alienation of the hostel-dwellers had been exacerbated by their exclusion from most political activities planned and initiated by township residents. The sporadic strikes, stay-aways and boycotts called to force political change or protest against living conditions were almost

always organized without consulting the migrants, who were not seen as a permanent or integral part of the community. The hostel-dwellers were thus often caught unawares by civic action, which they neither understood nor supported. For them, a strike or a stay-away simply lost them money by keeping them from work – their sole reason for being in the townships. They had no real stake in the community. The police and government were swift to take advantage of the anti-comrade sentiment among the hostel Zulus, and they encouraged and supported the rift between them and the wider community.

The sometimes heroic but always martial history of the Zulus had inculcated in them a feeling of superiority to other tribes. It was a chauvinism born in the bloody forging of the Zulu nation in the early 1800s from the various clans and chiefdoms that shared the northern Nguni language in the fertile lands east of the great escarpment, in the area now called KwaZulu-Natal. As Tarzan put it: 'The Zulus were always the top people in the hostels, because to fight is in their blood. Their father's father's forefathers were fighting, clan fights. It never stops. Never, never.'

I had known the Rapoos for two years before I heard what they had suffered in the kitchen in which I had first met them. Tarzan and I were under the dashboard of my car, fitting a car radio he had given me. While fiddling with wires, he told me how his father had survived an attempt by hostel Zulus to burn him alive. 'I woke up and this guy is standing right here with a gun and holding me. He tells me, "If you move, I will blow you," then they took us into the kitchen and I saw the old man, Boytjie. He was wearing his pyjamas. They poured petrol over him. They tried to burn him, but match after match would not light.'

Tarzan did not tell me any more, but it had clearly been a miraculous escape for the old man. What he did not tell me was that his younger brother, Stanley, had been killed that same night. It would be years before Maki, Tarzan's wife, would tell me the full story of that winter night in 1986.

Maki Rapoo is a large woman, stout, with a big laugh that comes

suddenly, often bringing tears to the corners of her dark brown eyes. She was born in Meadowlands in 1956 and went to the same neighbourhood schools as Tarzan. She was a shy girl and Tarzan was a confident boy who used to protect her from schoolyard bullies. But it was only after they had finished school and she went away to study nursing that they began to exchange letters and discuss marriage. By the time I knew them, they had three children. 'In 1986, Stanley and his comrade friends used to wait at the bus station and taxi ranks to tell people to not buy groceries in town. When they found a person carrying groceries, they would destroy the goods. Flour and mielie meal were scattered on the ground. The youngsters sometimes made the person drink the cooking oil or eat the mayonnaise, things like that.'

The tenth anniversary of the brutally suppressed Soweto uprising of 16 June 1976 saw a revitalization of resistance within the country. The express goal of the ANC was to make the South African townships ungovernable. One of the tactics was to enforce a boycott of shops in the white areas. Stanley had teamed up with other young men from the hostel and was especially friendly with two of the hostel boys. The Meadowlands Hostel was unusual in that there were not just men living in it – a section housed families, displaced people whose homes on the banks of the Klip River had been washed away in floods some years previously. Stanley was 19 then, one of the self-righteous children who patrolled the townships in gangs. But then Stanley and the other township teenagers discovered that the hostel kids were not destroying the groceries, but keeping them. The hostel boys had breached the ethics of the boycott. It was right to destroy goods purchased in white shops, but to steal them was wrong. The youth considered themselves the keepers of the revolution's morals. It was they who enforced the boycott code, while their parents struggled to make a living. The fall-out between the boys was to have fatal consequences as the hostel men became involved.

On a bitterly cold night in June of 1986, the Rapoos retired early and by eight o'clock they were all in bed. But they forgot to lock the doors, something they usually did. When the group of men and boys from the

hostel tried the kitchen door, they found it open and simply walked into the house. Near midnight, Maki awoke to hear a man say in Zulu: 'Cut the phone, they will call the police.' Within seconds, Stanley was beside her bed and he whispered, 'They are looking for me, tell them I am not here,' and slipped out of the room again. The week before, Stanley had suddenly given away all his clothes, claiming that he had found a job and would buy new ones. He also gave away his bible even though it was still new. 'Maybe he was expecting to die,' Maki said. 'He knew they were looking for him, but we did not realize it.'

A group of boys and men, armed with guns and machetes, were in the house. Tarzan awoke to find a revolver pressed under his chin. They threatened that if he dared move they would kill him. The intruders made the whole family gather in the kitchen. They put Tarzan and Boytjie in front of the fridge. One tall man poured petrol from a five-litre can over their heads; it ran down their faces, burning their eyes and soaking into their pyjamas. They were shivering from fright and the cold. Maki was in her nightgown with a towel wrapped around her waist.

'We knew the boys by name, they were Stanley's friends. One was Kalahajane and the other Mpandlane. One was a Zulu and the other from Kliptown. They started klapping (hitting) and kicking me, asking me where Stanley was. I said I did not know where he was.'

Tarzan shouted, 'Leave my wife alone,' but every time he moved, they pushed the gun more firmly under his chin. They kept another gun trained on Boytjie while some of them searched the house for Stanley. They went to the bedroom where Maki's new-born baby and the other child were asleep. They turned the bed upside down, to look underneath, and the children fell to the floor and began shrieking. Maki was worried that the baby had broken a limb or been seriously hurt, but she could not go to check. The intruders could not find Stanley and they said they would take all the boys in the house and kill them one by one until he appeared. It was no idle threat, and everyone knew it. At that, Stanley climbed down through the trapdoor from the ceiling, where he had been hiding. He was wearing only an old pair of trousers

with holes at the knees and at the back, ones that he only used for gardening and painting, and a pair of sandals even though the night was cold. 'You have found me, so let's go,' he said, speaking as if there was nothing to fear. He told the family that he had something to discuss with the intruders, and then he would return.

At that stage, Maki thought that they might beat him, or hand him over to the police. As they left the kitchen, the tallest of the Zulus poured the remaining petrol from the can on the floor and down the stairs. Another of the intruders took out a box of matches and lit a match, then threw it into the pool of petrol. It did not burn. Nor did the second one ignite the fuel. When he lit the third, Stanley reached over and grabbed his wrist: 'You have already found me, what are you doing? Let's go.' Then two of them took Stanley by the back of the trousers, one on either side, lifting him a little. The frightened family watched them go to the gate, the older men chanting Zulu songs as Stanley's friends and other hostel youngsters pointed out where other comrades lived. They saw one of the older men chop at the back of Stanley's knees with a panga. He screamed as the blade cut through his tendons, rendering him unable to escape. Once they were out of the yard, Maki and Tarzan ran fearfully to the gate and watched Stanley being led down the street. He was limping. They began to follow, to see where they were taking him, but they were forced to retreat as the group shot at them. 'Tarzan went for the police and I went to the bedroom. I knelt near the bed and opened the Bible at random. It was Psalm 144, and there I found, "What is a person? A person's soul is like the wind," and I knew that, definitely, they were going to kill him.'

After some time, Tarzan returned with the police. They took statements from the family, but instead of mounting a rescue into the hostel as they had hoped, the police said they should call for the van they use for collecting corpses. Suddenly one of Stanley's friends came running into the house; he had been shot and stabbed, and was bleeding profusely, but had somehow managed to escape from the hostel and run all the way to the house. He told them that Stanley had been killed and now they were burning him. The police said they should not wait for

the morgue van, but go fetch the body before it was burnt to ashes. Maki and Tarzan were scared, as were the police, who called for back-up.

They drove cautiously into the hostel. The police had their guns drawn as they made their way along the rutted dirt road through the dormitories and to the back, near the garbage dump to the place where they knew the Zulus did their killing. There were three bodies there. The killers were sitting and looking at them, just a few metres away. They were not in the least afraid that the police might arrest them. The police ignored the armed men and Maki was afraid to look at them directly in case they decided to kill her and Tarzan too. 'Stanley was still burning. The police used their hands to throw sand on him to put the fire out. He was bleeding. A lot. That was what stopped him burning too much.

'I was crying and Tarzan was holding me and comforting me by saying, "As long as they did not burn him too much, we can still recognize him."' But by the light from the police cars' headlamps the only way they could identify Stanley was by the ragged trousers and the beaded necklace he always wore. His eyes had been gouged out. They wrapped the body in a blanket and took him back to their home where Tarzan had to tell Boytjie how they had found Stanley.

As Maki reached the end of the story of Stanley's death, a small man walked into the rough brick room from which the Rapoos ran a series of pay phones. His ears had small red discs with white dots fitted in the lobes, and he wore a blue-grey pinstripe suit, unfashionably cut by some village tailor. He greeted us in richly-toned Zulu. He was from the hostel. Maki answered him in Zulu, and as he entered a booth to make his call, she said, 'Let's wait for him to finish,' and then she began to cry, tears flowing silently from her eyes. I handed her a pack of Kleenex and patted her hand uselessly. It was a long phone call and throughout it she could not stop crying. The little man in the suit finished and thanked Maki, paid her and left, politely pretending not to notice her tears.

'Ever time I hear someone speak Zulu, I get scared, or anxious. I do

not know how to categorize what I feel. I did not sleep for a long time after Stanley died.'

Tarzan does not like to talk about how Stanley died – he prefers to recall how the matches miraculously never ignited the petrol. But the memory eats at him, of how he, a powerful, confident man, was helpless to save his younger brother. They never see their kitchen the same way I see it; they can never erase the images from that dreadful night when Stanley died.

# MONSTERS

You must remember, a snake gives birth to a snake.

Victor Mthembu, participant in the Boipatong massacre on the
murder of a toddler, Aaron Mathope

|||

*18 June 1992*

Against the bright sheen of the new corrugated iron wall of the shack,
nine-month-old Aaron Mathope lay face down on a blanket. His aunt
sat on the ground next to him, tears drying on her cheeks as she gazed
dully at her sister's son. Aaron was dressed in a baby blue jump-suit and
seemed asleep, but there was a deep gash in his head where a blade had
been driven deep into his soft little skull. I knew that of all the gory and
heart-wrenching scenes I had already photographed that morning, this
dead baby was the image that would show the insane cruelty of the
attack on the small, anonymous township of Boipatong the night
before, that had left at least 45 people dead and 22 injured. But the light
sucked. The striking early morning light could have been wonderful,
but for Aaron, it was coming from the wrong direction: it fell across the
bottom half of his body, leaving his head in shadow — I was shooting
slide and the film would not tolerate the contrast. I had to show this
dreadful deed, but with the light and shadow the way it was, it would
have been an unusable picture. I asked Heidi to stand at the corner of

the shack and block out the sun; but sunlight was still streaming through and so I asked a survivor of the massacre to join Heidi in casting her shadow over Aaron. It bothered me that that I was doing this – was it manipulation of the scene, perhaps an ethical lapse? But I rationalized that it was no different to using a flash, so I took the pictures, images of Aaron's tiny corpse and his shocked, grieving aunt in beautiful, even tones.

Over the next days and weeks we got to hear of the details that had led to the killings, but not all of them. In the terse style of South Africa's post-apartheid Truth and Reconciliation Commission's 1998 report, following the series of public hearings into politically-motivated crimes, some of the missing parts of the puzzle were filled in. On the night of 17 June, at about nine o'clock, hundreds of Zulu men armed with rifles, pistols, spears, sticks and knives waited in KwaMadala Hostel across the main road from the township. They were waiting for policemen to clear Boipatong's streets of the defensive barricades erected by nervous ANC supporting self-defence units. The same police ordered the self-defence unit members to get off the streets, and allegedly used teargas against those who refused. This was unusual, residents testified. At about 9.30 that night, Meshake Theoane, an attendant at the petrol station at the entrance to Boipatong, sounded an alarm connected to the police station when he saw a group of armed men enter the township. Two white men responded, presumably policemen, and asked why he had sounded the alarm. When he told them, they seemed to show no interest and left. The attendant was puzzled, but concerned about the armed men entering the township, and so he asked the security guard, who stood watch at the petrol station, to use his two-way radio to alert the private security firm for whom he worked about what was going on. Two white men from the security company arrived a few minutes later, conferred with white policemen and then took Theoane and the black security guard away 'because it was not safe'. Theoane and the guard returned to the petrol station later and saw the same armed group leaving the township at about 10.30 p.m.

During the intervening time, late-shift workers at factories in the

adjoining industrial area claim to have seen police armoured vehicles dropping off men to the east and west of the shanty town adjoining the township. The attack started shortly after that. Residents, in the days after the massacre, told me that they had made several frantic phone calls to the police station during the attack begging for protection, but to no avail.

People later told me that police vehicles had been on the scene during the killings. Some claimed to have seen uniformed policemen taking part. Others told of hearing white men giving instruction during the attack. One survivor recalled hearing an Afrikaans male saying, 'Moenie praat nie, skiet net . . .' (Don't talk, just shoot).

Aaron's father Klaas and many other survivors maintained that it had not been just Zulus who had attacked them, but whites too. When Klaas had run from the armed group, known in Zulu as an impi, he had heard a white man's voice saying in Afrikaans: 'Zulu, catch him.' Seven shots were fired at him but he managed to hide in some bushes. From his hiding place, he listened to the attackers killing people. When it was all over, he returned home to find his wife lying on the ground with her intestines hanging out – she had been stabbed and shot repeatedly. She was near death, but told him to leave her and to go find their son Aaron instead. Klaas left his mortally wounded wife and went to look for the infant, but his child was already dead. The attackers had shown no mercy.

The days following the massacre were extremely tense, and I spent almost every day working in Boipatong; as did Ken and Kevin, along with almost every journalist. Joao was not there. He had been on assignment in the homeland of Ciskei until three days after the massacre – a holiday assignment to reward him for his hard work. On the morning of the massacre, he had boarded a plane out of Johannesburg, unaware of what had happened.

In the middle aftermath, survivors were interviewed by human-rights lawyers and they were consistent on two things: that the attackers had been Zulus and that the police had assisted them, as well as participating in the attack itself. Several surviving witnesses maintained

that the same policemen who had taken part in the attack had arrived the following day to investigate the killings. Boipatong was undoubtedly one of the worst incidents in the 1990–94 period and remarkable because police participation was undeniable. But deny it they did and they did their best to cover up their role, including erasing the police-log tapes of the night's activities. Commissions of inquiry were launched, but they all found that the police had destroyed evidence that might point to their involvement either by accident, or through incompetence. But the people of Boipatong knew the truth. The levels of anger were unprecedented.

Two days after the massacre, I watched a group of residents form an impromptu street court, a people's court, to hear evidence against a man who had been captured by self-defence unit members. The youths claimed that the Zulu man had participated in the massacre. I was inches away from the accused as dozens of bitter, angry men questioned him. It was all in the South African languages – seTswana, seSotho and isiZulu – and I could not understand more than a few words. The accused man was about 30 years old and I could see the muscles in his jaw jumping like worms under his sweaty skin as he struggled to control his terror. The questions went on for five or ten minutes, with several members of the community having their say. I was being completely ignored; it was as if I did not exist. Regardless of his guilt or innocence, I had no doubt that he was going to die – a sacrifice to communal anger. After hearing all the evidence, the leaders of the people's court said that they could not prove his guilt, and that he was to go free. To my surprise, no one raised a word of protest and the man walked rapidly away, under the protection of the militants who might have been his executioners.

It was the days after the attack before the police raided the hostel from which the attackers had come, just across the road from Boipatong. Several other journalists, including Joao and me, sat for hours waiting for the police to negotiate the right to enter the hostel. When they eventually did, all the weapons had been put into a single pile. There was no way to link any one of those weapons to an individual. While I

suspected the police of helping Inkatha, I was astonished at just how brazen they were about it. No one knew then that police and senior Inkatha leaders had come to the hostel and planned the massacre. It was only years later that the Truth and Reconciliation Commission would get more of the truth, as it offered amnesty from prosecution to perpetrators who would tell all. It was also during these hearings that local Inkatha youth leader Victor Mthembu, when asked why the nine-month-old infant, Aaron Mathope, had been killed, would state: 'You must remember, a snake gives birth to a snake.'

The Commission also found that 'white men with blackened faces participated in the attack'. It went further and stated that 'the police were responsible for destroying crucial evidence'.

'The Commission finds the KwaMadala residents together with the SAP responsible for the massacre, which resulted in the deaths of forty-five people and the injury of twenty-two others. The Commission finds the Commissioner of Police, the Minister of Law and Order and the IFP responsible for the commission of gross human rights violations.'

Despite the overwhelming evidence that the massacre had been planned ahead of time, and that there was police collusion before and after the attack, many chose to believe that it was all ANC propaganda. Besides eyewitness accounts, and the tales from the survivors, one of the men arrested for the Boipatong massacre told of police involvement before he mysteriously died in custody. Victor Khetisi Kheswa was known as the Vaal Monster and he was responsible for many killings. This small-time gangster and car thief had been adopted by Inkatha and the police in 1990 and so began the reign of terror in the townships south of Johannesburg – the Vaal Triangle (a heavy-industrial area named after the Vaal River).

The first drive-by shooting was on 2 January 1991. ANC member Chris Nangalembe convened a people's court that found Kheswa guilty of crimes against the community during a youth-led anti-crime drive in the townships. Kheswa was shot and wounded by the people's court, but he escaped. The next day Nangalembe was garrotted by Kheswa's gang. Many people attended the traditional all-night funeral vigil for

Nangalembe on 12 January 1991, but despite pleas to the police for protection, Kheswa and his gang attacked the vigil, leaving 45 mourners dead. I arrived the next morning, to find the ground stained by blood, and devastated survivors.

The drive-by shootings continued and the terrorized residents spent their nights digging trenches across their streets to try to stop the random attacks. ANC leader Ernest Sotsu's family was attacked in Boipatong on 3 July 1991. Sotsu was in Durban attending the ANC's first national conference since its unbanning, when the Vaal Monster and his gang came to his house. They shot dead his wife Constance, daughter Margaret, and two-year-old grandson, Sabata. But two of Sotsu's sons, Vuyani and Vusi, survived and were able to identify one of the attackers as Victor Kheswa.

Kheswa was arrested and charged with the murder of Sotsu's family, but released on R200 (then approximately $57) bail. A black policeman testified that when the gangster was arrested, he was given special food and privileges in the holding cell, and that he boasted of working with the police. People living in the area had often seen Kheswa in the company of the police, especially at scenes of violent conflict.

He was arrested again for the deaths of 19 people in April 1993 and for another 16 in June 1993, in addition to the charges about the 45 deaths as a result of the Boipatong massacre in June 1992. The police officer testified that Kheswa was angry that he had been arrested and that his police collaborators had not had the charges dropped. He threatened to reveal that he had been hired by the police to conduct the reign of terror in the Vaal Triangle. That same day, 10 July 1993, he died. The state pathologist's post mortem claimed he had died of natural causes – a virus that had induced heart failure. A separate examination on behalf of Inkatha and the Kheswa family found he had died of 'conditions including acute suffocation, electrocution, hypothermia and occult toxic substances'. The Vaal Monster had been just 28 years old when he died.

Sotsu, among others, claimed Kheswa had been killed by police because he could implicate them in third-force activities in the Vaal

Triangle between 1990 and 1993. But Kheswa was not the only person taking part in third-force activities: thousands of Inkatha members were trained in warfare by the police and the right-wing in secret camps. Inkatha leaders were given weapons and money by covert police units. White and black policemen or special forces members were repeatedly seen with Inkatha attackers, and one white policeman even gave testimony years later that he had taken part in attacks on commuter trains while disguised as a black person and would later return to the scene as the investigating officer.

It was into this atmosphere of suspicion about the police force's role in the attack that South African President and Nationalist Party leader F.W. de Klerk made a belated sympathy visit to Boipatong, four days after the massacre. I had gone to Boipatong expecting there to be trouble, as the residents would have a target for their rage, and the police would be nervous about De Klerk's safety. People greeted him with signs accusing him of being a killer. De Klerk smiled and waved from inside the thick glass, but it was obvious he would not risk getting out of the car. Despite a massive police presence, the enraged residents cursed and stoned his bullet-proofed limousine. The convoy accelerated away and I ran alongside, shooting pictures of De Klerk's ignominious retreat. After he left, police shot and killed a man during a confrontation I did not see. By the time I got to the open field, a crowd had gathered – they wanted to identify the body, but a ring of riot unit policemen refused to allow them near. The angriest and bravest among the residents stood face to face with the heavily armed white policemen, screaming insults and spitting at them. Then the inevitable happened: the cops opened fire at point-blank range. I had stupidly been on the wrong side – with the residents – but somehow I got behind the police line and photographed them firing round after round at the fleeing people. Several people were killed and many injured. There would have been many more casualties but for the rough and broken ground that afforded people cover. Someone in the township then opened up on the police with an AK-47 assault rifle. A lot of bullets were flying in all directions. There were people, including a Nigerian colleague,

trapped between the two sides, calling for help. That was one of the times that Heidi showed us all up: she said she was going to help them get out. I had no choice but to follow, both of us holding our hands in the air and screaming for the shooting to cease while we got the wounded out. Somehow, both the police and the comrades stopped firing, and the trapped and wounded were taken out before the gunfire resumed. Despite the pictures and the television footage, the police and Nationalist politicians claimed the images had been fabricated, that the people had been faking death and injury.

On the day of the mass funeral for the victims of the original massacre, there seemed to be coffins everywhere I looked. Some in limousine hearses, others on the back of dilapidated pick-up trucks, yet others carried shoulder high by comrades. Aaron Mathope's coffin rested on the floor of a darkened room as his family sat vigil over him. The only light came from two candles and in the open coffin lined with white tissue paper Aaron stared out with glassy eyes. He did not look real, it seemed more like a nativity scene of the baby Jesus in a manger than a murdered child in a cheap wood box, so small it could hardly be called a coffin.

There were dozens of coffins side by side, and a sad and embittered crowd filled the local soccer field. Clergymen of every conceivable denomination, including Archbishop Desmond Tutu, came to pray for the dead. Joao watched as Tutu made his way through the crowd, beaming and grasping people's hands at the dignitaries' area. Tutu had been to too many such massacres, too many funerals, and his was a message of hope, not despair. But his mood was not reflected among many within the crowd gathered to mourn. All the politicians who counted were there, including Mandela, who announced that the ANC was pulling out of the negotiations towards a future South Africa as a result of government complicity and police involvement in the killings.

Finally, all the coffins were neatly laid out in rows, emotions had settled somewhat and it was time for the speeches. Both Joao and Ken were shooting for *The Star*, and Joao decided to take a drive around the township, just in case there were any revenge attacks on Zulu speakers.

A photographer with the *Weekly Mail*, Guy Adams, joined him. Within minutes of leaving the stadium, they heard a gunshot, and saw a group of people chasing a man along a street. The fleeing man ran into the adjoining houses, where he hoped to lose his pursuers. Joao and Guy abandoned the car and followed the chase on foot. They caught up with the mob which had trapped the man on the driveway of a house.

The victim was a young man with dreadlocks, sitting on the concrete. A circle had gathered around him, telling him that he was Inkatha and that they were going to kill him. Joao and Guy were on their knees photographing him from behind, with the menacing crowd looking down on to him. Then a youth emerged from the anonymity of the crowd, stretched his arms high above his head and brought a large rock smashing on to the man's head. That was the beginning and then the killing-frenzy commenced. Everyone began pushing and shoving as they tried to beat or stone the suspected Inkatha member. Joao was shooting pictures through a confusion of legs. The frenzy of the mob waned after their victim lost consciousness. A youth unceremoniously grabbed a limp arm and dragged the man down the driveway into the middle of the dusty road, leaving a long trail of blood in his wake. He had not regained consciousness, but the attack resumed. Someone shot him with a kwash; another ran up and kicked him; one man hacked at the unmoving body with a panga. Joao watched a young child run up and throw a Coke bottle at the still body; it bounced off the corpse. He did it again, but this time the bottle broke, ending the game.

Throughout this, Joao continued to shoot pictures, getting sucked into the moment, thinking of nothing except what he was photographing. He paused to change film and wondered how long it would all continue. A minibus filled with men made its way through the crowd. The men inside were armed with several AK-47s. The vehicle slowly and deliberately drove over the inert figure on the road, each wheel rising over and dropping off him with a 'thunk'. Joao just watched. Suddenly an arm wrapped itself around his neck from behind and he was being pulled roughly backwards. He could not see who it was, but his assailant was yelling at him, angry, and he felt the cold

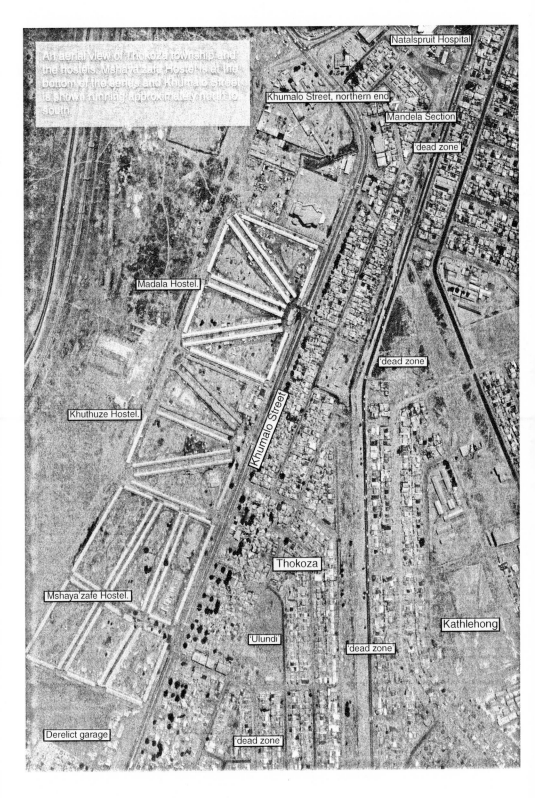

An aerial view of Thokoza township and the hostels. Mshaya'zafe Hostel is at the bottom of the series and Khumalo Street is shown running approximately north to south.

Natalspruit Hospital

Khumalo Street, northern end

Mandela Section

'dead zone'

Madala Hostel.

'dead zone'

Khuthuze Hostel.

Khumalo Street

Mshaya'zafe Hostel.

Thokoza

Kathlehong

'Ulundi'

'dead zone'

Derelict garage

'dead zone'

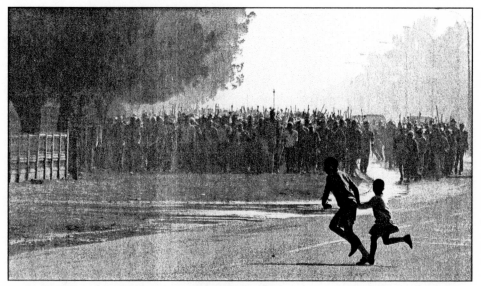

A girl leads her younger sister to safety as an impi, or regiment, of Inkatha-supporting Zulu warriors moves down Khumalo Street, Thokoza, at the start of the Hostel War, August 1990. Ken would later be killed in this same street, four years later.  (Ken Oosterbroek / The Star)

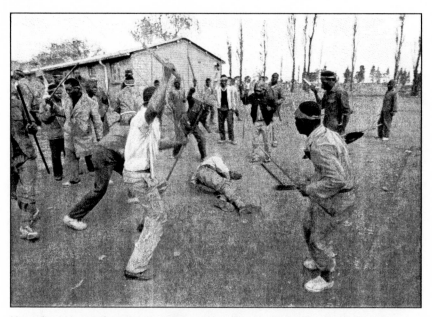

Nancefield Hostel, Soweto, 17 August, 1990. A group of Inkatha-supporting Zulu hostel dwellers kill a man they suspect of being a Xhosa – understood by the attackers to be synonymous with the ANC.  It turned out that he was an ethnic Pondo of undetermined political allegiance.  (Greg Marinovich)

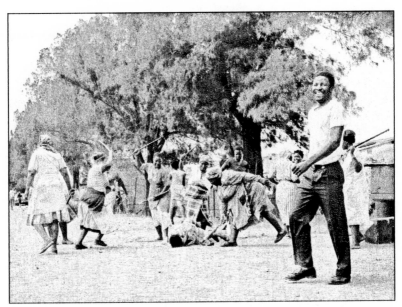

Khumalo Street, Thokoza, December 1990. A man laughs towards the camera as he passes a group of female Inkatha supporters beating an unidentified woman. The severely injured woman was later picked up by police, but it is not known if she survived. (Joao Silva)

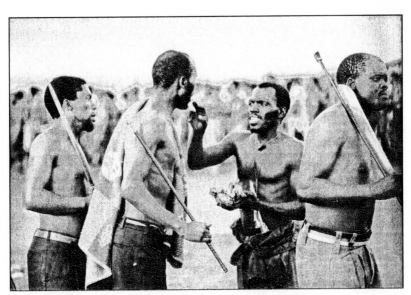

ANC-supporting Xhosa warriors receive magic potion or intelezi from a sangoma at 'the mountain' in Bekkersdal township, west of Johannesburg, 1993. (Kevin Carter/Corbis Sygma)

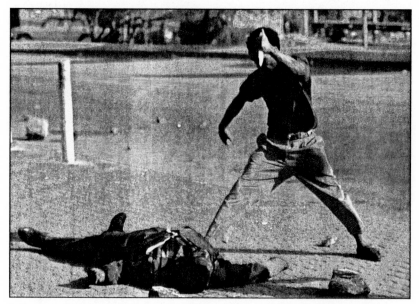

Inhlazane, Soweto, 15 September, 1990. An ANC supporter prepares to plunge a knife into Lindsaye Tshabalala, a suspected Inkatha supporter, during clashes at the start of the Hostel War. (Greg Marinovich)

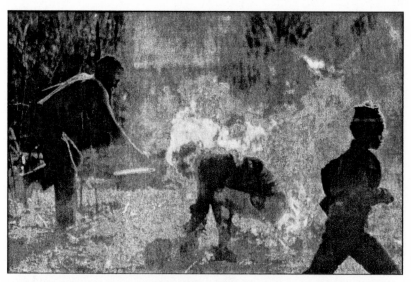

Inhlazane, Soweto, 15 September, 1990. An ANC supporter hacks at a burning Lindsaye Tshabalala as a young boy flees. This was one of a series of pictures that won the Pulitzer Prize for Spot News in 1990. (Greg Marinovich)

Maki and Sandy 'Tarzan' Rapoo explain how their nephew, Johannes, was shot dead by police in their Meadowlands Zone 1 suburb of Soweto, June 1992. They were in the kitchen of the house on Bakwena Street, where they had previously suffered the loss of Sandy's younger brother, Stanley. (Greg Marinovich)

Maki Rapoo leads her brother-in-law, Lucas, out into the yard of the family home on Bakwena Street to do a traditional dance during his wedding reception in 1996. (Greg Marinovich)

The maternal aunt of Aaron Mathope grieves next to the nine-month-old infant's corpse after he was hacked to death by Inkatha attackers, aided by police, in Boipatong Township, 18 June, 1992. 45 people were killed. One of the Inkatha attackers' leaders later explained the killing of Aaron thus: 'You must remember that a snake gives birth to a snake.' (Greg Marinovich)

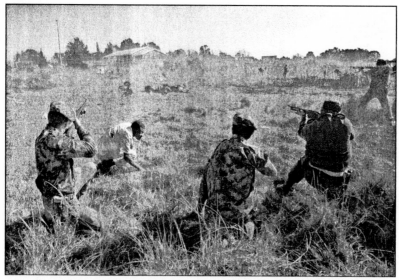

Policemen open fire on an unarmed crowd of Boipatong residents who had wanted access to a man shot dead earlier by police after President FW de Klerk was chased from the township on 20 June, 1992, days after the massacre. There were several deaths and injuries. Police and the government denied this incident occurred, saying residents and journalists had fabricated the casualties. (Greg Marinovich)

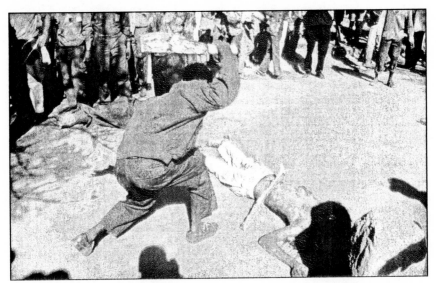

A resident of Boipatong hacks at the body of a Zulu man suspected of being an Inkatha member who had taken part in the Boipatong Massacre. He was later burned. (Joao Silva)

Daniel Sebolai, 64, who lost his wife and son in the Boipatong Massacre, holds back the tears during a workshop on issues related to the Truth & Reconciliation Commission in Sebokeng, 28 October, 1998. Next to him is Boy Samuel Makgome, 48, centre, who lost his eye during an attack on a train by Inkatha Freedom Party members in 1992. Hundreds of victims who did not find sufficient or any redress from the commission are counselled and advised of their rights by non-governmental self-help groups made up of human-rights victims. (Greg Marinovich)

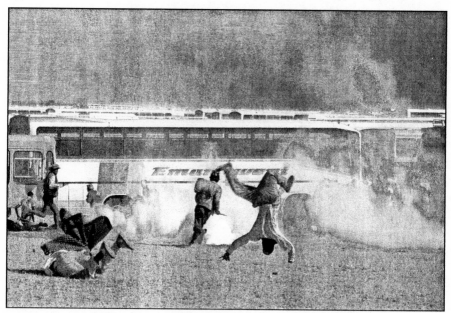

An ANC mourner takes evasive action from police gunfire during violent clashes at the funeral of Communist Party and ANC military leader, Chris Hani, 19 April, 1993. Hani was assassinated by white extremists. An election date for one year later was set soon afterwards. (Greg Marinovich)

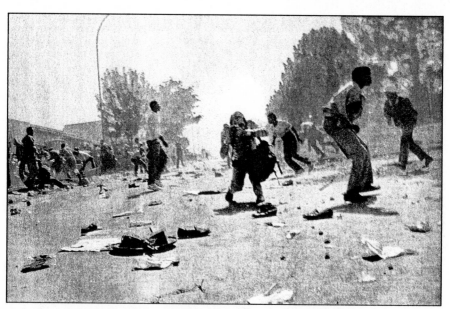

Kevin Carter aims his camera to take a picture of Ken Oosterbroek as Soweto residents flee police gunfire outside the Protea police station where they had been protesting after Chris Hani was assassinated by right-wing whites, April 1993. (Ken Oosterbroek / The Star)

touch of the barrel of a gun at his neck. Joao was scared. All he could think was that he would die next in this orgy of death. He screamed for Guy and began pleading with his attacker. Then Guy was alongside him and he was no longer being dragged. He turned to face an older man whose face was tight with anger.

They kept repeating that they had not taken any pictures showing faces, that no one could be identified: the usual lies that we told when we had angered men with guns. The crowd had not even noticed the incident: someone had found discarded tyres and they were intent on burning the dead man. A huge flame suddenly rose above the mob, a collective scream of what sounded like joy rose with the flames. The gunman was distracted, Joao and Guy turned and ran. They went through yards and climbed over fences until they finally reached their car.

Back at the stadium, tens of thousands of voices were singing the evocative liberation anthem, 'Nkosi Sikelel' iAfrika'. Despite the shock from what had just happened, or perhaps because of it, Joao got goosebumps, the hair on his neck and arms rising as he felt his skin tingling. Joao struggled to control his emotions as the mourners' song pleaded with God to bless Africa.

I watched Joao making his way through the crowd and I could see that something was very amiss. He came straight to me. I put my hand on his shoulder, asking what was wrong. Ken had joined us. We listened to Joao and Guy's story and then they took us to the scene, where the body was still smouldering. A woman came out from one of the houses and threw a blanket over it, giving us a look of profound distaste, as if we were responsible for the body outside her house.

# BAD BOYS

Here comes mellow yellow, yes ma, people are going to cry
Here comes mellow yellow, yes ma, it brings troubles
Mama, please don't cry
Mama, don't cry

Songs from the Struggle

|||

One morning in 1992, Heidi and I were at home discussing yet another story about zombies in a local Sunday newspaper. It seemed as if there was at least one witchcraft-related story every week. To Heidi, raised in western Europe, it was ludicrous that people could let their lives be so consumed by superstition, but belief in witchcraft, shades and the undead is widespread in South Africa. I had covered several zombie stories and knew that people truly believe in the ability of evil witches to turn the dead into zombies – the bewitched slaves of the sorcerer. Taking the paper, I went to find Joyce Jenetwa, the woman who came to clean house for us once a week, to hear what she had to say about zombies.

She was ironing in the kitchen. As she rhythmically pressed and folded each item, she would lose herself in memories or deep thought, trying to resolve problems that troubled her. When I casually interrupted her, showed her the article and rather flippantly asked if she thought zombies actually existed, she finished a pair of trousers before stating matter-of-factly that her granddaughter Mimi was a zombie. I

already knew that 13-year-old Mimi had been shot to death in her mother's backyard shack on 13 August 1991 – more than a year previously – but I was taken aback to hear that Joyce believed she was a zombie, in thrall to a shebeen queen.

Joyce was a short 59-year-old Xhosa woman with bright humorous eyes and a quick smile. She had been working for us for a year. A fiercely independent woman, she cleaned for several different households because she refused to be beholden to a single employer. In South Africa at that time, domestic workers were not protected by any union, or entitled to a minimum wage, and could easily be exploited by their 'masters' and 'madams'. Besides, she had her own life, with family, church and ancestral obligations that she did not want to sacrifice to some boss's late dinner parties and baby-sitting obligations.

Over time, she told me the full details of the story, and I gradually came to understand the notion of zombies as a way in which people deal with trauma. Joyce had opened my eyes as no newspaper article ever had, and I discovered an entire undercurrent to the violence, where ancient beliefs that I had thought were separate from the modern nature of the political struggle were in fact woven into almost every aspect of it.

Mimi had been killed in Thokoza, that strange and dangerous black township 16 kilometres south-east of Johannesburg, where I – and the other journalists – had come to accept that anything could occur. Thokoza had the highest death toll of any township during the four years of war that began in 1990, shortly before Mandela's release: on just one day in August 1990, for example, 143 people died in hand-to-hand combat. At one stage, there were so many casualties that the police had to leave the corpses lying in the streets for much of the day. Dogs left behind by residents fleeing the war formed ravenous packs that survived by feeding on the corpses. Joyce told me of those dogs shadowing funeral cortèges all the way to the cemetery.

Thokoza is a small, nondescript township. The main road, Khumalo Street, runs north-south for four kilometres through an elongated triangle from one set of migrant workers' hostels to another. At its southern end, Khumalo Street turns east for a further two kilometres

until it reaches three more hostels, grouped together in neighbouring Kathlehong township. We photographers got to know the roads and neighbourhoods that Khumalo Street traversed extremely well. Many of the pictures of violence we took were in that tiny area. It was on the wide dirt pavement bordering Khumalo Street that Joao photographed a man smiling at a mob of women beating another; it was across the blue-grey tar of Khumalo Street that Ken captured the moment when a young girl desperately pulled her even younger sister to safety from an impi of thousands of armed Zulus emerging from the early morning haze. The residents of Khumalo Street were regularly terrorized by the rhythmic clash of spears, stricks and sharpened steel on the hard cowhide shields which the hostel Zulus carried. This terrifying sound was punctuated by the occasional gunshot that elicited the war cry 'Usuthu!' from thousands of baritone throats.

The conflict in Thokoza pitted the hostel-dwellers against local householders. Migrants against residents. Most township residents regarded the hostel-dwellers as backward country bumpkins who contributed nothing to the community but discord. In tsotsitaal, the urban slang that sets city sophisticates apart from their country counterparts, the hostel-dwellers were referred to as stupids. More insultingly, they were mdlwembe – feral dogs – from the Zulu adage that says once a domestic dog has left the kraal, or homestead, and gone into the bush, it becomes wild and can never be domesticated again. For their part, Inkatha supporters often referred to their ANC opponents as isazi, or clevers, meaning deceitful city-slickers.

Most residents owed allegiance to the ANC, and relied for protection on volunteers who grouped themselves into self-defence units made up of militant youths and the occasional trained guerrillas who were given weapons by the armed wings of the liberation movements. Inside the hostels, the Zulu inhabitants were almost all combatants linked to other hostels by a controlling web of indunas or headmen, taking orders from the Inkatha leadership. This networking ensured the conflict spread rapidly from township to township, and that the ubiquitous hostels were at the centre of every conflict.

Soon, no-go areas developed around the hostels. We took to calling them the dead zones. We all passed through these no-man's-lands countless times during the conflict, sometimes casually, sometimes scared witless and sometimes all fired up with adrenaline while chasing the bang-bang. Running through the heart of the dead zone in Thokoza was Khumalo Street. At its northern end, on the left, was a sprawling municipal hostel complex, the impregnable Inkatha stronghold to which the Zulu warriors would retreat when the fighting was going against them. The furthest of the three fortress-like hostels lining the western pavement was dubbed Madala ('the Old One') by residents. The middle hostel was Khuthuze ('to be pickpocketed'), while the southernmost one, adjacent to the petrol station, was called Mshaya'zafe, a Zulu phrase meaning 'beat him to death'.

The Zulus eventually spread out to occupy the neighbourhood of little matchbox houses opposite, and nicknamed their territory Ulundi, after the rural capital of the KwaZulu homeland that is the seat of Inkatha's power. This area was feared and hated by non-Inkatha members, who would not dare to set foot there, just as a visit to the township was deadly for hostel Zulus. At the beginning of the war, it was possible for us to drive through Ulundi and even to enter the hostels, but as the conflict deepened and attitudes hardened, that stretch of Khumalo Street became a no-go area, though occasionally we would brave a run along it, sinking low into the car seats while racing through the stop signs and hoping no one would shoot. As the first year of the war wore on, venturing into the hostels became a scary gamble. One day it would be fine to go in, meet the induna and get permission to work, talk to people, drink a beer, photograph. On other days, when hostility ran high, we were soon met with aggression that prevented us staying or working. Later still, entering the hostels at all was out of the question.

At the other, southern, end of Khumalo Street, Khalanyoni Hostel was overrun early in the war by ANC fighters, most Xhosa tribesmen from the adjacent Phola Park shanty town. These warriors were called blanket men as they wore their initiation blankets to fight; hiding sticks, spears and guns under the heavy wool folds. They dismantled the

buildings, brick by multi-coloured brick, and used them to rebuild their shacks that were destroyed in the fighting. From day to day, the shanty town transformed itself from a maze of drab corrugated iron into a bizarrely colourful place. The surviving Zulu hostel dwellers from Khalanyoni retreated to the hostels at the northern end of Khumalo Street.

Once the pass- and influx-control laws of petty apartheid were annulled in the mid-80s, many former hostel-dwellers moved into shack settlements with their families. Those from hopelessly over-populated tribal homelands like the Transkei and Lebowa were eager to leave the countryside and move into urban townships, but Zulus continued to see life in the townships as a temporary sojourn. Their wives and families stayed on in the rural areas and the men went home to visit when work and money allowed. The system of land control in KwaZulu supported this choice: unless land remained in use by a family, it could be taken by the chief and reallocated to more productive families. Zulus were also strongly attached to traditional lands where their ancestors are buried and where their spirits resided. Zulus who died in the cities were rarely buried there – their bodies were usually taken home. One consequence of these strong rural ties was that the hostels came to be increasingly dominated by Zulus. The Zulu proclivity for murderous clan-feuds spanning generations was pursued just as viciously in the cities as they were back home. This meant that hostel Zulus were permanently prepared for conflict and organized in the traditional Zulu militarized social units, amaButho, or warrior-groups under the control of an induna.

It was these forces that were harnessed by the Inkatha political leadership and unleashed repeatedly in 1990 and 1991, in an attempt to ensure that it became a national political player. Tens of thousands of Zulus wearing red headbands and carrying spears, shields, machetes and the occasional assault rifle would surge out of the hostels and down Khumalo Street, a sea of chanting belligerence. At first they inflicted heavy casualties, until the formation of neighbourhood self-defence units evened the odds.

The conflict spawned an entire sub-culture. For the denizens, the map of Thokoza had been redrawn: Ulundi on one side, separated by the dead zone from the ANC neighbourhoods which had also been renamed. The three neighbourhoods surrounding the hostels most involved in the conflict became known as Slovo section, in honour of the Communist Party leader Joe Slovo; Lusaka section, with a nod to the Zambian capital where many exiled ANC leaders had found a home; and Mandela section.

In Mandela section, a group of young ANC fighters occupying a tiny cluster of homes in the northern-most corner of Thokoza somehow resisted the Inkatha impis. We got to know the self-defence unit there that was led by a man in his early twenties. He shared a nickname with one of the enemy hostels: 'Madala', they called him – 'The old one'. He had been given the name by his fighters, most of them in their teens and still trying to balance schoolwork with warfare. From one of their bases bordering a dead zone, in a house deserted by its owners, the teenage fighters would keep watch through a brick-sized hole in the wall. The hole was large enough to fire out of, but small enough to present a minimal target to opposing snipers. The house was shared by a dozen kids and their even younger camp-followers – pre-teens who ran errands and assisted during combat. The yard would be swept clean most days when there was no fighting. The boys washed their own clothes and cooked their own meals. Racy girls would sometimes appear, especially for parties, but they were excluded from the mainstream of the fighters' lives. Contributions from the neighbourhood residents enabled them to buy the food they needed, although some fighters took to crime to supplement the donations: Coco-Cola trucks were favourite targets for a hijacking when the boys needed money.

Some of the self-defence units earned a loyal following among the township folk, while others were simply regarded as gangsters. In Lusaka section, the fighters were proud of their heroic image. They wore bandannas and black T-shirts with 'Lusaka Section SDU' printed on them. They were extremely proficient in combat, silently using hand signals to communicate and moving like trained soldiers, which

they were not. They could strip and reassemble the battered AK-47s they used in a matter of seconds while under fire and they had young boys to carry ammunition clips for them. The idea was to keep the spare ammunition separate from the big machines in case they got picked up by the police or army – the scarce bullets were more valuable than the rifles themselves.

The ferocity of the fighting that engulfed townships on the Reef – the highly populated swathe of mining and industrial towns centred on Johannesburg – surprised South Africans. Various factors contributed to the volatile situation. Following the release of Nelson Mandela in February 1990 and the unbanning of the liberation movements, including the ANC, the Pan-Africanist Congress and the Communist Party, political competition intensified. Decades of suppression and the liberation movement's Marxist-influenced ideologies meant that there was no culture of political tolerance. Inkatha's decision to transform itself from a 'cultural movement' into a registered political party – the Inkatha Freedom Party – and to establish a membership outside of the Zulu homeland, ensured that a climate of violence predominated. Years previously, in 1980, the KwaZulu homeland leader Mangosuthu Buthelezi had broken with the ANC when he agreed to take part in the homeland process, allowing him to gather power and a partisan home-land police force in KwaZulu-Natal province. This eventually led to open conflict with the various ANC-aligned groups inside the country, especially the United Democratic Front. The ANC by contrast refused to work within the system of apartheid, and a bloody war raged in the province for over ten years before the release of Mandela.

Within the white security forces there were government ministers, officers and foot soldiers who played an active role in helping to spark the dangerously flammable tinder that lay between the opposing sides by supplying weapons and training to Inkatha. After decades of government propaganda demonizing the liberation movements as part of an anti-Christian, Communist total onslaught against white South Africa, it was unsurprising that the average white policeman (like the average white citizen) loathed and feared ANC supporters. The

antipathy was mutual. The ANC and the more radical black consciousness Pan-Africanist Congress considered all policemen legitimate targets for assassination. Ordinary black citizens hated and mistrusted police as the arm of the law that harassed, arrested and tortured them.

Relations between the police and Inkatha, however, were a different matter. It was not uncommon to see a Zulu migrant raise his hands in a show of deference or call a white policeman inkosi – 'my lord'. The bearded white AP bureau chief Renfrew, who might have been mistaken for a policeman on a bad day, told me how he had come across a Zulu castrating a dead Xhosa in the aftermath of a battle in Thokoza in 1990. The man with the knife had turned to him and said, 'Please, my colonel, let me finish just this one!'

The Zulu's attitude to Renfrew should not have been surprising; Inkatha and the white regime were using each other to gain an advantage over their political opponents – primarily the ANC. The same illegal strategies being employed by the government had been tested during the election run-up in South West Africa (as neighbouring Namibia was called while it was a South African protectorate – in effect, a colony). When Pretoria was faced with the inevitability of democratic elections, officials clandestinely set about fomenting communal violence in the hope of disrupting the elections and preventing a landslide victory for the former guerrilla movement, SWAPO. They failed, in the end, to do so, but the same regime and their covert units nonetheless redirected their energies to weakening the ANC power-base, especially within the urban areas where the liberation movement had the vast majority of support. They stopped at nothing – from gun-running and assassination to unlawful funding and crooked justice – to ensure that Inkatha weakened the ANC enough to upset their electoral chances. One early morning in 1990, for example, I arrived at Phola Park in Thokoza just 20 minutes after the sunrise. Xhosa warriors told me that they had killed a white policeman who had led an Inkatha attack on their shacks. The policeman had had black camouflage paint on his hands and face. He had lain in the grass for hours before the police managed to retrieve his body. I had just missed a picture that

would have proved the third-force theory. The first I had heard of the term 'the third-force' was in an ANC press conference in which they accused covert police and/or military units of provoking and indeed committing violence to disrupt black communities. It had become clear that there was a lot more to the killings than just the ANC and Inkatha attacking each other, and more than just police breaking up riotous situations.

One time in Soweto an army lieutenant complained to me from the top of his armoured vehicle that the police would not let him disarm an Inkatha impi that was rampaging through an ANC neighbourhood. Another then-inexplicable example of suspicious police behaviour was when I had raced to the scene of an explosion in Soweto, only to find white plain-clothes men, obviously cops, who threatened to kill me if I entered or if I took their pictures. They were wild, and clearly a law unto themselves. I complained to the uniformed police spokesman who was there, 'You heard them threatening me, I am going to lay a charge!' but he just kept walking me away from the house, he was clearly not going to side with me against them. Even though he was black, he was assisting his murderous colleagues. It was only years later that I discovered that the white men had been a part of the notorious Vlakplaas police unit responsible for assassinations, and that the explosion had been the sabotaged earphones of a Walkman tape-player exploding and ripping through the head of an ANC lawyer. Their real target had been their former Vlakplaas commander, Captain Dirk Coetzee, then being protected by the ANC in Zambia after he had spilled the beans on government hit squads. But Coetzee had not accepted the parcel mailed to him and it had been sent back to the return address, that of ANC lawyer Bheki Mlangeni, who, of course, had nothing to do with the sending of the booby-trapped Walkman in the first place. The tape inside the Walkman was marked as containing evidence on hit squads. He died as he pressed the play button. I never did get a picture showing illegal police or third-force activity. None of us ever did.

In this houses closest to the Zulu area of Thokoza, residents' lives

were tossed about like flotsam on an angry sea. The war advanced street by street, encroaching ever further into previously safe sections. Homes were burnt, windows broken, everything of value looted. Gardens were overgrown with weeds. These abandoned houses became front-line bases from which opposing sides sniped at each other, and soon one could hardly find a wall, iron gate or fence on Khumalo, Tshabalala and Mdakana streets that did not have a bullet-hole in it.

I had photographed much mayhem in Thokoza, but I had not been aware that I knew someone who had lost a loved one there. To find out that one of those many 'violence-related incidents' had happened to the woman who cleaned my house every Monday was disconcerting. Joyce's granddaughter, Mimi, had lived on the very edge of that dead zone in Thokoza, in Nkaka Street. Just days before her death in August of 1991, Mimi had called Joyce to ask if she could come and stay with her in Soweto, some 30 kilometres away, as parts of the giant township were still untouched by the violence that had completely engulfed Thokoza. Joyce was delighted. Mimi was her only granddaughter and the apple of her eye, and she longed to see her again. The child had stayed with her from the age of one until she was four, while Mimi's mother had looked for a place to stay, eventually finding a backyard shack in Thokoza. From then on, the child came regularly to stay with Joyce. Besides the ever-present threat of political violence, Mimi, just 13, was terrified of being jackrolled – the practice of certain criminal gangs of abducting and gang-raping girls for days at a stretch.

One such gang of thugs was the Bad Boys, a gang in Slovo section. They were small-time tsotsis, who had become increasingly brazen and dangerous in the now nearly-lawless township. They progressed from petty theft, mugging and burglary to armed robbery and hijacking vehicles at gun-point. One day in 1990, they had tried to rob the driver of a truck delivering milk to a neighbourhood store, owned by a Zulu businessman and founder of a small Zionist Christian sect, Bishop Mbhekiseni Khumalo. The bishop ran out of his store with the handgun he had bought especially for thugs like the Bad Boys, and fired at the fleeing tsotsis. One of the shots hit a woman in the street, killing

her. The Bishop claimed that the Bad Boys had killed her, but there were many eyewitnesses to the shooting. He remained unrepentant and grew increasingly belligerent, making the neighbourhood turn against him. The incident had happened at the time, in July 1990, when Inkatha, having changed into a political party, had begun a recruitment drive. The Bishop, a Zulu, asked for Inkatha's protection in return for promoting membership in his area. The Bishop and his new henchmen – well-armed and blooded veterans of the political conflict in KwaZulu-Natal – became known as the Khumalo Gang, and led a campaign of terror to force people to join Inkatha or leave the area. In the prevailing atmosphere, audacious groups, like the Khumalo Gang, planned and committed assassinations of opponents with impunity and ran their territories like fiefdoms, exploiting the traumatized community even further. The Bad Boys themselves were quick to take advantage of the anarchy, and jackrolling was their pastime. If the gangster saw a girl they desired, they would wait for her to come out of school, or even take her right out of her home. They would keep the girl at their hideout and repeatedly gang-rape her until they grew bored – which might take a day or a week. They would then drop her back home, telling her parents that they had enjoyed their daughter and would come back for her some time.

One day, when Joyce returned home from work to her own back-yard shack in Soweto, she found her niece waiting for her, looking very disturbed. Joyce grew nervous, guessing there was bad news. When she heard that Mimi had been killed, Joyce began screaming to drown out the words.

Joyce decided to go to Thokoza immediately, even though it was getting dark and there were very few minibus taxis around. She had to use a series of taxis to get to Thokoza. Once there, it was difficult to get one to take her all the way to the place where Mimi lived because the taxis stopped travelling by six in the evening. She found a taxi and pleaded with the driver to take her, explaining the situation. He reluctantly agreed to go as far as Natalspruit Hospital at the top end of Khumalo Street, but no further. Taxis belonged to associations clearly

affiliated to either Inkatha or the ANC and the driver would have had to drive through Inkatha territory to take her to her destination. She was now stranded over two kilometres from the house and the streets were eerily empty. People were too scared to be out after dark, so Joyce began to walk, both fearful of what she would find and of her own safety as she stealthily hurried along the dark streets that passed through the dead zone. She finally reached the darkened house, where Mimi's mother Eunice and her surviving daughter had joined the landlady in hiding for fear of a further visit from the gangsters. In the gloom, Joyce heard how her granddaughter had been killed.

Mimi had been sick in bed with the 'flu and, at about eight o'clock that evening, Eunice sent her elder daughter to the shop to buy a tin of soup, because that was all the sick child would eat. On the way back she passed a gang of thugs that she recognized as members of the Bad Boys gang. They called out to her, telling her to come to them. The girl decided to make a run for it as she was close to home. They chased her but she made it home ahead of them and slammed the shack door shut behind her. Her mother was watching television with the landlady in the main house, unaware of what was happening in the backyard. The boys banged on the door, saying, 'She is our girlfriend, we want our girlfriend; she is running away from us.'

The terrified girl hid behind the door and yelled back that she was not their girlfriend. The sound of the Bad Boys trying to break down the door woke Mimi. In her feverish, confused state, she jumped out of bed and ran into the other room of the shack, away from the door. But the thugs had come around to the window and as they broke the glass, Mimi called out to her sister, 'Sisi, what's going . . . ?' They shot her behind the ear, the bullet coming out through her mouth. The tsotsis climbed in through the window, ignored the young girl they had just shot, and took Mimi's screaming sister away. On the way back to their hideout, they abducted another girl from a nearby house. The girls were locked in a shack, while their captors began smoking dagga (marijuana) and drinking, getting primed for the party in which the girls would be raped. They were not in a hurry, they knew that they could keep the

girls as long as they wished – the police would do nothing. At one stage, late in the night, the stoned gangsters lost concentration, and the girls seized the chance to escape.

Joyce listened to the story with growing horror and disbelief. She did not want to accept that her grandchild was dead, but as the oldest in the family, she was obliged the next day to go identify Mimi's corpse at the government mortuary. When the mortuary attendant pulled out the drawer that contained Mimi, Joyce nearly fainted. She was naked and her one eye was hanging out of its socket. But Joyce steeled herself and examined her closely. Mimi's hair was like it always was, blow-dried back – the tight curls fashionably relaxed, so that her hair was long and straight. The young girl's breasts seemed surprisingly small – she had always had a large bust that Joyce used to playfully tease her about. Joyce was puzzled, did a person's breasts shrink after they died? She was overcome by the thought that she wouldn't see Mimi alive again.

That night, Joyce went back to Soweto. She slept uneasily and dreamt of Mimi. In the dream, Mimi hugged her as she did in life – coming up behind her grandmother and throwing her arms around her, her breasts pressing against Joyce's back. Joyce said to her, 'Take off your big breasts for me.' Mimi just laughed, but Joyce insisted, asking why her breasts had been so small at the mortuary, but now they were once again their normal size. Mimi pulled away from her. Joyce turned and saw from the child's face that she was upset. Mimi walked out of the shack and down to the street, without looking back, and then Joyce woke up. She could not get back to sleep and, in the morning, she told her daughter Tamara about the dream. Tamara reassured her that it was just a dream, that it meant nothing. But Joyce was deeply troubled, not just by the death, but by the idea that something unnatural had been visited on Mimi. She told her sister about the dream, who insisted they visit a traditional spirit medium, a sangoma, to see if anything supernatural had occurred. They asked around and were directed to a young sangoma. He put on his animal skin cloak to speak to his ancestors, and then he asked Joyce if she had come to see him about a female. Joyce said, 'Yes.' He asked if the person had been shot, and they

believed her to be dead. Joyce said that this was true. The sangoma told them that she was not dead. 'She is alive. She is being kept where she used to live.' He said that she was a zombie and described the zombie's mistress. To Joyce, the sangoma's description fitted that of Mimi's middle-aged landlady. Joyce and her sister paid and left. They wanted to be sure, so they went to two more sangomas, both of whom told them the same thing. For Joyce, it was a glimmer of hope – if Mimi was not dead, but a zombie, then a powerful sangoma could free her from the curse and return Mimi to her.

Ten days later, Joyce returned to Thokoza for the funeral. She had to dress Mimi's body. She had brought a pair of panties and a new T-shirt, but she was shaking badly when she approached the body. This time the body seemed different. Mimi's breasts were soft, as if they were an old woman's, and her torso was limp, but when Joyce pulled the panties on, she was surprised that from the waist down, her body was as hard as iron. The girl's hair had been cut short, but it looked as if it was growing. Joyce began wondering why her hair was so short, why the breasts were like that, and why she was not completely stiff like a dead person should be? Her suspicions that Mimi was not really dead were strengthened.

After the church service, the schoolchildren proceeded to the grave-yard on foot. They sang, 'Mimi, we loved you. Mimi, we loved you,' as they danced the militant toyi-toyi all the way to the cemetery. It was a large funeral with two bishops, three priests and several church choirs at the graveside. Joyce thought it was wonderful, except that it hurt so much because it was Mimi who was being buried.

The following day, Joyce and the family had to perform the traditional cleaning that follows a death – washing the blankets, linen and clothes of everyone in the house. Joyce returned to Soweto and went to see sangomas again, but different ones each time. It was unsettling and frightening, because they told her the same thing, all of them. They said that Mimi was working for the landlady, running her shebeen for her. Joyce was by now utterly convinced that Mimi was a zombie.

A week later, her Soweto neighbour ran over and told Joyce to switch on the radio, to listen to what was happening in Thokoza. The schoolchildren had caught up with one of the killers. They had tortured him until he gave up the names and whereabouts of the other Bad Boys who had taken part in Mimi's killing. The children hunted them all down, and then stoned and burned them to death. But revenge did nothing to assuage the pain and anguish Joyce felt: she continued to dream of her granddaughter. In one recurrent dream, Mimi asked Joyce to come and fetch her because she could not escape by herself. But when Joyce asked her where she was being held, Mimi would just point, then vanish.

Joyce never accused the landlady of making Mimi into a zombie – she had no proof. Her only hope was to find a sangoma who could break the spell Mimi was under, who could exert enough supernatural power to free Mimi from her captor's sorcery. She spent much of her scarce savings on charlatans who said they could help, but without success. I came to understand the zombie business as Joyce's way of clinging to hope. If she forsook the possibility that Mimi was not really dead, then she would have to face the fact that her grandchild was never coming home again. But Joyce's continued hope that one day her beloved Mimi would return masked a deep despair: 'I know nothing about zombies, honestly. People say that they exist for a long time, until God takes them. Then they die.'

Sometimes I would grow angry with her, hearing of yet another experience of wasted money and dashed expectations. But I came to see that I was wrong, and rather than trying to divert Joyce from her superstition, I learnt that everyone has their own way of dealing with trauma. Joyce's belief that Mimi was not really dead was not so different from my own belief that God would spare my mother from cancer.

# INTELEZI

Death is natural
You are welcome to this funeral

Traditional Acholi funeral song

|||

The constant exposure to war began to get to us. During one of the brief periods of calm following the Boipatong massacre, Joao and Kevin were at Joao's flat smoking dagga and sharing a bottle of bourbon. Joao fumbled to construct a joint. Viv was pretending to be asleep – she was sick of the men and did not want to be included in their drunken talk. The conversation turned to women, relationships and emotional need. Joao was being hardcore: 'I don't need anyone.' (Viv would confront him the next morning about being such an arsehole, and he would contritely apologize.)

Joao was still struggling with the joint and then dropped all of the dagga on to the floor. Joao was taken aback as Kevin got down on to his hands and knees, and began to lick the palm of his hand to pick up as much of the dagga as possible. Joao and Viv had four cats living inside the flat and the thought of smoking the fallen dope disgusted him. Joao threw Kevin the bag of dagga, 'Fuck that, here's more. That shit will be full of cat hair.' Kevin looked at him strangely and said, 'You don't know what it's like being an addict and not having!'

As they shared the cat-hair joint, their conversation moved on. Joao was adamant that there was a price to be paid for the pictures we took. This was something we hardly ever discussed. Kevin was having none of it and he was getting annoyed: 'Retribution? In order to have retribution there has to be a sin!' 'There has to be retribution for the things we sometimes do!' Joao persisted. 'Are you saying what we do is a sin?' Kevin asked.

Joao could not answer, but he felt that there had to be some form of retribution for watching people kill each other through our viewfinders when all we did was take pictures.

That night was the first time that Kevin had admitted to having an addiction to buttons and needing, not just choosing, drugs. Button-smokers crush a Mandrax tablet, a banned tranquillizer, and then mix it with dagga before stuffing it into a broken-off bottle neck. This so-called white pipe produces a powerful rush, often causing the smoker to keel over, before sinking into a couple of hours of sedated calm. Mandrax is not an elegant drug; button-kops (button-heads) share a communal spittoon into which they slobber, spit up phlegm and sometimes vomit.

Kevin was, however, paradoxically affected by Madrax. Instead of the usual mellow downer most people experienced, he got a jolt of energy. He would become all fired up with ideas and emotions. That was one of the reasons why Joao and I never realized the extent of his addiction – I always assumed that he could not be doing buttons when he was so hyper. One day in 1993, Joao went around to Kevin's place. He knocked on the door for a while, but no one answered. He could hear loud music, so he knew that Kevin had to be in. Kevin finally opened the door and Joao was shocked to see that he was bleeding profusely from a cut above his eye. Kevin told him how he had been in Alexandra township and had gone down on one knee to take pictures when a young comrade had come running past and kicked him in the face. The hard edges of the camera had cut him above the eyebrow.

Joao followed Kevin to the backyard where he found a friend of Kevin's, Reedwaan, holding a white pipe, and struggling to keep his

balance. Joao grew a little suspicious – the wound seemed fresh and he could see that Kevin and Reedwaan were swaying all over the place. They offered Joao a bust on the pipe; he refused and left. Years later Joao found a roll of black-and-white film of pictures of Kevin in his backyard posing with boxing gloves and the blood from a cut above his eye running down the bridge of his nose. When we asked Reedwaan, he admitted that the story Kevin had told Joao and the rest of us about the Alex incident had been concocted. Kevin had cut himself by falling into a rosebush in the yard after he had bust a pipe and the rush hit him. Most button-smokers sit down while smoking and let themselves keel over when the drug takes effect, but Kevin would inexplicably stand up and then fall over. This habit irritated Reedwaan because it interfered with his own high – he always had to keep an eye on Kevin. On a couple of occasions Kevin had nearly gone over a balcony while rushing.

By late 1992, Kevin was fast approaching burn-out and we all were pretty strung out. He eased off covering the violence and took up being a late-night disc-jockey part-time. If I was awake at midnight, I would listen to him. He had a good radio voice – warm and rich; sometimes he would say something to us over the air between songs. While he did not leave news-photography altogether, he joined us on fewer dawn patrols – hardly surprising since his radio show ended at five in the morning. Ken had also eased off on the morning cruising, leaving Joao and me to do it alone much of the time. Ken's life was pretty taken up with his work in the photo department at *The Star*, and his marriage to Monica was an intense, claustrophobic affair that naturally excluded the rest of us. But he would sometimes tell us stories of times when their emotions went way over the edge. On one occasion, Ken was on his way to shoot a boxing match in the homeland of Bophuthatswana, an hour-and-a-half drive from Johannesburg. Monica called him and said she wanted him back, I forget the details of why, but she told him that she was going to start tearing up his pictures one by one until he got back. Ken knew she was capable of it and immediately turned around and returned home. In another much-told Ken and Monica incident:

they were having a fight that became nasty. In a rage, Monica began to burn a pile of cash that was in a fruit bowl in the dining-room. Ken had been saving up for an expensive leather jacket and there was a lot of money in the bowl. Crazy as it was of Monica to burn the banknotes, I found it even stranger that Ken apparently made no attempt to stop her. We heard other stories in a similar vein, of broken plates and record collections. Their fights became legendary and whenever they invited any of us over for dinner or a birthday party we never quite knew how the evening would end.

Kevin's love life was just as bizarre as Ken's. He had a thing for a fellow journalist who, though attracted to him, did not want to have a relationship with him. But she liked having him around and while she would not allow him to sleep with her, they would hold hands, kiss, that kind of stuff – the romance without the sex. He was beside himself; the more she played him, the harder he threw himself at her. I was friendly with both of them, but she was of course making his life hell. Joao and Viv, on the other hand, were a stable, loving couple whose only problem was that Viv felt herself being kept at a distance because Joao would rarely discuss the details of what had happened to him during the day. But she preferred it that way – she would have worried far more had she heard the gory details of the township war every day.

We were all doing well professionally. We were good at covering conflict. Many other photographers had covered the violent aspects of the South African story, but most of them didn't last very long, or they kept at an arm's length from the violence. It was possible to cover the news without getting so close that you risked being burnt. There were notable exceptions, and none more than two great black photographers who had been taking pictures for years before I was born. Peter Magubane, 30 years my senior, began as a driver for the internationally famous black South African magazine *Drum*, moved on to being a darkroom technician and, with characteristic tenacity, became a photographer for *Drum* in 1954. In those days photographers had to hide and sneak to get photographs showing the birth of apartheid, exciting but dangerous times. During its heyday in the 50s, *Drum*

magazine photographers would dress up as labourers and smuggle themselves on to white farms and into mines to get pictures of the appalling conditions under which blacks worked. Peter did his share of exposing brutal white farmers, leading to his first arrest in 1963. When he asked why, the arresting white policeman told him, 'You know why you are detained.' He spent 586 days in solitary confinement without ever being charged for a crime. When he was released, the state placed a five-year banning order on him. The ban meant he was unable to take pictures, but Peter was a fighter and he joined the (now-defunct) *Rand Daily Mail* and continued working. He was arrested and sentenced to a further 123 days for contravening the banning order. During the student uprising of 1976, his nose was fractured by the police. Peter thrived on the challenge. His courage was rewarded: in 1980 he was offered a contract by *Time Magazine*. The conflict was to affect him personally: in 1992 his son, Charles, was killed in political violence. As he put it, in an interview soon afterwards, 'Violence is not exclusive and it has claimed many victims at random. My son was hacked and shot in the head like an animal.'

Alf Khumalo was another legendary photographer and a great teller of stories. His favourite memories were of covering the classic boxing match, 'The Rumble in the Jungle', in Zaïre between Mohammed Ali and George Foreman. Ali befriended Alf and he would go visit the boxer in the US. Joao, Kevin and Ken, who at different times all worked with Alf at *The Star*, were a regular audience for his anecdotes, especially during the late shift. While I occasionally had the chance to listen to his favourite stories, they had the bonus of Alf digging into his photo cubicle to show them a negative. Alf would open the door and a pile of negatives and prints would simply slide out from the cubicle, jam-packed with a life's work. But Alf could always find the picture.

Both Alf and Magubane had photographed the Mandelas before Nelson went to jail and they were close to Winnie in the struggle years. They were both still working when Mandela was released after 27 years in jail. At press conferences, Mandela would leave the podium and come over to shake Alf's hand, chatting fondly to the black

photographer with his ancient Nikons and a sports jacket that always refused to match his tie, shirt or trousers. Foreign photographers would click away and ask us, 'Who is that?' and we would laugh and say, 'That's Alf.'

The June 16 Soweto uprising of 1976 saw the emergence of another generation of photographers. One was Sam Nzima, who took what was possibly the most famous South African picture of all time – the broken body of a schoolboy, Hector Petersen, being carried by a weeping classmate after he had been shot by police. The child was bundled into a reporter's Volkswagen Beetle and taken to hospital, but it was too late; Hector Petersen became immortalized as the first to die in the children's revolt against the state. Sam Nzima's picture was sold and resold thousands of times by the newspaper group that owned *The Star* (Nzima had worked for the *World*, banned for its coverage of the 1976 uprising and now defunct), but he never saw a cent until more than 20 years afterwards when he was finally granted the copyright. For Sam the stress of work and the exploitation of his images were too much: he left journalism and became a store-owner in a homeland, helping a relief agency's feeding scheme.

After the Soweto uprising, another generation of politically motivated news-photographers joined the Magubanes and Khumalos, but they were mostly white. The brief period of black renaissance in the 50s that had allowed the potential of black South Africans to blossom as novelists, poets and photographers was inexorably crushed by apartheid. Photo-journalists like Paul Weinberg, Omar Badsha, Gideon Mendel, Giselle Wulfsohn, Guy Tillum and others came to the fore photographing the Struggle. They learnt much from the old-timers: Paul Weinberg never forgot being in Leandra township in 1986 when Magubane saved a family besieged by a mob who were out to kill them. By the time the Hostel War happened, this group had mostly eased off covering the violence after years of struggling with the system and the restrictions imposed during the various States of Emergency that made news so difficult to cover.

Black photographers had the language and cultural skills and contacts

in black communities that allowed them greater insight and access, unlike the whites, who hardly ever understood even one of the nine major black languages. But black photo-journalists were much more prone to harassment by the police – no white photographer was ever detained for 18 months in solitary as Magubane had been. Despite the price he paid for his success, as well as the loss of his son in the violence, he never resented those who achieved acclaim more easily, even if they were white. When Joao won the Ilford Award in 1992, Magubane celebrated by simply picking up Joao and the heavy trophy in his arms like a baby.

In the post-apartheid era that followed Mandela's release, black journalists continued to have it tougher than their white counterparts. The Emergency Regulations restricting the press, pass laws restricting the movement of blacks and detention without trail for political offences were a thing of the past; but the partial tribalization of the Hostel War made working in conflicting zones like walking a tightrope for black journalists. While everyone was vulnerable to the violence, we as whites were exempt from tribal identification. The tribalism of Inkatha and the Zulu-dominated hostels made it very difficult for non-Zulu black journalists to work there safely. But the danger was not restricted to hostels alone.

We found this out the hard way, in 1993, when on an assignment with *Weekly Mail* journalists, one of them the effervescent and dread-locked Bafana Khumalo, in Bekkersdal township, about 80 kilometres west of Johannesburg. Zulus who had fled the war in Thokoza had settled in a section of Bekkersdal, and Inkatha soon launched a branch there. That immediately sparked fighting in that previously peaceful township. We were in Mandela Park, a shanty town on the outskirts of Bekkersdal that was inhabited exclusively by Xhosa ANC supporters. One the edge of the shanty town, we came across a group of armed Xhosa warriors. They told us they were going to 'the mountain'. We were puzzled, as the area was flat, without even a hill to be seen. We followed the group until they led us to a raised mound – just a few feet high. It was the clearing they used for ritual purposes and they called it

the mountain in memory of their hilly home territory. Dozens of men and boys had gathered, singing a melancholy war-song as they walked in a slow circle around the clearing. It sent chills down my spine.

We were very excited. We had heard about the ceremonies in which warriors readied for battle, where they received magic potions from specialist sangomas, but had never before seen one. The protective potion was called intelezi and we had often seen the power of people's belief in its ability to make them invulnerable to bullets or harm. Each sangoma has his own recipe for intelezi, but it must contain human parts, preferably from an enemy killed in battle. The braver the fallen fighter, the more powerful the magic potion. Warriors doused in it were fearless in war.

The light was perfect, the sun slipping partially behind clouds as it sank quickly to the horizon. The warriors passed by the sangoma one by one, allowing him to apply a dark paste to their faces. They ignored us as we encroached closer and closer. I was getting anxious – the light was nearly gone and I felt that my photographs were failing to capture the essence of the ritual. The warriors went around again, this time to be sprayed with a foul-smelling liquid from a bucket. After several more minutes taking photographs, we paused at the edge of the mound, excitedly discussing how privileged we were to see the ritual. But we were also well aware that none of us had shot the perfect picture, despite the great light on this remarkable scene. During the process, we had become separated from Bafana. He was a former advertising copy-writer (one of his gems was 'I'm too smooth and creamy to be a margarine') who had only recently started covering news, and who had moved to journalism because of the Struggle. He had become hooked on the adrenaline: he loved being in the middle of the conflict, watching history being made. If the news editor mentioned the word 'story' Bafana would be there, notebook at the ready, anticipating the chance to go out and cover the violence. With such an attitude, he should have been a photographer.

While we were taking pictures, Bafana had been confronted by some of the comrades who were born in the township. There were two

distinct groups at 'the mountain' preparing for battle. There were rural Xhosas who were taking part in the intelezi ceremony and didn't give a damn if we were there or not; and there were township-born comrades. The latter were living in the squatter camp because over-crowding in the township meant they could not get a brick house to live in and rent charged on the preferable backyard shacks was too expensive for these – mostly unemployed – people to afford. They were archetypal members of the 'lost generation,' caught between the system and the Struggle, having neither education, jobs nor a future beyond angrily hitting back at a repressive state that seemed too powerful to be hurt. These comrades accused Bafana of using their blood to make a living. Two ANC officials were trying to convince these angry young men that the press had a right to be there, sticking to the official position that freedom of the press was guaranteed; but the coms were having none of it.

Bafana had been born in Soweto, but his name and ethnicity were Zulu, and rather than talking his way out of trouble, he was getting in deeper. The Zulu he spoke was rich and formal – proper Zulu, not the abbreviated township version. He had never learnt to speak Xhosa properly; the two Nguni languages of Xhosa and Zulu are mutually understandable and usually it would not have been an issue, but on that afternoon as the Xhosa-speakers prepared for battle against Zulus, it was a potentially fatal distinction. His dreadlocks, earring and fashionable clothes established a class difference between him and the shanty-town residents. They had little enthusiasm for journalists in smart cars who would arrive at their worst moments carrying expensive equipment. We would witness their misery before leaving again with a record of suffering that we would use to make a good living. They did not want us there, they hated us – but it was Bafana they turned on. They were comfortable in threatening Bafana – he was accessible, culturally and linguistically. Bafana understood that they knew that if they killed him, the police would not try to hard to find them: 'One more dead nigger won't make much difference among all the deaths', whereas whites were royal game. Blacks had, for centuries, absorbed the hard lesson that

to harm whites was to invite massive repercussions. For once, Bafana was an outsider. He had always felt that in being a participant in the Struggle, he was a member of embattled communities everywhere, and that he was an honorary member of that squatter community too. They began to accuse him of being a member of Inkatha. That he was black and pro-ANC was not the point, he was an outsider, and they were now labelling him as an impimpi – justification for his pending execution. Bafana was about to become the classic victim of mob justice, of the necklace.

Suddenly Kevin looked up from where he was chatting with Joao and me on the far side of the clearing and cried out, 'Bafana's in trouble!' He had caught sight of the body language of Bafana and the men around him. We rushed to the alley between shacks where a petrified Bafana was being led away by a group of men. Kevin grabbed Bafana by the wrist and began pulling him away, as we talked and cajoled, trying to convince the Xhosas that Bafana, though his name was Zulu, was in no way an Inkatha member; that he was an ANC supporter, a comrade. The men's faces were sullen, filled with hatred, but they let us get Bafana away from them and to the cars. If Kevin had not noticed what was happening, they would have been out of sight a few seconds later. Bafana would have been dead by the time we had finished photographing the ceremony.

When Bafana got back to the office, he wrote a powerful story on what he had seen and then swore off covering violence, conflict or hard news. This was to be his last news piece. He began covering the arts world, as far from the bang-bang as he could get. Bafana had been a true adrenaline junkie, but on that afternoon in Bekkersdal, he saw the logical conclusion of it all: we were living on the violence, feeding off it, and there was only one way it could end.

# FLIES AND HUNGRY PEOPLE

Vulture stalked white
piped lie forever
wasted your life in black-and-white
Kevin Carter

<div style="text-align: right">

from 'Kevin Carter' by the Manic Street Preachers,
Sony Music/Columbia, August 1996

</div>

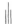

*March 1993*

Kevin's eyes could not be misinterpreted when Joao told him that he was prepared to go to Sudan. Kevin wanted to go too, it was his chance to escape the web of problems he felt trapped in.

For Kevin, the war in Sudan – said to be a genocide of the Christian Dinka and Nuer tribes by the Islamic government – was a chance to free himself of his crazy infatuation. So one-sided was the relationship that a desperate love letter he had dropped off at the woman's house was read out to the guests at a dinner party she was giving, leaving them uncomfortably amused. He also wanted to get off the white pipe. Sudan seemed to present the possibility of making everything right and revitalizing his career, which seemed to have come to a dead-end at the cash-strapped *Weekly Mail*. The newspaper had not been interested in the Sudan trip and insisted he take leave if he wanted to go.

Kevin approached various people for whom he had freelanced in the past. Paul Velasco, then owner of the South African photo-agency

SouthLight (now renamed as PictureNet Africa), advanced him some money, as did Denis Farrell at the AP; he also borrowed some from me. Combined with his salary, this was enough to cover the air ticket and hotel accommodation while still meeting his commitments back home.

Kevin was on a high, motivated and enthusiastic about the trip. He was on the rebound from his spectacularly unsuccessful relationship when he met Kathy Davidson at a party. A good-looking, intelligent and pleasant school teacher – the perfect antidote to his usual choice of hard-edged women. Kathy found him intriguing and attractive, and let him have her telephone number.

For Joao, the excursion was a chance to expand his career. He was still working at *The Star* when a former photographer, Rob Hadley, who had taken a job with the United Nations' Operation Lifeline Sudan project, had offered him and Kevin the chance to get into southern Sudan with the rebels. Joao had jumped at the offer, and began making the arrangements. *Newsweek Magazine* had promised money – a guarantee to secure a first look at the pictures. When Joao approached Ken to get leave for the trip, Ken instead secured Joao an assignment from *The Star*'s foreign news service. If his pictures from Sudan were as strong as those from his self-funded trip to Somalia the previous year, it could lead to other assignments with major international magazines. His dream of being a war-photographer beyond the borders of South Africa had begun to materialize.

Fax messages from Rob stressed the latest downturn in Sudan – the major rebel factions had split into tribally based groupings with the result that entire villages had been massacred by opposing tribal militia, and the government had seized the opportunity to launch a massive offensive against the divided rebels. The part of southern Sudan that Joao and Kevin wanted to get to was an especially vulnerable area in the remote hinterland dubbed the 'the Famine Triangle' by aid workers.

The Southern tribes of Sudan are Christian or animist and had been grouped together under the rebel umbrella group, the Sudanese People's Liberation Army (SPLA). They had been fighting for

autonomy from the Khartoum government, which had been domi-
nated by Islamic northerners ever since independence in 1956. The
low-key war had been spurred to new intensity in the 80s by the
government's adoption of Islamic Sharia Law. The story which Joao
and Kevin hoped to cover was the recent bloody split in the SPLA.
Sudan is a notoriously difficult country to work in, with a government
that refuses journalists entry to the south, and rebels that are either press-
shy or expert at manipulating the prying eyes of outsiders. The breaking
and forging of alliances makes it difficult to predict the situation from
one week to the next, and aid organizations have great difficulty in
getting food aid in with any regularity.

Kevin and Joao prepared carefully for the trip. The day before they
left for the Kenyan capital of Nairobi – the best transit point for trips to
southern Sudan – they met at Kevin's rented house in the Johannesburg
suburb of Troyeville. Kevin's entire bedroom was covered by
numerous packets and bags. Ken had accompanied Kevin on a shopping
trip for everything from mosquito nets to dehydrated food – they did
not know what they might need. Joao and Kevin sat on the bed,
laughing and excited, and shared a joint. Ken was drawn into their
excitement, and took a picture, then left them to finish their packing.

The next day, after a five-hour flight north, Kevin and Joao arrived
in Nairobi and went to the Parkview Hotel, one of the cheaper, rather
dingy, hotels that cater to backpackers and other budget travellers. To
economize, they shared a room that enjoyed a view of a muddy alley.
The telephone only reached as far as the lethargic receptionist and there
was no television.

It was a Sunday in Nairobi and deathly quiet. They went for a walk,
Kevin hyper-active, striding and talking fast. They ended up drinking
beer on the colonial Oaktree Hotel's veranda, watching the tropical sun
set over the city. Kevin was excited and happy to be in Nairobi, and
they were both looking forward to getting to Sudan.

The next day things started going wrong. Kevin tried to change a
100-dollar bill and the bank rejected it – it was a counterfeit. They
contacted Rob at the Operation Lifeline Sudan headquarters at Girgiri

on the outskirts of Nairobi, but further disappointment was in store for them. The plan had been that they would fly in on a food drop, and spend about a week on the ground before being picked up on the next food delivery, but an upsurge in fighting meant it was unsafe for the planes to land, and the aid flights had been suspended. Their trip was put on hold – indefinitely.

Every day they went out to the UN compound to see if the situation had changed, but for five days they got the same negative answer. The disappointment built up in the tiny hotel room. Joao was furious, unhappy. All his careful planning was going down the toilet. Time passed slowly and painfully; they spent sparingly and ate in increasingly cheap restaurants. They did the rounds of the aid agencies, to see if any of the other organizations were flying in, despite the fighting. They abandoned the more expensive personal taxis and began using matatus – the colourful local minibus taxis which pack in up to 20 passengers. The drivers seemed to be in competition as to who could fit the largest disco speakers in their vehicles. When the buses were very full, the speakers would serve as seats, and on one such crammed trip Kevin had to sit on a speaker. The reggae that blared out of the speaker was too loud for anyone to speak and be heard, so Kevin sat back with an amused look of contentment, and took the occasional picture through the window with his cherished old Leica M3.

In spite of their lack of progress, Kevin was having a good time. All he could talk about was how this trip was going to work out and how everything was going to be great. He made plans to resign from the *Weekly Mail*, go freelance and pursue a relationship with Kathy – get some stability in his life. Joao, on the other hand, was uptight. The pressure was getting to him, he had sold the trip to *The Star* and *Newsweek* on the strength of combat images, and there he was, stuck in Nairobi with little hope of getting near the fighting any time soon.

Then suddenly there was a UN trip to Juba – a besieged, government-held town in the south of Sudan. A barge carrying food aid had been travelling up the Nile and had finally made it to Juba. It was an 'in-and-out', a one-day affair. Since Kevin had the guarantee from

the AP, the UN put him on the plane flying in. There was no room for Joao, who had to stay behind. He was livid. Joao had done most of the preparatory work, set up the main part of the trip, and Kevin, who had mostly just followed his lead, was getting into Sudan while he cooled his heels. He assumed the worst: this was it – there would be no other chance to get to Sudan and he would return home without having shot a frame.

What Joao and Kevin did not know was that the UN was having great difficulties in securing funding for Sudan. An appeal earlier in the year for 190 million dollars had barely raised a quarter of that. The UN hoped to publicize the famine in which hundreds of thousands of southern tribesmen faced starvation. Without publicity to show the need, it was difficult for aid organizations to sustain funding. There is nothing like a disaster to boost an aid agency's profile, and they needed to have the media cover the existence of the emergency. There are those who insist the war in Sudan would have ended decades ago if food and other aid had not been allowed to sustain the fighters; that the aid agencies and their food were manipulated, used by both government and rebels as a weapon of blackmail against the civilians in their areas of control, but Joao and Kevin knew none of this – they just wanted to get in and shoot pictures.

Kevin flew off to Juba while Joao sat brooding in the depressing hotel room. It was still daylight when Kevin returned. The trip had been a waste of time, he told Joao. They had landed, been taken to a pier on the While Nile, shown a barge with food being unloaded, suffered through a press briefing – and that was it. Despite the barge having had to travel for two months up the great river, during which it had been raided for over half of its cargo by famine-stricken people on the way, the only half-way interesting pictures Kevin found were of children scrambling for some grain that had spilled on to the dock. Kevin tried to alleviate Joao's sour mood by showing him the negatives to prove just how useless the trip had been. Though Joao realized he had missed nothing, the knowledge did not make him feel any better. Joao was given to omens and they were looking pretty bad at that moment.

They decided to give it two more days and if nothing changed, they would head home. But then they received the news they had been waiting for: one of the rebel factions had given permission for the UN to fly in. In addition to the cargo plane carrying the food, Rob was going in on a light plane to assess the situation on the ground. Joao and Kevin were welcome to join him, but there was no guarantee as to when they could be picked up again. The following afternoon they were in the air, once again buoyant at the change in their fortunes. Three hours later, they landed just inside Kenya's northern border, at the settlement of Lokichokio, just a few hundred metres from Sudan. Lokichokio was a tent-city, an UN forward-base for the big Hercules cargo aircraft that flew food and medical supplies into the famine areas.

Kevin and Joao were allocated a tent, then they had dinner out in the open, under a crystalline African sky. Dinner was good and the beer was cold, and they hoped to have more under the seamless canopy of stars, but the bar closed soon after ten. Back in their tent they could not sleep – too much excitement, too many thoughts of what might happen to them tomorrow.

'What do you think is waiting for us there?' Kevin asked, his voice loud in the dark silence that had settled on the camp. Joao could see Kevin's profile, lit by the glowing tip of his cigarette.

'Flies and hungry people, from what I've heard,' Joao replied.

Their conversation skipped from topic after topic, but unlike all other similar conversations Joao had persevered through with Kevin, this time it was all positive. No self-indulgence, no self-pity. The future looked bright: Kevin was confident that the trip would be successful, that he would be able to cover his costs and make some money. This new girl, Kathy, was going to be just right for him. But mostly they spoke about South Africa, their work, the violence and where the country was heading in the coming years and the upcoming vote. The first elections that all South Africans could finally take part in were just 13 months away.

The conversation came around to Kevin's tattoo. He had a

misshapen map of Africa drawn on his right shoulder, clearly the work of an amateur. Joao told him he had seen better tattoos on convicts. Joao also had a tattoo on his right upper arm showing a winged angel, with the motto ACCEPT NO LIMITS on unfurled scrolls. It was also less than fantastically well drawn, but it was a work of art compared to Kevin's.

After a lengthy discussion of tattoos, they decided Kevin's should be re-done, reshaped so that the continent would look like the real thing, all in black, but with a single red tear coming out of South Africa and spilling on to his arm. The tear would somehow signify Kevin's own pain as well as the pain of those whom he had photographed. They laughed that it would at least look better than his current tattoo. The pilot, who was trying to sleep in the adjoining tent, pleaded with them to keep quiet. They lowered their voices, noticing that dawn was not far off – they could hear the sounds of workers preparing breakfast.

Two hours later, their plane touched down in the tiny southern Sudanese hamlet of Ayod. It taxied to a halt at the end of the dirt airstrip and the pilot turned the plane in to position for a quick take-off, should it prove necessary. Half-way through the turn the front of the little plane lurched to an abrupt halt. They climbed out and saw that the front wheel had sunk into thick sand and the plane was stuck. It was nothing serious, the plane was undamaged, and they had started to push it out of the beach-like sand when they saw the massive cargo plane approaching. The cargo plane was making its approach for descent. Fortunately, dozens of Sudanese had come to greet the plane, the sound of aircraft meant food, and they quickly helped to wheel the little plane off the runway, averting what could have become a complicated situation.

As the cargo plane landed, its giant propellers raised a storm of sand and pebbles. The Sudanese crouched low alongside the runway, braving the hot, stinging blasts to be nearer the food. There is never enough food in these circumstances to feed everyone and the hungry villagers rushed the plane to try to ensure that they got their share of nutritious biscuits and maize meal. Those too weak to get to the runway

had to rely on the aid workers for food. Some 200 metres from the runway, a low brick building from which the food aid was distributed stood out among the surrounding conical huts made of long thatching grass. That was Ayod. The first food consignment after months without aid attracted a pushing crowd of hungry Sudanese. They wore patched rags or walked around naked. Mothers who had joined the throng waiting for food left their children on the sandy ground nearby. The small food aid building also served as a clinic and was full of ill and starving people. There were those who needed special care if they were to survive, and others that could only be comforted before they died. Kevin and Joao separated. There were pictures everywhere. Once in a while, Kevin would seek out Joao to tell him about something shocking he had just photographed. In one of those foul-smelling rooms, Joao saw a skinny child lying spread-eagled on the dirt floor. It was dark and he struggled with the light, trying to get a frame. Kevin joined him and went down on to his knees to shoot the picture; he then looked up at Joao, wide-eyed. Despite all the happy anticipation of the night before, all the excitement had disappeared now that he was witnessing the effects of the war-induced famine.

Joao left the room. He wanted to find rebel soldiers who could take him to someone in authority. Their plane would take off in an hour and they needed to secure rebel permission to stay on. Joao found a group of fighters. They were dressed in rags, the only indication that they were indeed soldiers were the AK–47 assault rifles hanging limply from their shoulders. Kevin joined Joao and they tried talking to a rebel with deep traditional scars etched vertically on his cheeks, but the fighter spoke no English and communication rapidly broke down. They kept frozen grins on their faces as they tried to mime their way through the conversation. The only thing that was apparent was that the rebel had developed an interest in Kevin's wristwatch. Somehow, Kevin gave the rebel his watch. Joao was surprised, but understood Kevin to be giving the soldier the cheap watch in an effort to ease his conscience about all those hungry people he could not help – or to secure goodwill to help them get across to the fighting.

They separated again. Joao photographed a half-naked man walking past him, completely oblivious to the white stranger. He went back inside the clinic complex, where he was told that permission to stay had to be obtained from the rebel commander, Riek Mashar, who could most probably be found at Kongor. This was good news; their little UN plane was heading there next.

Joao left the cool of the clinic and returned to the harsh sun and headed in the general direction of the runway, to where he had last seen Kevin. He came across a child lying on its face under the hot sun – he took a picture. Joao assumed the child had been left there by its mother while she went for food. He moved on to where he could see a man on all fours, digging at the arid soil with a hand tool of some sort, trying to plant seeds in the desiccated ground, hoping that the rains would ultimately arrive. Kevin had seen Joao and was coming towards him, moving fast, frantic. 'Man,' he put one hand on Joao's shoulder, the other covered his eyes. 'You won't believe what I've just shot!' He was wiping his eyes, but there were no tears, it was as if he was trying to obliterate the memory of what he had photographed, of what was burnt on to his retina.

Joao gave him a look. He didn't like this 'I-shot-shit' at the best of times, much less when he had not seen any outstanding picture opportunities, but Kevin continued, not even noticing his friend's sceptical look. 'I was shooting this kid on her knees, and then changed my angle, and suddenly there was this vulture right behind her!' Kevin was excited now, and talking fast. 'And I just kept shooting – shots lots of film!' His arms were all over the place, as they usually were when he was recounting something exciting.

Joao perked up, 'Where?' looking around, hoping to catch up on this amazing-sounding scene. If it were still there, he needed to shoot it. 'Right here!' Kevin said, pointing frantically fifty metres in front of them. Joao could see a child lying face down on the dry, grey-brown soil. The child looked similar to the one Joao had photographed a little earlier, but there had been no vulture near it then, and there was none now. 'I've just finished chasing the vulture away!' Kevin's eyes were

wild, he was speaking too fast, and losing words. He kept wiping at his eyes with the green bandanna he wore around his neck. 'I see all this, and all I can think of is Megan.' He lit a cigarette and dragged hard, getting more emotional by the second, the thin grey smoke disappearing into the air. 'I can't wait to hug her when I get home.'

Joao sensed immediately that he had missed out on a big moment, and, imagining what the picture would look like from Kevin's description, knew his own take was going to look bad. Joao consoled himself with the thought that Kevin always got overly excited. He, on the other hand, had nothing to get excited about at all. But he was prepared to wait and see the pictures, being used to watching Kevin get electrified about images that sometimes turned out to be very average. Minutes later, they were back in the plane and leaving Ayod behind.

Kevin was telling Rob and the pilot all about the moment he had just experienced and how it made him feel, and that all he could think of was his own fortunate young daughter back home. He repeated how much he looked forward to seeing her, to hugging and kissing her. 'Just five minutes in Sudan and he is blabbering about how terrible it is and how he'd never seen anything like it, all because of war,' Joao thought. Up in the air, away from the realities, Kevin's mood improved and he seemed a little happier. The realization of what he had shot was seeping in, for both Kevin and Joao. Joao sat quietly in his seat, withdrawn, disappointed and wishing he were elsewhere. The flies that had persistently followed them at the camp took off with them, making themselves at home in the plane. 'So far my prediction is right,' muttered Joao miserably to himself; he felt he had nothing but pictures of some hungry kids and half-naked men with guns. 'Flies and skinny people.'

In New York, four years later, Nancy Lee, then *The New York Times* picture editor, bought me lunch and told me about how the vulture picture came to be published in the *Times*.

'It all started when we were trying to illustrate a story out of the Sudan and it was really hard. Very few people got in. Nancy Buirski

called around. She called you and you said Kevin had pictures.'

That phone call from *The New York Times*'s foreign picture editor Nancy Buirski had come late at night, waking me with its insistent ringing. There are few things I hate more than those late-night calls – people seem to ignore time differences, and I am partial to my sleep. Nancy Buirski wanted to know if, by any chance, I had recent pictures from Sudan. They were doing a story and needed to illustrate it. Their Nairobi correspondent had been in Juba when a food aid barge had arrived after 59 days of arduous and dangerous travel up the Nile. (It was the same barge Kevin had flown in to photograph, before he and Joao had both finally flown in to Ayod for those few, fateful hours.)

I told her that I had never been there, but that a friend of mine had returned from Sudan just a few days earlier with a great picture: an image of a vulture stalking a starving child who had collapsed in the sand. Was that the kind of thing they were interested in? From what had been a long-shot phone call, suddenly Nancy got excited. I gave her Kevin's phone number. I had a strange feeling, a kind of jealousy, an envy, about introducing that picture to people. I, like many others, knew that it was going to be a massive picture and had been telling Kevin that, encouraging him to make the most of it, but when Nancy Buirski called me, I had a moment when I thought about not telling her of it. It was silly, and just a fleeting thought, maybe because he had shot it with a lens borrowed from me, maybe because I liked being the only South African Pulitzer-winner. In reality, I did not hesitate in telling her about Kevin's vulture picture, but the selfishness of that short-lived, regretful thought has stayed with me, bothering me.

When that picture and a selection of others were finally transmitted to the *Times*, Nancy Buirski was waiting at the machine for it to roll off. Nancy Lee says she cannot forget the moment when she first saw the vulture picture – the *Times*, at that time, still had the old-style wire machine which would suddenly spit out prints, one at a time. Once she saw the picture, she instructed Buirski to make sure that Kevin not sell it to anyone else before they had published it.

Nancy Lee recalls that after the picture ran, people started calling.

There was a lot of interest in what had happened to the girl. So she called Kevin and asked him. He said she had continued on to the feeding station. 'Did you help her?' 'No, she got up and walked to the feeding centre, we were very close, within sight of it.' 'So you didn't do anything, you didn't help her?' 'No, but I know she made it, I saw her.'

The *Times* then ran an Editors' Note saying that the girl had made it to the feeding station. But Nancy Lee was still unsatisfied, 'I remember Nancy Buirski and I both felt uncomfortable. If he was that close to the feeding station and the child was on the ground, then, having taken the picture – which was, I think, important to do – why had he not gone there and got help? What do you do in cases like this? What is the obligation of any news professional in the face of tragedy in front of them? I don't know; I have a humanistic feeling about it and a journalistic feeling about it. If something terrible is about to happen and you can stop it, if you can do something to help once you've done your job, why wouldn't you? It bothered me, as a person. He could have done it, it would have cost him nothing. She would have weighed something like ten pounds. He could have picked her up and carried her there, could have gone there and got someone to come back and help her, whatever.

'I don't like to judge people, I was not there, I do not know what the situation was, I don't know. But I would have helped the girl, me, as a person.'

Editors' Note

A picture last Friday with an article about the Sudan showed a little Sudanese girl who had collapsed from hunger on the

trail to a feeding center in Ayod. A vulture lurked behind her.

Many readers have asked about the fate of the girl. The photographer reports that she recovered enough to resume her trek after the vulture was chased away. It is not known whether she reached the center.

# 'IT IS GOOD THAT ONE OF YOU DIES'

We are telling you that people are being destroyed;
We are from the South, where guns cry.

<div style="text-align: right">Songs from the Struggle</div>

|||

*9 January 1994*

I spent the second half of 1993 in Bosnia, chasing pictures in mountain valleys and deserted villages. In September I decided to take a short break and flew to New York City to try to secure an assignment for the upcoming South African elections. My first choice was *Time Magazine* – the Rolls-Royce of news magazines as far as photographers are concerned. But the picture editor in charge of international coverage, Robert Stevens, said it was too early to make a decision. In any case, they had Peter Magubane and Louise Gubb, both respected South African photographers, and their top war-photographer, Jim Nachtwey, was also coming in to cover the election for the magazine. Disappointed, my next stop was *Newsweek Magazine*. The then photo director, Jimmy Colton, agreed to a contract for the election period – guaranteeing at least six days work a month; though in reality this would work out to be every other day and more in the frantic build-up. It was a good gig – there were going to be a lot of photographers out there and to have secured something was important. I went back to

Bosnia, doing work mostly for *Newsweek*, *Time* and the AP until the end of the year.

In January of 1994, I spent a few weeks in Somalia for the AP covering the withdrawal of US forces. From Mogadishu's Sahafi Hotel, I spoke to Robert from *Time* again. This time, he asked me if I would work for them during the elections in South Africa. I was exasperated and told him I would love to but that I had already committed to *Newsweek*, and it would be unprofessional to switch now.

I knew I was making the wrong choice. The reason for my unease about working with *Newsweek* as opposed to *Time* was one of corporate culture. I felt unsure that *Newsweek* were the right people to back me up in what was a potentially dangerous story: in Bosnia, I had done work on guarantee for *Newsweek*, covering the Muslim–Croat conflict, a nasty war where a drive along a valley road saw you cross front-lines several times, and came to experience the difference between *Newsweek*'s attitude as opposed to that of their great rival, *Time*. I had asked if I could hire a 'hard car' – a bullet-proofed vehicle that would dramatically increase my safety, and give me an advantage in getting pictures. *Newsweek*'s answer was no; they suggested I get a ride with someone who had a hard car. This meant asking Nachtwey, the *Time* photographer, if I could ride with him. Given our friendship, it was unlikely he would refuse, but it also meant that whatever advantage *Time* had had from spending over $1,000 a day on a hard car might accrue to me – the competition. When *Time* assigns photographers to a war zone, they make sure that there is as little extra pressure put on them as possible. They spend money to get the best pictures and safeguard their photographers, even if they are just freelancers. An assignment is an agreement to temporarily employ you on a fixed day-rate, pay all your expenses and accept responsibility for you in case something happens. *Newsweek*'s method was to give freelance photographers a guarantee that would cover expenses, day-rates and car-hire. The guarantee system could put a few dollars more in your pocket if you stayed in cheap hotels and skimped on expenses. It was quite different to being on assignment.

The system of guarantees had evolved as a hands-off way of getting photographs. The company is allegedly less liable if someone gets hurt or killed while on guarantee than if that person is on assignment. Photographer-lore has it that *Newsweek* had instituted the system after photographers working for them had been expensively hurt or killed.

I was still in Somalia when I learned that Abdul Shariff, a South African photographer, had been shot dead in a township while stringing for the AP. I did not know Abdul well, but he was a likeable guy with a very good eye. Abdul's death happened on a sortie into Kathlehong with ANC leaders, a trip which none of the journalists had foreseen as dangerous.

The election dates, 27 and 28 April 1994, had finally been set the year previously, following nationwide outrage, and the threat of civil war, after the assassination of the popular Communist Party and ANC armed-wing leader, Chris Hani, by a right-wing white fanatic on 10 April 1993. It was a classic confrontation of good and evil, whichever side you were on. At that time, it had seemed as if everyone was holding their breath waiting for the country to explode, but the ANC and Communist Party leadership called on their supporters to exercise restraint. The police acted swiftly on information supplied by one of Hani's white neighbours, and the Polish-born assassin and his accomplices, including a leader in the far-right Conservative Party, were arrested. This was followed by the announcement of the election date, and the expected explosion failed to materialize. But the announcement of a date raised the stakes for those who did not want fully-democratic, non-racial elections. Political violence increased steadily over the next 12 months as the elections approached.

The continuing violence had disrupted communities so seriously that senior ANC leaders were planning to go to Kathlehong, one of the trouble-spots, in a show of support for the residents, most of whom were ANC supporters. The politicians were fearful that the township war would prevent campaigning and, more worryingly, voting in the upcoming April elections. Political violence was escalating as parties which were willing to take part in the election stepped up their

campaigns. On the other hand, Inkatha and various right-wing groups – both inside and outside of the parliamentary system – which were all refusing to participate, busied themselves with training and organizing hit squads to disrupt the election. These groups had pinned their hopes on widespread disruption, bordering on civil war, forcing the transitional government – made up of the ANC, the ruling white National Party and centrist parliamentary parties – to accede to their demands of a more federal constitution and white homelands. But there was also the added complication that some ANC self-defence units were out of control – terrorizing their own communities and fighting turf-wars with other comrades. Some of the units had been infiltrated by police operatives, who used their cover to sow further confusion. The ANC leadership wanted to be seen to be dealing with the problem. They had ensured that every media organization knew about their visit to the heart of one of the dead zones in the townships. They expected the visit to be good public relations.

So, on 9 January 1994, dozens of journalists were waiting outside Shell House, the ANC headquarters in downtown Johannesburg, preparing to join the caravan of cars heading out to Kathlehong. AP reporter Tom Cohen had agreed to meet Abdul at the ANC building. Abdul, of Indian Moslem descent, was a lithe, dark man with a black beard. He had moved up from KwaZulu-Natal to work in Johannesburg and had recently started stringing for the AP. He was extremely serious about what he did; as Tom put it, 'He was not one of these jerks that just went plodding in there, taking pictures. He was sensitive and very much aware of the implications of things.'

'Did you bring the vests?' was the first thing Abdul had said by way of a greeting. Tom was amazed that Abdul thought they would need bullet-proof vests for what would surely be a simple enough assignment. 'No, I don't think we'll need vests. But they're at the office, we can go and get them – we have time.' Abdul demurred, 'Never mind, it will be fine. We probably don't need them.' A little joking started among the group of journalists that were around them. 'This will probably be the day one of us gets it,' cracked one of them. Tom joked

that he would probably have to write Abdul's obituary. Abdul laughed uncomfortably.

Joao, Kevin and Gary Bernard (now a staff photographer at *The Star*) were already in the township. They were with David Brauchli, an American photographer with the AP who had based himself in Johannesburg months ahead of the election. He was a bang–bang kind of photographer and naturally became friendly with the boys. He had quickly realized that Joao was the best local photographer available and persuaded the AP to offer Joao a good contract and the possibility of covering foreign wars. The offer was irresistible and Joao left *The Star* in mid-January. Ken was still at *The Star*, but he was also planning to leave the newspaper after the election, though not many people knew. He wanted to move beyond the restraints of working for a daily and longed for the freedom of spending weeks on a single shoot. Kevin's self-esteem was high on the praise that followed publication of the vulture picture and he had grown confident that he could make it as a freelancer. And so, he'd left the *Mail* to string for Reuters.

Tom and Abdul followed ANC leaders Cyril Ramaphosa and Joe Slovo to Kathlehong, where they were expected to do a standard brief walkabout and then deliver speeches at the local stadium. Instead the politicians parked on an uneven dirt clearing that served as a soccer-field and immediately set off down the middle of the road towards the hostel.

The journalists, caught unawares, had to hurry to catch up, jumping to avoid the muddy puddles left by overnight rain. As they neared the Inkatha stronghold, shooting broke out. ANC bodyguards closed to form a shield around their charges and hurried them away from the danger zone. ANC self-defence unit members emerged from the front-line houses and returned fire towards the dormitory complex. Tom took cover with the others in the last of the vandalized houses that faced the hostel. For several minutes, there was just the rattle and crack of automatic gunfire as comrades would race up to the edge of cover and blindly spray bullets in the direction of their Inkatha foes.

Abdul decided to cross a clearing between the front-line houses. He was half-way across when he was hit in the chest by a bullet and fell.

Young township residents broke cover to carry him away, in great pain, but still alive. The battle continued with ANC militants passing battered Kalashnikovs between them. They fired from the hip, the bullets going in all directions. Tom was completely unaware of what had happened to Abdul and was concentrating on moving safely away from the battle.

Joao, Kevin, Gary and Brauchli had earlier that day heard of a shooting incident in neighbouring Thokoza and had driven off to see if anything further was happening there. Nobody had envisaged trouble starting at the ANC walkabout, given the massive police presence. The cruise was fruitless as all was by then quiet in Thokoza, and so they decided to join the ANC delegation. As they neared the soccer-field in Kathlehong, they saw Reuters photographer Juda Ngwenya race past with his car full of comrades, some of whom were hanging dangerously out of the windows, waving traffic out of the speeding car's path. They were curious, but assumed that Juda was taking a wounded combatant to the nearby Natalspruit Hospital. Their relaxed mood evaporated; something was going down, but since they did not know what, they decided not to follow Juda. In the residential area near the hostel, comrades were milling about and journalists were standing around looking shocked and frightened. Some of the journalists were inter-viewing one of the politicians. Joao shot a few pictures and asked a cameramen what had happened. He said a photographer had been shot – it was the little Indian guy, but he didn't know his name.

With a jolt, Joao realized that it could have been Abdul whom Juda had been taking to the hospital and they quickly headed there. At the casualty room, several people were being treated, but Abdul was not among them. Joao asked a nurse if she had seen a wounded journalist being brought in. She stared at him and then said, 'He was dead on arrival. Could you please identify the body?'

Joao and the other photographers followed the nurse through casualty to the rear, where she opened a door that led into a tiny room. It was a laundry closet, the shelves lined with linen and hardly big enough for the metal gurney to fit in it. Soiled laundry was piled up on either side of the stretcher and bright sunlight streamed in from a small

high window at the far end of the narrow room. On the gurney, a green sheet covered a human form, its head nearest Joao. The nurse pulled the sheet aside. It was Abdul. It seemed as if he was asleep, but then the nurse pulled the sheet further down to reveal a hole in the centre of his naked chest. It went through Joao's mind that the wound looked remarkably neat, that it seemed to have done so little damage. Without a thought or a moment's contemplation, Joao lifted a camera and shot a frame. The nurse was angry, astonished, and tried to stop him. Joao exploded: 'If I can take a picture of all the fucking dead people in this country, then I can take one of my friend.' He turned and stalked out, and only later when he processed the film did he discover that he had shot the picture without setting exposure and the neg. was completely underexposed. Secretly relieved, he threw the roll into the dustbin.

By that time Tom had also heard the news that an Indian photographer had been shot and taken to hospital. He tried to tell himself that it was not necessarily Abdul, but he rushed to the hospital to check. Tom arrived at casualty as the photographers were coming out. Brauchli said, 'Abdul's fucking dead; he's fucking dead.' 'What?' was all that Tom could muster. He thought that perhaps they had not seen the body and there was some mistake, so he insisted on going in to look for himself.

Afterwards, he could not get the image of the wound in Abdul's chest out of his mind. He kept reliving the exchange about the bullet-proof vests from that morning and he could not avoid the fact that the wound was exactly where the ceramic plate of the bullet-proof vest would have been. But he also had to get a story out: it was a major news event and the AP had not yet filed. It was the AP's photographer who had been killed and the other wires were going to beat the AP on its own story. And there was still Abdul's obituary to write.

I returned from Somalia a month later. That day, Joao and Gary picked me up and we went to Kathlehong to see where Abdul had been shot. As we crossed the invisible boundary from Thokoza into Kathlehong, we stopped at a shack that served as a self-defence unit base, to see what was going on. There we met Distance, a hardened

ANC fighter with the looks and physique of an adventure movie-star. It was a quiet day and one of us mentioned Abdul. Distance looked at us and then said: 'I am not sorry your friend Abdul was killed. It is good that one of you dies. Nothing personal, but now you feel what is happening to us every day.'

# REVOLUTION

If he is alone, don't mind him;
If there are two, they are just discussing their own affairs;
If there are three, they are planning something;
If there are four, they are communists. Shoot them.

Bophuthatswana homeland President Lucas Mangope's alleged instructions to his security forces after a failed ANC-led coup.

|||

*March 1994*

In the twilight of the great apartheid experiment of trying to make South Africa's black population legally non-South African — by assigning them to ten ethnically-based homelands — Bophuthatswana was the most Frankensteinian of its issue. The homelands were the culmination of a disastrous philosophy to separate white- and black-owned land — to the detriment of black people. Some 3.5 million people were often forcibly uprooted and dumped into the patchwork of 'independent' and self-governing states – the homelands. By the time Mandela had been released, and the ANC unbanned, the homelands were in the process of being reabsorbed into South Africa, but Bophuthatswana's leader was refusing to relinquish its dubious sovereignty. The black Tswana homeland's repressive and ill-humoured president, Lucas Mangope, had over the decades proved himself the ideal puppet to the apartheid state. Cloaked in the make-believe garments of independence, the lucrative fantasy realm was to prove maddeningly difficult to disassemble.

His subjects, the Tswana, were traditionally a farming people. From the 50s onwards, their land had been incorporated piecemeal into a homeland that resembled an unfinished jigsaw-puzzle. Entire communities were forced to leave their villages and farms in 'white' South Africa, victims of 'black spot removals', the technically legal South African version of ethnic cleansing, and been resettled in distant tracts in the middle of the bush.

Bop – as Bophuthatswana was frequently called – lay west of the climatic divide where drought shifts from a periodic hazard to an ever-present menace. Which was, of course, precisely why it been located there. The fertile bushveld thins as one follows the afternoon sun. There, driven by a nostalgic desire for the days of self-sufficiency, the displaced peasants planted crops that withered on the stalk in postage-stamp fields and kept stock beyond the carrying capacity of the land.

The previous decade had been one of particularly severe drought. Every blade of grass had been devoured by the herds of emaciated animals roaming from mud-brick village to bone-dry field in search of nourishment. The thin layer of topsoil blew away at an alarming rate. In an effort to halt the erosion, the Bop government had ordered the sale or destruction of the numerous donkeys which were used to pull the four-wheeled carts. Unable to get a decent price in an overwhelmed market, the peasants hid their donkeys and waited for the storm to pass, but police teams were sent to locate and shoot the beasts. The donkey became one symbol of Mangope's rule and his subjects said that the donkey massacres would return to haunt Mangope. But it was the avocado pear which was to be adopted as the symbol of resistance.

A village meeting, held in the late 80s to oppose the forthcoming forced incorporation of the two tiny black farming communities of Braklaagte and Leeufontein into the homeland, was broken up, unsurprisingly, by Bop police. But, instead of the usual one-sided cakewalk, a villager threw a hand-grenade into an armoured personnel carrier. Several policemen were killed in the steel casket and the inevitable crackdown followed.

Months later, at another tense meeting held under the mistrustful

eyes of the police, a departing villager lobbed a dark green avocado through the open hatch of an armoured vehicle. The panicked policemen dived out of the vehicle without thought of retaining their dignity. The humble avocado had become a weapon, as well as a lunch favourite among tickled activists.

In March of 1994, just over a month before South Africa's first nonracial elections were due to be held, Mangope was still insisting that the ANC was a banned organization, four long years after South Africa proper had legalized the liberation movement. Aware that a fair poll would see him unceremoniously dumped, he announced that there would be no general election in his fiefdom. Bop residents, emboldened by the new-found freedoms across the 'border', rioted against the decree. Mangope was nervous and his notorious policemen seemed less than enthusiastic about quelling dissent, perhaps eyeing the changes next door and worrying about their futures.

In 1988, elements in the military had staged an abortive coup under the leadership of a man optimistically called Rocky Malebane. Mangope called on Pretoria, which sent in the South African Defence Force to crush the mutiny. But in 1994, he could no longer rely on the apartheid government, which had its hands tied in the uneasy transitional power-sharing with Nelson Mandela's ANC.

Ken, Kevin and Joao were in Bop to photograph the unrest that had started at the university on 10 March and spread through the captial. The end of Bophuthatswana was clearly imminent. That afternoon, Joao and Kevin had to take film back to Johannesburg; Ken had a transmitter, so he did not also have to make the journey. Joao and Kevin were planning to return early the next day, but both were replaced by more senior agency photographers. Kevin was furious that a Reuters staffer had been sent to Bop when he felt that the story rightly belonged to him, and he decided to go back the next day anyway. Joao was pissed off because he had been assigned to shoot a Mandela gig in the morning. Brauchli, as the more senior AP photographer, had been assigned the job, while Joao had to cover the more mundane event, before being able to return to Bop.

Heidi and I had woken very early on 11 March to leave for Bop. We were on the last stretch of the 300-kilometre drive from Johannesburg to the twin towns of Mafikeng and Mmabatho and a cool dawn picked out the thorn trees along the road. I was watching the fuel gauge drop faster than the signposts could count the kilometres down. Something was wrong with the car, which was finally rebelling against the punishment of following the election campaign and years of abuse while I chased pictures. I tried to keep the revs as low as possible, but the chances were good that we might not make Mmabatho without refuelling.

The rural petrol station-cum-trading-stores we passed, spaced progressively further apart as we headed deeper into the dry west, were all shut. In desperation, I turned into a mine-housing compound in search of someone to sell us fuel. A hastily-dressed Afrikaans women showed us the home of the foreman. He could help, she assured us. Despite the early hour, the little community was abuzz with activity. Inside the small, over-furnished house, the foreman's wife was talking excitedly on the phone; 'Everyone's been called up,' she said into the receiver.

I was startled. The situation in Bop, just a few kilometres away, must have worsened if the army was calling up reservists. Perhaps the South African government had decided unilaterally to take the homeland back under its control in an attempt to quell the unrest and ensure that next month's poll could take place. Her husband wiped shaving-cream from his throat and nodded a curt greeting to me, then disappeared back into the bathroom to finish his toilet.

'There are people coming from Rustenburg, Ventersdorp, even Witbank,' she continued in Afrikaans, her voice trembling. I realized that she was not talking about the South African Defence Force, but white supremacist militias, raised in those predominantly right-wing towns. Bop was plumb in the middle of the Western Transvaal, heartland of the white right, and there would be no shortage of armed volunteers. Without waiting for an answer about the fuel, I got up, smiled and discreetly left. We had to get into Bop before the right-wingers, or the army, or whoever, sealed the border. Sure enough, on

a level stretch of road just before town, a pair of civilian pick-ups were parked alongside the road. A bearded man in khaki shirt and shorts was on the gravel shoulder. As we approached, he stuck his hand out for us to halt, but I kept going, neither accelerating nor braking, and waved. He couldn't quite decide if we were of his ilk or not. It was enough of a hesitation for us to get past them and into Mafikeng.

Mmabatho is a new town, built specifically to house the government of Bop, and Mafikeng was the old African town and mission that had gained fame during the Boer War of 1899–1902 for resisting a 217-day siege. It should have become infamous instead, as the British and other white defenders had eaten well every day of the siege, whereas its black inhabitants had starved. Mafikeng also became the site of a notorious British concentration camp for captured Boer civilians.

Unknown to us then, Mangope had called on the right-wing Afrikaner leader General Constand Viljoen to come to his rescue. Viljoen, a former chief of the army, had formed the Freedom Front, a coalition of right-wing Afrikaner groups that were pushing for an independent white volkstaat, that were allegedly the sunny face of racism. Viljoen's white paramilitaries were to assist the Bop security forces regain control of the streets. But within the ranks of Viljoen's right-wing army were the Afrikaner Resistance Movement (known by its Afrikaans acronym AWB), a bunch of neo-Nazis led by Eugene Terre'Blanche, a corpulent drunk who liked little more than riding a stallion at militaristic rallies, where he would mesmerize audiences with his brilliant, often hypnotic, rhetoric. Despite his propensity for falling off his horse, he was still regarded as an intrepid figure by a minority of whites.

In farm pick-ups and dated cars, thousands of white South Africans heeded the call to defend apartheid and reinforce their claim to a white homeland. But the bottom line for most of the white supremacists was an opportunity to kill blacks. They had long visualized a fight to the bitter end against black communist revolutionaries, and the negotiated settlement that De Klerk had reached with Mandela was, to them, a betrayal. Their country and heritage had been signed away without a

battle being fought on South African soil. The black liberation movements had never mounted a serious military campaign against the potent white state. The armed wing of the radical black Pan-Africanist Congress, APLA, was widely derided as two men and a fax machine despite some ugly acts of racial terrorism, including an attack on a church packed with white worshippers that clearly demonstrated their refusal to distinguish between 'hard' and 'soft' targets, civilians or soldiers.

We joined a handful of cars waiting in vain for a petrol station to open. There were nervous whites and their families wanting to fill up so that they could leave town, as well as the newly-arrived right-wingers. No one paid more than cursory attention to the body of a black woman in her forties crumpled against one of the walls.

'Ons is op 'n kaffirskiet-piekniek (a kaffir-shooting picnic),' a man told me. He and his girlfriend were sitting on plastic chairs set up on the back of a pick-up and drinking beer, icy from the coolbox between his knees. For him and his kind, this was a potential orgy of racist, white trash goonery. They had chosen the right place to enact their violent fantasies: Bop was by far the most surreal of the ten homelands that had made up the phantasmagoric landscape of apartheid.

For white South Africans, Bop had for years been their vacation from the Calvinist restraints of their own society. In the homeland's luxuriously kitschy Sun City resort, they came to gamble, carouse with black prostitutes and watch pornographic movies. Vast sums of cash brought in the Miss World pageant, international golf, world title boxing fights and musicians, all of whom, with a nod and a wink, finessed the sports and cultural boycott of pariah South African by visiting 'independent' Bophuthatswana.

Despairing that the petrol station would ever open, we pushed on towards the town-centre and found dark-green-uniformed Bop soldiers patrolling the streets. Alongside them were white men, most dressed in camouflage or khaki uniforms garnished with the three-legged swastikas of the AWB.

We wandered around nervously, until one of the Boers told us that

he would put a bullet through our heads if we came within 300 metres of them. These were not my favourite people. They were concentrates of hatred, aggression and fanaticism, cloaked in Christian and Old Testament righteousness. Perhaps it was the way I walked, dressed, or some kind of psychic power that allowed them to pick up my antipathy, but they could smell that I was a Kaffirboetie, 'n kommunis, a word which can be delightfully hissed through tightly-drawn lips.

We decided to forgo valour and check out the black residential areas where we would most likely find ANC supporters. I was not sure where to go, since I used to avoid Bop like the plague. To me, it was a place imbued with evil. The irony of the AWB's arrival to help prop up Mangope's tyrannical reign was that I had years previously dubbed the Bop security forces 'the black AWB'.

Lost, we wound our way aimlessly through the suburbs, with the fuel gauge showing empty, when we happened across a petrol station that was being plundered by a black mob. I decided in favour of the blunt approach and parked right in front of the pumps. The looters stared at us as if we were insane. I saw flickers of greed pass from eye to eye. A car full of cameras and who knows what other treasures had just rolled into their hands. I got out and announced that we were journalists and desperately needed petrol. A couple of guys, bare-chested, with shirts tied around their waists, looked at each other. 'No problem,' they said in unison. The pumps had been ripped right off the wells, and a bucket was lowered into the reservoir. We all laughed and joked, and suspicious characters asked for money for the petrol. 'Just a donation,' they assured me. I paid up, probably more than the value of the petrol, but on that day, the fuel was priceless. I had just looted a tank of fuel, and I could certainly identify with the pleasure looters took in the pastime. As Heidi and I continued cruising, we came across a group of black civilians gathered under a large willow tree. They were fearful and showed us patches of blood soaked into the sand, holding out cartridges they had found nearby. It seemed that the right-wingers had been driving around town shooting at any black they saw.

We went to the one hotel that was still open, where all the other journalists had set up base. There were working phones, food, booze and armed security guards at the gate. Ken was there with Monica; they too had run out of gas and he had abandoned *The Star*'s car somewhere in town. No one was sure as to what would happen next.

The right-wingers had made their base at the airport on the edge of town. On our way there, we passed car-loads of them driving through town, belligerently waving their guns. Some wore balaclavas to cover their faces, others were brazenly bare-faced. Near the entrance to the airport terminal we met John Battersby, the *Christian Science Monitor* correspondent. His face was swollen and bleeding; he had been badly beaten by goons when he tried to get in to speak to the Afrikaner leader Viljoen. And John doesn't even carry cameras, the usual magnet for trouble. We returned to the hotel and waited for some kind of development. The Bop military base was a little way up the road, and if they did stage a coup, as rumour said they were now contemplating, they would have to come right past the entrance of the hotel. I nodded off on the comfortable couch thoughtfully located in the reception. After a while, I started awake, jumpy that we were missing something. Heidi and I went back out for a cruise.

The streets were deserted. There were no right-wingers to be seen and the Bop security forces were also absent. In a poor residential area of town, we found a slender black man who claimed to be an ANC official of some sort. He told us that someone had been killed near the airport. Following his directions from the back seat, we almost drove straight into a column of right-wing vehicles at an intersection. The ANC guy went into silent shock. 'Get down, on the floor!' I yelled at him and he folded himself into the space behind the front seats. Fervently hoping they had not seen our passenger, I smiled pathetically at the menacing figures standing on the backs of their pick-ups, a variety of guns trained on us as they passed. The column stretched left and right as far as I could see. What were they up to? I had to get into the column, but there was the problem of our little secret in the back seat. 'Com, I have to follow them. Is that OK with

you?' I absent-mindedly looked in the rear-view mirror, thinking I would see his face. 'OK,' his quavering voice gamely floated up from the floor.

South Africans have an old-fashioned sense of road etiquette, and so, when I caught the eye of one of the drivers and indicated that I wanted to be let into the line ahead of him, he nodded and stopped to allow me in. After a kilometres or so, we heard a burst of gunfire and then everyone was pulling to the sides of the road. We did the same and watched as dozens of these fools started firing at random into the mud huts alongside. For some reason they also peppered a water tank. I could not discern any incoming fire and I wanted to take pictures, but I was scared to step out of the car, knowing their antipathy to journalists. I could take pictures through the windscreen, but if they saw me and came over, they would find our passenger and kill him without a qualm. Probably kill all of us. 'I'm getting out,' I told Heidi. She looked horrified, 'Don't!' but we both knew that I would. I took a few steps away from the car and began shooting pictures. Within a minute or two, they noticed me. The guns all swung towards me and they began to yell and curse.

'But I'm showing you being attacked,' I tried to convince them in my best Afrikaans. 'It's in your interest.' No one bought that line, but it stalled them a little. The column had begun to retreat and in their eagerness to leave it looked as though they would not bother with me. I started to relax, but then I turned to my right and I saw a man standing on the bed of a light pick-up some 15 metres away. He was pointing a pistol right at my head. 'I'm going to kill you now,' he informed me softly in Afrikaans. I watched his index finger tighten on the trigger. Everything slowed right down. I knew he was not bluffing, that he was going to shoot. Suddenly, a tall wiry man with an ugly grimace underneath his greying moustache stepped between the gun and me. He ripped the one camera off my neck and hurled it to the ground – the other of my two cameras was hanging from my shoulder, and I used my elbow to push it out of sight, behind my back. His face contorted and he was saying something, but I could not hear for the

blood rushing through my ears. I could have kissed that unattractive face – he had unwittingly save my life. Then they were all gone and we were alone.

I walked shakily back to the car and got in. Heidi looked at me, her face pale, stricken. We pulled off on to a side road where black residents urgently waved us to a hiding place behind the hut that the AWB had been shooting up. I feared they might follow us, not believing we had somehow managed to get away unscathed. I also had difficulty believing how stupid I had been. I knew the pictures were shit from the first frame. But there was no time to dwell on it: a woman had been severely wounded in one of the houses. They carried her out into the dusty yard, where Heidi began to dress her wounds. She looked in a bad way, blood everywhere.

The convoy we had intercepted had been trying to leave Bop. The homeland army had been unhappy with Mangope's decision to call on the Boers, and the unmitigated racism displayed by the right-wing militia had utterly alienated them. Their disappearance from the streets was the sign that they had withdrawn their support of Mangope. Constand Viljoen had watched his attempted rescue of the homeland leader start to degenerate into a racial showdown and ordered his men to pull out.

A few hundred metres further up the road from my close call, Kevin and Jim had also inadvertently intercepted the retreating column. When Afrikaner gunmen started to take pot-shots at them, Jim had accelerated up the sand verge to get ahead, overtaking the slow-moving vehicles in the column. Within seconds, they ran into an intense gun battle between the retreating neo-Nazis and the better-armed Bop security forces.

Scrambling out of the car, they lay flat on the ground. The firing petered out and Jim looked up to see a 70s Mercedes and three AWB members surrounded by a dozen uniformed Bop soldiers. He had to get there. Holding his camera above his head to show the Bop soldiers that he was not a combatant, he slowly stood up. In the aftermath of the gunfight, the silence was conspicuous. He took a step forward – still no

reaction. Jim then walked the short distance across the road and began to take pictures. Kevin followed right behind him.

One of the right-wingers was dead, crumpled face down in the dirt, blood flowing past the tripod swastika insignia on his shoulder. Another was lying across the back seat, the third crouched next to the driver's seat, waving his pistol back and forth across the semi-circle of black men facing him. Jim tried to calm him down: 'You're surrounded, don't start shooting. Stay calm.'

The bearded man, Alwyn Wolfaardt, was wounded and scared, and asked for an ambulance. 'We can't call an ambulance. They will do it, they will arrest you then they'll get you an ambulance,' Jim said, as he and the others kept shooting pictures. He had been in similar situations before and he felt that the peak of danger had passed; the presence of all those journalists should also have had a calming effect. The Reuters photographer alongside Kevin also thought that the crucial moment had passed. He wanted to get back to Johannesburg to file in time to make European paper deadlines, taking Kevin's films with him.

Several more journalists arrived. A Bop soldier quickly walked in and pulled the pistol out of Wolfaardt's hand and instructed his captives to lie flat on the ground. Journalists were questioning Wolfaardt. A black radio reporter asked, 'Aren't you sorry for what you have done?' Wolfaardt just kept asking for an ambulance, but no one responded. It was too good a journalistic moment. Kevin could not quite believe what he was seeing. He recognized how important this scene was and tried to capture it all: the swastika-like emblem; the blood; the fear of their victorious black enemies etched on the right-wingers' faces. The worm had well and truly turned.

A hundred metres away, CBS cameraman Siphiwe Rallo was rolling long on the scene. He watched through the viewfinder as a Bop policeman tried to fire a semi-automatic rifle into the journalists' backs. The journalists were oblivious to the danger just behind them. The deadly weapon jammed, and the policeman struggled to clear it, but his rage and haste slowed him down – time enough for another uniformed Bop man to take it from him.

Meanwhile, the cameras and tape recorders worked on. Without warning, one of the Bop soldiers walked swiftly up to the two surviving right-wingers and executed them with rapid single shots from his assault rifle. It was over in a heartbeat. The death of white supremacy.

Kevin had finished the films he had in his cameras and was busy rewinding them when those first shots were fired. There was no way to reload fast enough to catch those few desperate seconds, and he had to just watch it happen.

Oblivious to one of the most dramatic moments of South African history being played out just a little further up the road, I was looking for the camera that my unlikely saviour had hurled into the weeds bordering the road; but it seemed that one of the fleeing right-wingers must have paused long enough to help himself to it. I was scuffing pointlessly in the grass when a television crew drove past and the cameraman yelled out of the window, 'Some AWB have been killed up ahead!'

I ran to the car and called for Heidi. We sped up the road to find three white men sprawled against and half out of a shot-up car. They were all very dead. I saw Jim and other photographers running away. The scene caught my eye and I shot a few frames of the dead men and three photographers fleeing like culprits. I had missed the killing of the AWB men and the drama surrounding it, important pictures, but despite that professional regret, I felt a surge of elation, a bitter pleasure at seeing those corpses in the Bop dust. Kevin would later say how the cold-blooded execution of those men had disgusted him, but for me it was pure justice.

Working the scene from different angles, I looked up to see a white man in Bop army uniform charging toward us. He screamed abuse in a heavy Afrikaans accent, called us scavengers and hysterically chased us away with a shotgun. He was one of the South African military men seconded to the homeland security forces, and was clearly distraught at the murder of his countrymen. Black men in the uniform he wore had killed white men with whom he shared language, culture and probably ideology – they were the Volk, the chosen race of Africa.

We drove back to the hotel. It was a Friday, and if I could get the film back to the *Newsweek* office in Johannesburg quickly enough, it could still be shipped to New York in time to make the magazine's Saturday deadline. Everyone was in a state of excitement. I entrusted my film to CBS, who were driving back to Johannesburg to feed their tape to New York.

Ken also arrived late at the battleground. Unsettled by the deserted scene around the Mercedes, he shot out of the car window, planning to move closer once he had a picture in the bag. The same white officer with the shotgun raced out of the barracks and thrust the barrel into Ken's face. Ken instinctively shied back and pushed the barrel away from him as the man pulled the trigger, and the shotgun discharged harmlessly into the air. In the aftermath of the gun battle, the Bop army had retaken the streets. Using armoured personnel carriers, they herded the confused and fearful AWB stragglers out of town. Afrikaner militants still trapped inside the homeland feared they would be killed as they tried to leave. A group approached Ken and pleaded with him to help them escape, to safeguard them – their hatred of the press had disappeared along with their bravado. 'Sorry,' Ken replied, with suppressed satisfaction. 'We're only here to observe.'

Joao had raced to Bop after doing the early morning Mandela job, but he was too late to get anything. He was upset, because he knew that he had been forced to miss great pictures. But Brauchli somehow also missed the pictures that counted – he had arrived on the scene when it was all over. Denis Farrell in Johannesburg knew AP were going to get severely beaten world-wide unless he came up with a frame to match Kevin's Reuters picture. Desperate, he called his opposite number at Reuters, Patrick de Noirmont, and asked for an out-take, a reject, from Kevin's films. This was not that unusual – I had on more than one occasion snipped a neg. for my opposition when they were in real trouble on a story. The rule is to make sure you keep very quiet about it and to make sure that the picture you give is never going to beat yours. I had once foolishly allowed a Reuters photographer in Bosnia to choose his own neg. from my AP take and woke up the next

morning to discover that I had been beaten by my own picture. Patrick had been in the game a long time and he gave Denis an inferior image from the scene; Kevin's Reuters pictures dominated the play while the AP got its arse kicked.

# THE SIN OF LOOKING

Let's go get some bang-bang!

Kevin Carter

|||

*April 1994, Johannesburg*

The democratic transformation of South Africa was big news. Thousands of journalists, photographers, cameramen and producers had descended on us either to witness the birth of a non-racial democracy from the ashes of the apartheid state, or to watch the conflagration – either way it was a great story and profitably career-advancing. The violence escalated dramatically as the election date approached, and various groups tried to derail the process.

By now, we had become a tight-knit group: Ken, Kevin, Joao and me – the so-called Bang-Bang Club that had been suggested all those years ago. But in fact, it was not just us four, it had been enlarged to include a few local and foreign photographers whom we had befriended over the years. After some time, we shut the door and even excluded a long-time friend who had arrived in the country late. He found that he could not team up with the group of globe-trotting conflict-photographers he usually worked with. We regretted it, but we had consciously made the decision to exclude any more people from joining

our already overloaded clique.

We were arrogant, elitist and highly competitive. And for us, it became a comical spectacle as several visiting photographers – strangers – desperately tried to hook up with us: what easier way to be able to access and photograph the violence than with local boys who knew the terrain and had all the information? I recall an evening in that period when I told one renowned international photographer that he could not join us as there were already too many people travelling in the group. He called me back near midnight in a frothing rage and warned me that I would need him one day, that he was too important to be treated in this fashion. I listened and tried not to laugh: this famous photographer was being excluded from an elite he felt he belonged to, his ego was bruised, but he also knew that every week he was getting his butt kicked by our pictures.

Early one morning in April, Joao, Ken, Jim and Brauchli turned on to the road leading into Thokoza. They were surprised to see three clearly marked journalists' cars parked on the verge. They slowed down to see if anything was going on, then realized that the foreign photographers were simply parked there. Odd. They drove past and were then amazed to see the little convoy pull out and follow them along Khumalo Street. Joao laughed. But Brauchli became angry – this had happened before and these people were leaching off our local knowledge. Let them find their own pictures. Approaching the dead zone, yet another car swung out of a side street and slipped into the convoy, right behind the lead car. Brauchli lost it and told Jim to stop the car. He stormed up to the car behind us and aggressively said 'Hey, why are you guys following us? Do your own thing, stop following us!' The driver was a South African, Paul Velasco, who knew the townships well enough to not need to follow anyone, and he had happened to pull out from the side street and into the convoy at an unfortunate moment. Velasco, who is notorious for his quick temper, yelled back, 'Fuck off, you piece of shit!' and dropped the clutch, overtaking the bang-bang car. Bauchli, undeterred, proceeded down the line, berating each car in turn.

It was funny, but in truth we had spent years working here, learning how to get pictures in extremely difficult circumstances, and now people reckoned we should help just anybody who waltzed into our backyard for a couple of weeks. They did not even offer to buy us lunch – the usual way that foreign journalists milk information from local ones. We were happy to work with some people, especially those who had put in the time and effort to be 'one of the boys', but others we wanted no truck with – it was quite arbitrary.

In that first quarter of 1994, South Africa was precariously balanced on the edge of the abyss – a fully-fledged civil war between several groupings based on race and political allegiance. Far-right-wingers had begun a terror campaign and were calling on whites to rise up against the state in order to be allowed to take a portion of the country and secede – in effect, to form a white homeland, an ironic inversion of their original policy. Despite the humiliation in Bophuthatswana, dozens of rural towns flew the old Transvaal Boer Republic's vierkleur flag and had declared themselves independent of the New South Africa, as the nascent post-apartheid state had been dubbed.

We were all working incredibly long and arduous hours – one day we would be chasing a speeding campaign-convoy to some remote rural town where we would have to battle security and crowds to get worthwhile images; the next we would be ducking bullets in yet another violent incident. I recall the entire period as one of extended exhaustion.

Kevin's position at Reuters had become tenuous. He would some-times come in with brilliant pictures from conflict – such as the ones from Bophuthatswana or the townships – and then on other occasions he would completely fail to deliver. He had resumed doing hard drugs on a regular basis and Kathy eventually grew sick of it. In the first week of April, over Easter, she told him to move out of her apartment, which they had shared for almost a year. The most stable element in Kevin's life was no longer his to rely on and he seemed to lose control almost completely. A few days later Reuter's chief photographer, Patrick de Noirmont, sent Kevin to cover Mandela speaking at a Johannesburg

Kevin Carter plays with children as a local villager looks at his camera in the Kenyan border settlement of Lokichokio, March 1993. (Joao Silva)

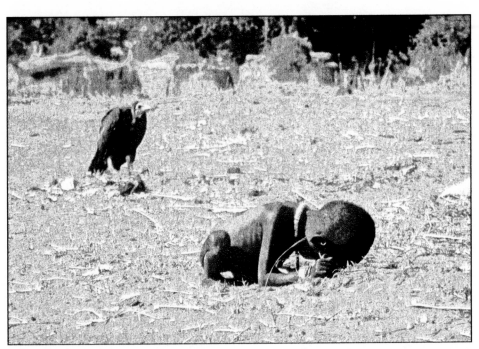
A vulture seems to stalk a starving child in the southern Sudanese hamlet of Ayod, March 1993. This picture would win Kevin Carter the Pulitzer Prize for Feature Photography. (Kevin Carter/Corbis Sygma)

Left:
Greg Marinovich covering floods in the Kwa-Zulu Natal town of Ladysmith, 1996, shortly before he left to take up a post in Jerusalem for The Associated Press. (Joao Silva)

Below:
Ken Oosterbroek, with a South African Defence Force armoured vehicle behind him, during the fall of the homeland of Ciskei, February 1994. (Joao Silva)

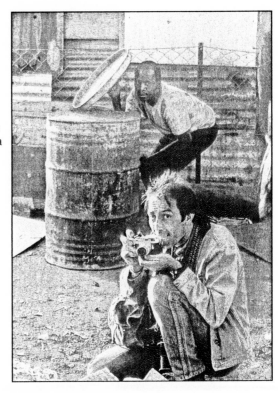

Right:
Kevin Carter crouches while covering clashes between the ANC and Inkatha in Alexandra township, Johannesburg.
(Guy Adams)

Below:
Gary Bernard, left, and Joao Silva on a winter morning in Soweto township, July 1994.
(Greg Marinovich)

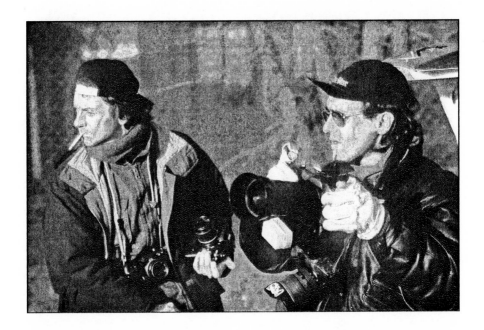

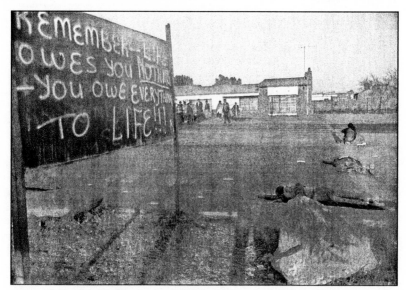

Three dead men lie in the street where they were gunned down during a battle between Inkatha and the ANC in Soweto's Dobsonville suburb. The graffiti reads 'Remember – Life owes you <u>nothing</u> - you owe everything to life!!!' (Joao Silva)

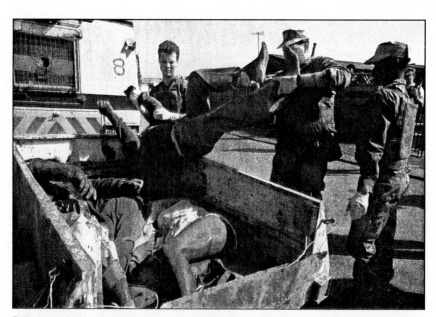

Policemen load corpses into an open trailer after a night's violence between ANC and IFP supporters in Thokoza, July 1993. Sixty people were killed in the township that weekend. (Joao Silva)

An Inkatha supporter lies dead amongst his traditional Zulu weapons after several hundred warriors tried to storm the ANC's headquarters, Shell House, during a march in downtown Johannesburg, 1994. Several Zulus were killed, and it became known as the Shell House Massacre. (Greg Marinovich)

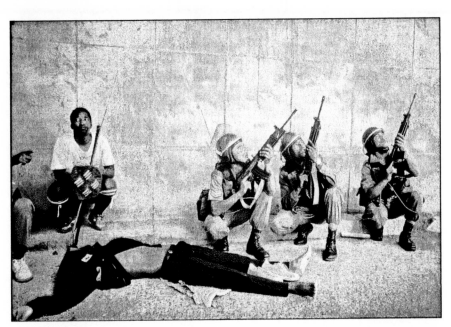

An Inkatha supporter lies dead with his shoes taken off for his journey to the next world as soldiers look for the sniper after several hundred warriors tried to storm the ANC's headquarters, Shell House, during a march in downtown Johannesburg, 1994. Several Zulus were killed, and it became known as the Shell House Massacre. (Greg Marinovich)

Kevin Carter during a late night shift as disk jockey at the Johannesburg station, Radio 702. (Joao Silva)

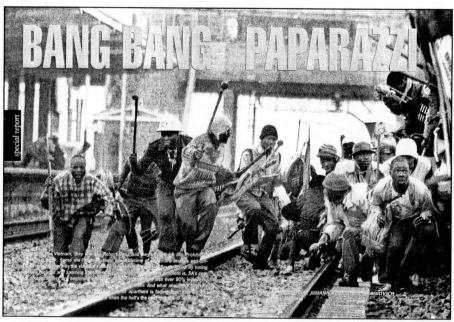

The print-ready artwork from the article entitled 'Bang-Bang Paparazzi', which featured in the South African magazine, Living, that led to a subsequent article called 'The Bang-Bang Club', featuring Kevin Carter, Greg Marinovich, Ken Oosterbroek and Joao Silva. (Joao Silva)

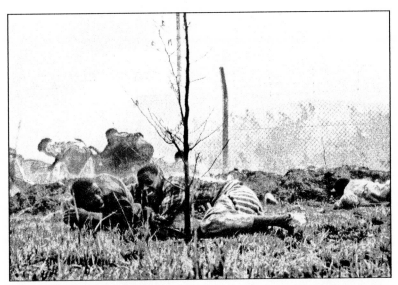

Bisho, 1993. Ciskeien homeland soldiers opened fire on tens of thousands of ANC supporters who marched across the South African border to demand the Ciskei disband. Some 26 ANC marchers were killed. (Greg Marinovich)

Then State President of South Africa, PW Botha, and his wife Elize, are greeted by a woman in the black township of Sebokeng, south of Johannesburg, in the late 1980s. (Ken Oosterbroek / *The Star*)

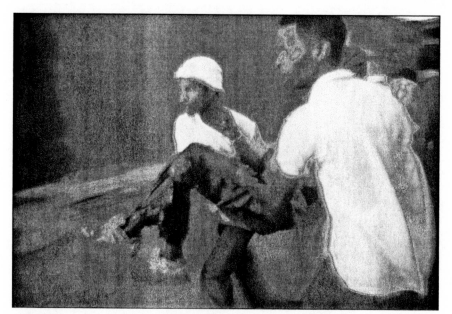

ANC fighters carry a wounded comrade during clashes with Inkatha supporters in Alexandra township, Johannesburg. (Kevin Carter/Corbis Sygma)

Smoke rises from a cap of an ANC self-defence-unit member shot in the head at pointblank range after he mistakenly opened the door to Inkatha gunmen in the dead zone in Thokoza township, 1995. Four other ANC militants were killed. (Greg Marinovich)

hotel. Kevin did not return for hours and Patrick was getting anxious and irritated waiting for the film. Late that night he finally heard from Kevin – he had been arrested for reckless and drunken driving and possession of drugs, and was now being held at a police station. Patrick was enraged – even more so when he heard the full story. Mandela had already begun to speak when Kevin had walked in, holding a glass of wine in his hand and visibly out of it. He slowly negotiated his way to the front row where the other photographers were, stepping carefully over the microphone cables that led to the podium. He sat down and after a while said he was bored. He got up and walked back the way he had come, and as he passed the last photographer he said loudly, 'If the old man catches a bullet, phone me.'

Kevin went back to his car, where he had a 'ready-made' white pipe waiting. On the way back to the Reuters office, he failed to negotiate a turn and crashed the car into a garage door and a wall, hitting his head against the windscreen. When the startled house-owner came out to find out what was happening and assist if need be, she saw Kevin swaying next to the car, blood pouring down his face. She started screaming at him to keep away from her. Kevin was not looking his dashing best: the haunted artist had degraded into a wasted-druggie look. The police arrived – the woman's hysteria and Kevin's usual belligerence towards the police resulted in Kevin getting involved in a tussle with a policeman. The police also found a bag of dagga and the used bottle neck from the white pipe in the car. When Patrick got to the Brixton police station, the first question he was asked was, 'How can you work with people who are stoned and drunk?'

Patrick was allowed into the cell where he found Kevin, still wasted. Kevin told him that he had been beaten up by the cops. Patrick left angrily, having retrieved the Mandela film. Patrick then called Kathy, even though he knew that she and Kevin were no longer together. She rushed to the police station, where they would not allow her to see Kevin, even though she had the money to pay his bail. The police insisted he had to spend the night in jail. Early the next morning, Kevin looked dreadful; he had not been allowed to wash, and his face was

caked with dry blood from the gash above his forehead. He told Kathy that he had slept on the cold concrete floor and that he had not been given even a blanket. He was charged and a court appearance date was set; Kathy was then allowed to post his bail. She felt guilty about having kicked Kevin out and that he was now in such a bad way. She still cared for him and allowed him to stay at her flat for the day while he recovered. That night Kathy suggested that he seek professional help for his addiction, but Kevin insisted he could beat the drugs on his own. In the days leading up to the accident and arrest, Kevin had undoubtedly been coming to work stoned. Judith, a friend at Reuters, recalls that there was a general feeling that he was unravelling, losing it; when people in the office heard about his accident, the collective feeling was that he gone too far.

What happened at Reuters following the arrest is not completely clear. I had always believed that it was common knowledge that they had fired Kevin after the incident, but Patrick and the Reuters bureau chief, Rodney Pinder, offer different versions of what happened. One version had Patrick firing Kevin the night of the accident in a fit of anger, and then relenting the next day – he had seemingly started having second thoughts, thinking he had been too hasty and that maybe he should give Kevin another chance. In another version Pinder insisted that there was no place for someone like Kevin at the agency, and Kevin was fired. Pinder himself now says that he suggested they fire Kevin, but had left it up to Patrick, who had thought that they needed Kevin, as he would probably bring in good pictures over the election period. Colleagues who had been in the office were sure that Kevin had been fired. Kevin was also convinced that he had been fired. In any event, whether the confusion led Kevin to believe he had been fired, or he really had been, the outcome was the same: it added to Kevin's instability at a time when he need something to hold on to.

At *The New York Times*, the picture editors were pondering over whether to submit Kevin's vulture picture for Pulitzer consideration. Kevin had never worked for them – they had bought just one picture from him, and they were under pressure to enter their own photo-

staffers' work towards journalism's most prestigious award. The *Times*, the world's greatest newspaper, had never won a Pulitzer for photography, despite bagging many for writing, so when nomination time came around, they eventually did submit Kevin's picture – it was without question the most powerful image they had published that year.

The *Times* found out that Kevin's picture had won several days before the 12 April 1994 official announcement. Nancy Lee, *The New York Times*'s picture editor, and Nancy Buirski, the newspaper's foreign picture editor, tried to figure out a way to make Kevin available without letting him know about the award. So Buirski called Kevin and asked him to be on standby for the *Times*. She told him that she wanted him for an assignment, but did not have all the information just yet. Could he just wait for their call, at about three o'clock in the afternoon South African time? Kevin was more than happy to stay at home and be paid a day-rate for it. To celebrate this good fortune, he went and scored Mandrax and dagga and got completely wasted.

At exactly three o'clock, as the names of the winners were announced in New York, the *Times* patched through a conference call to Johannesburg. Nancy Buirski spoke to him first: 'Kevin, I've got some good news and some bad news for you. The bad news is that I don't have an assignment for you, and the good news is that you've just won a Pulitzer for your vulture photograph!'

Nancy Lee recalls that Kevin did not comprehend what they had said, he was mumbling some nonsense, and in New York the two women looked at each other in distress across the desk. They tried again: 'Kevin, you've won a Pulitzer for your picture out of Sudan!' But Kevin was so stoned that he started babbling on about how bad things were in his life. 'Ah gee, that's good, that's great, but I really needed that job. See, I've just wrecked my car and I'm out of money, and . . .'

Nancy Lee interrupted him, 'Kevin, those things are just not going to be important now. I don't think you heard me, you've won a Pulitzer!' 'Yeah, yeah, that's great, but I really needed that job, 'cause I

lost my Reuters gig . . . Reuters fired me . . .' 'I'm sorry, what?' Lee asked, 'Kevin, do you understand what I have just said to you? You have just won a Pulitzer Prize, everything else does not matter right now. This is a big deal.' Buirski and Lee struggled to get Kevin to comprehend the enormity of the moment. 'Right, yeah,' he mumbled. He did not get it at all. They gave up trying to get through to him and hung up with the single thought – what were they going to do?

They tracked me down to the KwaZulu-Natal coast, some 600 kilometres from Johannesburg, where I was on assignment. Again, it was a conference call. 'We have a real problem here. Kevin has just won a Pulitzer and he doesn't get it. We want to know what is going on. He seems to be drunk,' Buirski said. My heart sank, thinking Kev must be fucked on buttons, and I mentally ran though a list of possible excuses. It was a warm overcast day, and from where I sat talking to them, I could see the steely grey ocean below. I decided to tell them the truth, figuring they would want to hide Kevin's addiction as much as I did. I explained what Mandrax was, and what effect the white pipe had on its users. They listened in shocked silence and agreed to put off anyone trying to call Kevin, while I would get Joao and Ken, who were in Johannesburg, to go help him.

Joao was already undressed and sitting in front of the television when I filled him in. He immediately called Kevin and it was clear that he was in no state to speak to anyone. He then phoned Ken and they agreed it best to get Kevin to Ken's house while they tried to get him straight enough to talk to people. Joao went to collect Kevin from the flatlet he had been staying in since Kathy had kicked him out just days before. Joao hooted at the gate, as they had agreed, and Kevin came out. He was silhouetted against the driveway light and Joao could see that he was swaying as he made his way to the gate, hardly a surprise given that he had been slurring his words on the phone. Kevin blew off Joao's congratulations and instead harped on about the chaos of his current living conditions and how all his things were still in boxes.

Once at Ken and Monica's house, close friends and colleagues

gathered to celebrate the award. But Kevin was too far gone to do interviews and so Ken kept fielding the calls as news of the Pulitzer spread.

It was the first time the *Times* had won a Pulitzer Prize for photography, and Nancy Lee was glad that it was for this picture, which was becoming a symbol of famine, and used as such throughout the world. But she also was concerned. She had been really excited about sharing the news of the prize with Kevin, but then came the call in which he did not seem to grasp the significance. As she said later, 'Then you think, boy, nothing is ever easy, this moment of seeming glory has a taint to it.' It was a day of celebration at the picture desk at the *Times*, but there was also a feeling of unease, because of who they thought Kevin was.

The picture had caused a sensation. It was being used in posters for raising funds for aid organizations. Papers and magazines around the world had published it, and the immediate public reaction was to send money to any humanitarian organization that had an operation in Sudan. The heart-wrenching image of a starving, helpless infant being scrutinized by a vulture had inevitably raised the question, 'What happened to the little girl?' and, followed close on that, 'What did the photographer do to help her?'

The barrage of questions had begun to get to Kevin. He could not answer that he had simply left the child there; that the child was not in any direct danger from the vulture, since it is a fact that vultures will never attack anything still showing signs of life. Nor was the child likely to die of starvation, as the feeding-centre, with its ability to administer emergency nutrition, was barely 100 metres away. Kevin at first had told people that he had chased the vulture away, and that he had then gone and sat under a tree to cry. He did not know what happened to the child. But the questions kept coming, and he began to elaborate that he had seen the child get up and walk towards the clinic. It quelled a lot of people's fears for the child, but it did not get Kevin off the hook of the moral dilemma: after he had shot the picture, why did he not just pick her up and take her to the centre – at most – a few hundred feet

away? His job as a journalist to show the plight of the Sudanese had been completed, exceeded, in fact. The bottom line was that Lifeline Sudan had not flown Kevin and Joao in to pick up or feed children – they were flown in to show the worst of the famine and the war, to generate publicity – but the questions remained.

An aid worker I met in Uganda years later, Marcie Auguste, who was working in the nearby town of Kongor when Kevin and Joao were in Sudan, said that all the aid workers who had seen the picture had wondered about the child. But based on their experience, they were sure that the child had been temporarily laid down by its mother and that the little girl was probably alive today. It was comforting for me to hear, but back in 1994, the issues had begun to haunt Kevin. He had not made an effort to assist the child – had he failed a crucial test of his own humanity? Joao maintained that there never was a problem, with the centre so close; the child would have been fine. He had photo-graphed a similar child face down in the dry sand and he had not thought there was a need to assist the child. But then, there had not been the vulture to emphasize the danger.

I am not sure what I would have done in the same circumstances. In different conflict situations, all of us have, at times, stopped photo-graphing to assist wounded civilians. Heidi and I used to work together and she did not believe that journalists were exempt from a duty to assist people. After a few tense discussions, we agreed that if we came across a wounded person, the photographers would have a 60-second window to take pictures before she would start to assist the victim. Every one of the photographers we worked with, including Kevin, respected this, and after our photographic window had elapsed, we tried to frame the pictures to keep Heidi out of them. And, as Joao said, think of good captions to explain what the white hands were doing in so many of our frames. When we were the only people with a vehicle who could safely cross front-lines and ferry injured people to hospitals, we would do so. But it was not always that simple: there are no fixed parameters for when to intervene and when to keep taking pictures.

When Joao and I had been in Somalia in 1992 for the heart-breaking

famine, neither of us had personally picked up a single sick or dying child, though we had seen hundreds. We would get our Somali bodyguards to pick up starving people and load them into the back of our pick-up, but we never personally laid a hand on a single child. We watched them die in front of us and took pictures. I had felt utterly impotent as I took pictures of a starving father as he realized that his last living child had died on his lap, watching through the lens as he closed her eyes and then walked away.

Good pictures. Tragedy and violence certainly make powerful images. It is what we get paid for. But there is a price extracted with every such frame: some of the emotion, the vulnerability, the empathy that makes us human, is lost every time the shutter is released.

# 'SHOW US YOUR DEAD'

I hope I die with the best fucking news pic of all time on my neg. – it wouldn't really be worth it otherwise . . .

<div align="right">Ken Oosterbroek's diary, Friday, 20 May 1988</div>

|||

*18 April 1994*

The youths were silent as they vainly tried to fend off the soldiers' heavy military boots thudding against their heads and bodies. I climbed on to the table in the tiny room, trying to get a view of the assault as Joao and then London-based freelance photographer Mikey Persson went to their knees, their flashes firing intermittently. Shit, I thought, they're getting frames and I can't see a thing. I could just hear the muffled thump of leather on flesh and the occasional soldier's curse. The blue-uniformed South African peace-keeping soldiers had stormed the house, an ANC hideout in one of the dilapidated homes in the dead zone, and captured the youths with their battered AK-47 assault rifles inside. It was the second day of the National Peace-Keeping Force's full deployment in the township. They were tasked with separating the warring factions, and the idea was that this transitional military force, selected from the liberation guerrilla armies, the homeland security forces and the South African Defence Force, would have more legitimacy than the apartheid state's police or defence forces. But they

found themselves jeered, stoned and shot at by both township residents and hostel-dwellers, both of whom felt that the peace-keepers were biased in favour of their enemy. They were suffering the peace-keepers' curse – trained to kill but tasked to pacify.

These peace-keepers clearly thought it their right to kick their prisoners. The young fighters, by their silent resignation to the punishment, accepted that being assaulted was their due. Despite wanting to get pictures of the assault, we photographers did not find it at all extraordinary either – it was the South African way. The irony was that many of these black peace-keepers had fled the country to join guerrilla armies to escape the police brutality they had suffered during the suppression of the 1976 Soweto uprising, all the way through to the death squads of the 80s and 90s.

The peace-keepers ceased the beating and ordered us to get out. Within minutes they emerged, displaying the weapons they had seized, and pushing the three bleeding self-defence unit members ahead of them. By now more ANC supporters had gathered in the overgrown yard. They were using a combination of threats and pleas in an effort to negotiate the release of their comrades, but more importantly they wanted the weapons returned. The peace-keepers were having no part of that discussion and as the confrontation became more aggressive, the heavily armed soldiers took up defensive positions opposite the apparently unarmed kids. We quickly moved behind the line of kneeling blue uniforms, framing the shot in case they did open fire on the comrades. But the kids decided it was a losing battle and backed down. We followed the soldiers as they herded their prisoners through the no-man's-land of the dead zone towards their armoured vehicles, parked in Inkatha territory.

Within minutes, the peace-keepers were under fire from the ANC side – an unequivocal response to the arrest of their fellow fighters. The peace-keepers' commander, a white captain, barked out orders for his men to deploy along the street. We followed closely as the soldiers made their way towards the source of the gunfire. They crouched against the meagre cover afforded by fences and walls, and we followed.

Suddenly the captain was screaming at us, telling us to leave the area or he would have us shot. We all leapt up, breaking cover and charging up to him, entirely forgetting the danger of standing up in the middle of a skirmish. 'Who the fuck do you think you are to threaten us?' Joao shouted, poking the podgy officer in the chest with his forefinger. Jim and I were also shouting at him, while Ken, towering over all of us, was yelling too. The officer was clearly startled at being mobbed by civilians, brandishing cameras and righteous indignation. He was from the old school where anyone in uniform held power over mere civilians. But the old days were gone, and we were vehement in letting him know that there no longer was a State of Emergency that prohibited journalists from being at such scenes. But it was more our combined aggression than our legal right to be there that made him back down. The scene must have bemused the ANC gunmen who had been firing in our direction, because despite our little group being an easy target, no further shots were fired. Good street theatre.

Everyone calmed down and I took the captain to the side of the road to discuss our presence. He maintained that we were getting in the way of his men, endangering them. I convinced him that we would stay behind his men and that we had all done this before, in wars around the globe. We ended up with a reasonable compromise, but the fire-fight was over – the pause to watch our little drama had defused the situation. The peace-keepers were now ready to leave the area and that left us stranded deep in Inkatha territory. Inkatha was not very accepting of the presence of journalists – they were in fact openly hostile, and for us to now have to walk out of Inkatha's Ulundi stronghold, across a kilo-metre of the dead zone into ANC territory, would have been extremely dangerous. I asked my new acquaintance – Captain Alberts – if I could get a ride out in the armoured vehicle. The plan was to go for our car so that I could return to collect my colleagues who refused to ride with the peace-keepers, a principled stand of no significance, which simply meant I had to drive across the front-line twice.

Back in the ANC area, things had quieted down. Some of the foreign photographers had brought in hand-held radio scanners that could pick

up the police frequencies. While standard equipment in the US and many other places, the scanners were illegal in South Africa. During the early days of the war, Kevin had managed to get a scanner from a tow-trucker friend of his. It may have been faulty, but in any case we never figured out how to use it. But the new ones that had come in were great and since most of the police message traffic was in Afrikaans, we local boys were essential if the scanners were to be useful. While listening to the various police frequencies, we overheard a message that sounded as though a policeman had been killed. But the static, crackle and police verbal shorthand meant we missed where it had taken place. Ken, Joao, Jim and I began cruising the area in the car, frantically trying to pick up an intelligible reference to where the dead cop was. After half an hour of fruitless driving and listening, we joked about going to the police station and asking them directly. Right, maybe Ken – known for his lack of tact – should be the one to go in. Joao imitated Ken's gruff voice: 'Show us your dead!' We all laughed, then somehow Ken figured out where the incident had occurred. We raced to an open field next to the cemetery in Kathlehong and found three wounded black teenagers lying on the ground, surrounded by policemen. The cops were surprised to see us and said the kids had fired at them and that they had all been wounded when police returned fire. It was unclear what had happened, but there was a strange atmosphere; something weird had gone down, but no one was about to tell us about it. We took pictures and, vaguely disappointed (no pictures of dead cops), returned to the dead zone in Khumalo Street.

There was a lull and dozens of journalists had gathered in the side streets waiting for the next phase in the action. There was an air of expectancy: it was clear that Thokoza was gearing up for a major battle. I was thirsty, a little bored, and decided to make the dash across Khumalo Street to buy us cold drinks, which meant risking 30 metres of possible sniper fire. In retrospect it was stupid to risk getting shot for a Coke but at the time I felt that the risk was negligible and, in any event, the crossing was uneventful. I bought drinks from a small tuck shop, but they did not have enough change. 'Never mind, keep it,' I

said. 'No, I will find you change,' the shop-owner insisted. It was just a couple of rand and I said to keep the change and then sprinted back across to where the guys were waiting. Both Ken and Kevin took pictures of me racing across the tar, a big grin on my face and bottles of Coke in my hands. We swallowed the cold drinks greedily, then the shop-owner came charging across the road with my change. I laughed and again told him that he should keep it; finally he accepted the money and ran back again. He had wanted to make sure I did not think he was trying to cheat me by pretending to not have change. It was just another of the quirky things that happened amidst the chaos and carnage, small displays of goodwill, humour and outright craziness.

Kevin had to go: he had to return to Johannesburg to be interviewed about the Pulitzer he had won just a week back. Joao told him to cancel, that it was dumb to leave now as the township was going to cook, but Kevin left anyway, saying he would be back in the afternoon. A few minutes after Kevin had left, ANC activists decided to string a 'Vote Mandela' banner across Khumalo Street, within easy range of the gunmen in the hostel. Everyone knew that this would provoke a response from the hostel-dwellers. As the comrades struggled to tie the long banner between a pine-tree and a lamp-post, we gathered under them, waiting, the peace-keepers' armoured vehicle between us and Mshaya'zafe Hostel. It was not long before the expected shots rang out. Everyone scattered for cover and the peace-keepers' vehicle trundled up the deserted street. We followed, using the slow-moving vehicle for cover. BBC journalist Jeremy Bowen was doing a stand-up further down Khumalo Street. Finishing the piece, he watched the group of photographers follow the blue vehicle up the street. 'One of those arseholes is going to get shot,' he said to himself.

The armoured vehicle was accelerating. I looked to the side and saw Jim leaning forward, straining to keep up with the vehicle. It was obvious that we were going to lose the race and we peeled off, making for the safety of the houses lining the street. Civilians were crowding the pavement and peering out of front yards to watch the action. There was an atmosphere of excitement and glee – the soldiers were going to

take on their enemy for them. Another episode of the neighbourhood's favourite spectator sport was about to unfold, but this time with well-armed soldiers on their team. A self-defence unit member appeared with an AK and we followed as he threaded his way along the narrow alleys that led through the houses. By the time we emerged near the derelict petrol station on Khumalo Street again, we found that the peace-keepers had formed a barrier of armoured vehicles to prevent the ANC supporters crossing the concrete forecourt towards the hostel. Our gun-toting guide melted into the crowd. We kept moving and the line of soldiers let us through.

The first thing we saw was a peace-keeper hopping across to an armoured vehicle, leaning on a colleague who was carrying his boot. He had shot himself in the foot. Joao and I followed him, taking pictures, and after he had struggled into the back of the high vehicle we pulled away and exchanged malicious grins. It was a silly picture, one that showed the peace-keepers to be farcically unprepared for this nasty neighbourhood war they found themselves in. We should have thought about that a little more. We moved on, to the long pre-cast concrete wall that marked the end of the garage forecourt and that shielded us from the outer wall of the hostel, some 20 metres further ahead.

Dozens of soldiers had taken up positions along the wall, crouching in the rank profusion of weeds and grass. Their officers were moving among them, preparing them to advance around the edge of the protective wall to charge the hostel that the sniper was firing from. The windows of the hostel that faced us had long ago been blocked by plywood and iron-sheeting, and the walls were pockmarked by the bullets from many gun battles. The soldiers were scared – this was more than they had bargained for when they signed on as peace-keepers. Some were so reluctant that a stocky black officer was kicking them to get them moving. Though doubtless a time-tried military motivational method, it did not seem to be working too well. Ken, Gary, Jim, Joao, several other photographers, a couple of television cameramen and I were all lined up parallel to the soldiers, focusing our lenses on their clearly terrified expressions. I approached the black officer who had

been using his boot to encourage his men, 'We are not going to get in your way, but we want to follow you guys in. We'll stay behind you. Is that OK?' 'Sure, that's fine,' he said. 'Hey, and if one of us gets hurt, you will help us, right?' I half-joked. He smiled back.

There was a tense, anticipatory lull as the solders readied themselves. We waited for the moment when we would have to fling ourselves around the wall and into the line of fire. Adrenaline was pumping into my veins. I was scared, but it did not occur to me to leave – there were pictures to be had. This is what we do.

A little while earlier, Ken had called Robin Comley, *The Star*'s picture editor. He was angry, telling her to make sure the paper ran a story about how the peace-keepers were fucking up in the township. Ken had, some weeks before, gone to photograph the peace-keepers training. He had seen them practising crowd control with batons and shields – as far as he was concerned, that preparation was not what they needed for the war in Thokoza. Then, he went on to tell Robin about a mouse that he had been forced to kill at home that morning. About how Monica had made him kill it and how upset he was over that. Robin listened for a while, quite unsettled by this strange conversation. She had never heard Ken ramble on like this before. 'Ken, can we discuss this another time? Anyway, haven't you got pictures to shoot?'

The first breezes of autumn had begun, blowing an empty tin across the forecourt; its eerie rumbling clatter stood out from the white noise of the armoured vehicles' idling diesel engines. The hiatus was broken by a burst of gunfire from the hostel. A soldier on top of one of the armoured vehicles began to fire towards the hostel gunman.

And then I got hit. An utter confusion of sensations overwhelmed me. The video footage of cameraman Sam Msibi captured me as I was hit and careened into him and Joao. The videotape has the blur of my shadow merging with theirs and there is the violent gasp of air leaving my lungs on the soundtrack before the camera hit the ground and switched off. I had always known that I might be wounded somewhere some time. On many occasions, death had come too close to allow me to dismiss the danger, but I had never truly felt that I would be

wounded. I had accepted the intellectual possibility, even probability
that one day I would be hurt; but on an emotional level, I was
untouchable, immortal. The illusion of safety that was merely the
absence of being hit had unexpectedly been blasted away to reveal an
unimaginable vulnerability. The pathetic belief that I was in control of
myself, my own destiny and my immediate environment was shattered.

As Joao and Jim dragged me along the ground towards cover, we had
no idea that Ken had been shot. We were caught up in our own crisis.
Smoke rose from the barrels of the rifles next to us as the bullets
continued to crack and whine. I couldn't figure out whom they were
shooting at. Joao was yelling at them to stop firing. He looked down at
me and shot off a series of frames: it was important to him to record the
moment. I had been hit in the chest. I had seen enough chest wounds
to know that it was serious and could be fatal. At first I wanted to know
if the bullet had gone right through my torso, so that I could know how
much time I had to live. But neither Jim nor Joao wanted to look, and
then that panic passed and I felt strangely relieved that I had finally been
shot. I had always experienced guilt about being a passing voyeur
during other people's moments of tragedy. A strong sense of peace came
over me, a feeling that I had now paid my dues.

Then Gary cried out, 'Ken O is hit!' Jim left me and ran in a low
crouch to where Gary was trying to get a response out of Ken, whose
eyes were glassily open. A trickle of blood was running out the side of
his mouth. As Jim bent over Ken, one of the soldiers right next to them
fired again, the blast of cordite and the passage of the bullet raising the
hair on Gary's head and then Jim's – they both dropped flat, screaming
at the soldier to stop firing. One bullet had come within millimetres of
killing them both. Jim scuttled back. The light-meter he habitually kept
in his shirt pocket fell out, stopping at the end of the cord that tethered
it. Jim picked it up, and reflexively took a light-reading before slipping
it back in his pocket. Perhaps he was checking to see whether it had
been damaged in the fall. 'Ken's gone, but you'll be OK,' he said into
my ear.

Joao ran over to see Ken, who was being picked up by Gary and a

peace-keeper. There was nothing he could do but take pictures: Ken would want to see those pictures of himself tomorrow. It passed through his mind that Ken, always exceptionally mindful of how he looked in photographs, would prefer a picture where his hair was not hiding his face. He recalled how Ken had insisted on photographing Joao's injuries after he had been smashed in the face with a brick during riots in Johannesburg the year before, when Joao was still with *The Star*. Ken, the consummate professional, had instilled in Joao the ethic of getting the picture first, then dealing with the rest later. The minutes on that garage forecourt seemed to drag on for ever as we tried to get an armoured vehicle close enough to the wall to get Ken and me into it without having to risk more gunfire. The peace-keepers near Ken were still firing haphazardly, and their commander shouted repeatedly at them to cease fire. Their shooting threatened no one but their own comrades and us.

Jim was propping me up, waiting for Ken to be loaded into the back of the armoured vehicle first. Gary and the officer I had spoken to earlier were carrying Ken and they clumsily bundled him into the back. Jim and Joao struggled to carry me and, with the help of others, pushed me in. Ken was crumpled in a heap on the narrow metal floor at my feet, and I perched uncomfortably above him. The video footage was more reliable than my own memory, its unwavering eye showing what I could not see: Joao raised his arms to the sky and cursed in frustration, 'Fuck!' Then the vehicle began to move and he leapt on to the step pulling himself inside. The white captain we had previously argued so fiercely with drove the vehicle himself, yelling back over his shoulder: 'We have three minutes! Hang on . . . three minutes!' In spite of all that had happened between us and the peace-keepers, including them shooting us, those words gave us a measure of hope. The captain, surely experienced in this, was certain that we had three minutes – there had to be a chance.

A young British photographer felt Ken's pulse. There was a moment of hesitation and then he looked up at us and said there was a pulse. Joao instructed him to give Ken mouth-to-mouth, which he immediately

began doing, straddling Ken in the cramped floor space where Ken lay between the sets. We still thought there was hope, but he actually knew that there was no life left. He just could not face being the one to say that it was too late for Ken. Once at Natalspruit Hospital, just off the top end of Khumalo Street, Joao was the first out and he ran into the hospital entrance heading towards where he thought he would find help. It was all familiar from three months earlier when he had rushed in there in search of Abdul, only to be directed to a laundry cupboard and the lifeless corpse. Joao was not sure whom it was he hoped to find — a nurse or a doctor perhaps — but instead he came upon a row of gurneys, and he pushed one back towards the armoured vehicle. Gary and the rest were pulling Ken from the back of the vehicle. They lowered him on to the gurney and rushed him into the entrance foyer, where nurses pointed out the way to the emergency room.

Inside the rudimentary emergency area, the doctor immediately began trying to resuscitate Ken. I followed unsteadily and nurses and colleagues helped me on to an operating table. The doctor examined me briefly. 'I'm OK. Look at Ken,' I said and he turned away. Joao would not leave the room. He wanted to be there, to make sure that no one mistakenly pronounced Ken dead if he were still alive. Or maybe he needed proof that Ken was not coming back. The doctor pronounced him dead after Joao had helped him lift Ken's torso and peel off his blue journalists' union T-shirt to look for a wound. Joao ran his hands through Ken's hair, but in their haste, he and the doctor had missed the tiny entry wound under his arm. 'Could be a broken neck,' the doctor erroneously surmised and then Ken's corpse was covered by a sheet and wheeled into a corner. A bullet had penetrated Ken's chest cavity at his armpit. The high energy of that point-blank shot meant that the bullet had disintegrated on meeting the soft tissue of the organs in his chest: that was why there was no exit wound.

I was alive, despite some minutes during which I had been doubtful, but when Ken was declared dead, some of the resilience I had regained evaporated. I looked up and saw Mark Chisholm and Rob Celliers, two of the most hardened television cameramen I knew, just staring at me,

their faces in total despair; their cameras weren't rolling, just hanging at their sides. The doctor turned his attention to me. With a distinct lack of gentleness, he slashed through the flesh under my arm and shoved a foot-long plastic drain deep into my chest to draw the blood and fluid from my collapsed lung. I gasped, 'Jesus, that's like being shot again!' He agreed, and then said, 'I put it in wrong, we have to do it again. Sorry.'

He had started to examine the gaping, dinner-plate sized wound in my chest when a woman was wheeled in, a victim of a car accident and in a bad way. The doctor left me to try to resuscitate the woman, her head a bloody mass and strange, watery breathing sounds coming from her. She died within minutes and was wheeled away. He came back to me, finished cleaning out the wound and sewed up the flaps of flesh and skin with large, untidy stitches. Then he began to examine the wounds to my butt – shrapnel had made large holes in my left cheek. Joao watched in fascination as the doctor's finger disappeared into the holes peppering my bum – not the most dignified of wounds. I had not known about the wounds, nor even noticed that another piece of fragmented bullet had shattered the bones of my right thumb. Joao stepped outside to get away from the image of Ken dead and covered. Ken was now just a corpse in the corner of an otherwise distracted room – all that vitality and personality was gone.

Brauchli began a series of phone calls. His first was to the AP news desk to report that two journalists had been shot in Thokoza and to get them to send an ambulance to get me out of the township hospital. Next Brauchli called Ken's wife, Monica. He was nervous about telling her: 'No fucking way I was going to tell Monica. She was way too fucking unstable.' But he knew he had to: 'Monica,' he said. 'Look, Ken has been shot in Thokoza, can you get hold of *The Star* and get down to the hospital right away?' 'What?' she screamed. 'Hang on, just get hold of *The Star* and get here.' 'Is he OK?' she asked. Brauchli prevaricated. 'I don't know, Jim just told me that he was shot and that's all I know.' He did not have the heart or the courage to tell her. 'Please, Monica, call *The Star*.'

Before the shooting, I had called Heidi at home and told her that I

could not leave Thokoza just yet, but that I would come fetch her as soon as things quietened down a little. The next call she received was from Donna Bryson at the AP, who told her that she had something to tell her but not over the phone. 'Why not? Come on, Donna, what's up?' 'Greg got shot in Thokoza.' Heidi felt numb. 'Is he dead?' 'No, but nobody actually knows what's going on out there.' Donna promised to pick her up to take her to Thokoza.

Heidi and Donna went to Thokoza with the new bureau chief, John Daniszewski. John drove, Donna sat next to him, looking at the map to find their way to Thokoza. John was a notoriously slow driver, and that day was no exception. They had been in the car for a full hour, when someone up front switched the radio on. The news reader was saying, '. . . Ken Oosterbroek died on the spot. Greg Marinovich was seriously injured and now is being treated in Natalspruit Hospital.' Heidi lost her temper. 'Why didn't one of you tell me that Ken is dead?' she shouted. 'And can't you drive faster?' She immediately apologized; it wasn't anybody's fault, but Heidi was scared and tense. They reached Thokoza, but then they got lost trying to find the hospital. When they eventually got there, Heidi rushed towards the entrance, but Jim stopped her, saying, 'I called *Newsweek*. You don't have to worry, they are paying for everything.' Heidi thought he was very sweet, but the last thing on her mind was bills. Outside casualty, Chisholm with his Betacam on his shoulder, told her, 'Greg is OK, but don't go in there, he's about to be operated on.'

She waited anxiously outside, but then saw journalists leaving the room and thought that if they could be there, so could she. When I saw her, I burst into tears; she took my face in her hands as I blurted out that I was sorry for getting shot. Heidi had always cautioned me when I went into dangerous situations. She had feared my getting hurt and I had always assured her that nothing would ever happen.

Monica arrived a few seconds later and went straight to Joao who was standing outside the entrance. She knew that he would tell her the truth. 'Is it true? Is Ken dead?' Joao felt that she wanted reassurance that it was all a mistake, that Ken was OK, but he looked into her eyes and

said, 'Yes, it's true.' Monica ran into the hospital and found Ken lifeless in the corner of the emergency room, his shoes, socks and shirt neatly packed below the sheet-draped figure. She began weeping, a deep, anguished sobbing, hugging Ken's body. She was wearing a Mickey Mouse T-shirt. Heidi went over to comfort her. Monica said, 'His hair is so strange, this morning it was much smoother.' Then she began to talk to her dead husband. 'You can wake up now, Ken, it's over. Wake up!'

Heidi, always the straight arrow, said to Monica in her Euro-English accent, 'Ken doesn't wake up any more.' Monica turned to her and said: 'You're lucky, your man is alive; mine is dead.' Then Monica just sat quietly next to her husband's body, holding his hand, and weeping.

Kevin had raced back to Thokoza after hearing about the shooting on the radio. Outside the entrance to casualty, Gary flung his arms around Kevin's neck and blurted out that Ken was dead. Kevin just stared straight ahead. His best friend was dead.

*Newsweek* and the AP (with remarkable loyalty to a freelancer who was no longer working for them) had begun to try to get me evacuated to a better hospital. *Newsweek* had no plan in case someone got hurt; AP had a list of phone numbers, but no step-by-step procedure despite Abdul having been killed while working for them in neighbouring Kathlehong just three months before. *The Star* had no set plan either. Nor did I, other than a vague faith in my colleagues and the comrades getting me to a hospital as quick as possible. A planned emergency procedure would not have helped us that day – the helicopter rescue services that were called that afternoon all refused to go to Natalspruit Hospital, never mind Khumalo Street – too dangerous, they said. There was no way an ambulance was going to enter an ongoing battle to get someone out. But in any case, no rescue service could assist someone hurt in a township battle faster than the people that were around. We had all, on many occasions over the years, had to abandon photo-graphing the news and rush wounded fighters or civilians to hospital – often we were the only ones with a car available. There is an elaborate, unspoken code about helping people in trouble, in any war zone, in any

country. The limits and responsibilities are unclear, just how much risk to take to assist colleagues, combatants, civilians. The rules are fluid, yet seemingly understood – if you can, you help. If it is a friend you do whatever your heart tells you to, but for strangers, it was uncommon for us to risk our lives.

When they finished with me and the ambulance had arrived, I asked them to wheel me to Ken. I touched his foot, the only part of him I could reach. I said goodbye, starting to weep, as the meaning of Jim saying 'Ken is gone' finally sank in. Brauchli loomed over me with a camera and said 'Greggy!' to get me to look towards him. 'Nema dozvola, nema slike,' I said weakly in mock-pidgin Serbo-Croat, mimicking how often we had been told 'No permission, no pictures' in the former Yugoslavia's civil war.

I was loaded into the back of an ambulance with Heidi. Once inside the panel-van I was surprised that it was not an intensive care ambulance. There were no medical facilities whatsoever, not even straps to keep me in place on the stretcher. The medic – if he had any medical training at all – was only concerned about not losing the pistol he carried, in case 'the blacks' attacked him. The ambulance service that had been commissioned to fetch me had been beaten to it by a pirate company that specialized in listening to the hospitals' radio messages and stealing the business. Unfortunately these privateers had none of the equipment needed to sustain life, and as the shock began to set in, I started to lose it. My pulse dropped and my breathing became more and more shallow – having survived Thokoza and Natalspruit Hospital's crude but effective casualty department, I was going to slip quietly away in the back of a panel-van, stuck in rush-hour traffic. Heidi knew I needed oxygen as I had a collapsed lung that had filled with blood, but there was none, and she kept asking me questions and demanding answers to ensure I did not lose consciousness. Watching my condition deteriorate, she yelled at the driver to switch his siren and emergency lights on and get to the hospital, quick. He complied, but by the time we got to the resuscitation unit in Johannesburg, I was slipping in and out of consciousness.

# 'AT LEAST YOU
# WERE THERE'

Let us hope that Ken Oosterbroek will be the last person to die.

Nelson Mandela, on Inkatha's announcement that they would,
at the last moment, participate in the elections. The violence
ceased.

|||

*19 April 1994*

The day after Ken and I were shot, dozens of journalists wearing bullet-proof vests were crouched beside gun-wielding comrades in the little gardens lining Khumalo Street when Joao arrived with Kevin and Mikey Persson. Several fierce exchanges of fire between the Zulus and the comrades, intent on overrunning the hostel, had emptied the street of people – the usual collection of combatants, journalists, camp-followers and spectators all hugged the verges for cover. Joao walked slowly and deliberately up the exposed pavement along the deserted road towards the wall where Ken had died. He barely noticed the photographers he passed as he approached the abandoned garage fore-court, barely noticed the gunshots. Near the last corner, Louise Gubb – a wise photographer a few years older than us who often worked for *Time Magazine* – was on her knees, worried about the bullets and, distractedly, about the unheeding feet that were trampling the lovingly tended flower-bed. Then she was wondering about whose lead to follow; ordinarily she would have taken her cue from one of us, figuring

we had spent the most time in Thokoza and should know best just which yard to leap into or when it was OK to move with the ANC fighters, but now two of us had been shot and she was unsure of just how much faith to place in the bang-bang boys' judgement. She was cradling her long 300mm lens and thinking about the balance between pictures and safety when she saw Joao moving past her, once again not wearing a bullet-proof vest. Louise had watched the television footage of the shooting being played over and over again the night before, and she knew how much he must be hurting. She left the safety of the yard and came to Joao, hugging him tight, telling him how sorry she was. Joao struggled to fight back the tears as he squeezed back. They were the only two people standing upright in Khumalo Street; then she led him to the little garden out of harm's way.

Gary had decided not to go to Thokoza that day – he was scared; but much more than the fear of being hurt was the dread of returning to the place where Ken had died in his arms. Why anyone who had survived yesterday's shooting chose to go back there was not totally clear at the time. Were they there simply because there was a war going on and it was their job to take pictures, or was it to continue where Ken and I could not? Was it a defiance of death?

Looking back, the answer is that the South African story was in a crucial phase – the election just nine days ahead spelled the end of apartheid, but it was looking more and more likely that the nation would tear itself apart, starting from the jagged rip that was Thokoza. It was a story we had all risked death for many times before and even Ken's death was not going to stop Joao and Kevin from going into Thokoza – documenting that little fragment of history was more important than personal considerations, or safety. They could not stay at home that day, especially that day.

For some unfathomable reason, the peace-keepers, the police, as well as the regular army, had departed from Thokoza. The dead zone was left to the isazi and the mdlwembe. The comrades took their chance and hundreds of youths tried to overwhelm the hostel defenders. The attack began from the last street that intersected Khumalo Street before the

Mshaya'zafe Hostel. Behind the petrol station was a flat field wild with tall khakibos weed and all that Joao could see of the hostel were the dirty white walls punctuated by small windows. The fighters ran out from the houses and charged across the field, trying to get to the hostel perimeter; Joao went with them. The tops of the weeds cracked and sang as bullets ripped through the green leaves. The comrades dropped to their bellies and urged each other on. Most of the attackers were bare-handed, or carried unlikely weapons such as kitchen knives and hammers among the handguns and deadly Kalashnikov assault rifles.

Joao shot a few frames of fighters crouching next to their commander who was telling them to charge, but the intensity of the incoming fire and the terrifying noise of the bullets ripping through the khakibos convinced the fighters and Joao to retreat – it was simply too dangerous. Joao had already come to that conclusion: they were attacking defenders who were safely behind thick walls whereas he and the comrades had weeds for cover in an open field. Joao mimicked the comrades – he lay flat on the ground and clutched his cameras close to his chest, then rolled like a pole, flattening the weeds as he made his way to the road. He rolled off the curb and stayed flat; there was no way he was going to stand up in that fusillade. He looked around and realized why there had been no journalists in the weeds; they were all in street, staying low and photographing the fighters at the rear who were giving covering fire for their comrades in front. The fighters rose to their feet for a few seconds to hold the AKs above their heads and spray bullets towards the hostel, before dropping to the ground again. Joao now realized that many, if not all, of the bullets that were raking the weeds were coming from the ANC side, almost doing Inkatha's work for them.

As the battle continued, Joao lay on his stomach, not shooting. Joao later told me that at that moment he was thinking about Ken and me. He felt a sadness and a regret that we were not there getting those pictures. He imagined how excited we would once again have been, all there together that day. He visualized Ken stooping over the large lightbox at *The Star*, editing and calling the editors over to show them

the images, passionately discussing how the page should be laid out, how the photographs should be used.

Joao's reverie was harshly broken by a frightening explosion of gunfire right behind him. He turned to look, and there was an ANC fighter with an AK-47 crawling over the back of his legs. The comrade was completely ignoring the presence of the photographer, other than using Joao for cover as he fired and then moved on, Joao twisted over and shot frames of the fighter slithering over the back of his legs.

The ill-conceived attack petered out and the crowd of fighters and their sidekicks moved to Khumalo Street and the garage quadrant. They passed through the courtyard up to the concrete wall where Ken had died and then on to the very walls of the hostel itself. Joao had never before seen something like this in the townships. Without any security forces to intervene, the residents were determined to eradicate Inkatha from their stronghold. The dozens of young men charging through the hail of bullets seemed not to care about their own safety; some were even attacking with empty Coke bottles.

Joao was running alongside one of the AK-wielding attackers and trying to get a frame on the run when suddenly the fighter's legs were lifted out from under him – he had been hit. Within seconds of the com dropping, another picked up the AK-47 he had been carrying and continued the assault, while four others picked up the fallen youth. Joao focused, framed and shot as he ran alongside boys carrying the wounded com – a fountain of blood was squirting from his side in an arc. Joao followed them inside the petrol station, where several other wounded comrades had also been brought. He saw another fighter sitting cross-legged on the paved floor, concentrating on replenishing AK magazines with fresh rounds as swiftly as possible, oblivious to his comrades being brought in dead or wounded.

Joao had stopped short of following the mob all the way to the wall. From where he had taken cover at the last petrol bowsers, he could see Jim and a couple of other photographers at the wall, beyond the spot where Ken had died. Jim's luck held where others' ran out. Even to Joao, who had a well-deserved reputation for being fearless, that seemed

too risky. He watched as the attackers made the hostel wall and climbed on top of the roof to try to set fire to the building – a youth wielding a wheel spanner managed to get a tyre on to the roof and set it alight, but then the defenders shot him off with a spray of bullets. Joao was totally immersed in the action. He was shooting the best combat pictures he had ever made, briefly forgetting the pain of Ken's death.

Brauchli later told me that he had been watching Joao run alongside the stricken comrade, shooting away, oblivious to the bullets pinging off the pavement. Brauchli shot too, just as a reflex, no thought, no composition. There were more bullets flying through the air that day than he had ever seen before. Brauchli had covered wars from Azerbaijan, Armenia, and Somalia to Bosnia, where he had lost a testicle to shrapnel in Sarajevo. But on that day, in that township, it seemed to him to be 'like a fucking movie. Coms were running up and just blasting off clip after clip at the hostel. It was insane.' Brauchli watched photographers running with the coms, trying to get a picture. But he couldn't comprehend what they were all doing there. Was it to justify Ken's death? Somehow it seemed terribly irrelevant to him. He couldn't get up the courage to go to where the shooting was to make pictures. He didn't want to get shot. He didn't want to do anything. He was mentally exhausted. He went to the old grease pit inside the garage and sat at the bottom, not making pictures, not moving, not thinking, just sitting and listening to the chaotic sounds of battle all around him.

The comrades had managed to set the roof of the hostel on fire, but they were suffering too many casualties, and then the regular army reappeared. Their arrival ended the battle as swiftly as their departure had precipitated it. The coms melted back into the township, the weapons disappeared and the firing ceased.

Though the fierce battle had temporarily delayed everyone's reaction to the violence of the day before, its lasting impact became clear after that first full day back on the job. Mikey came to Joao after the battle and said he'd had enough, it didn't feel right any more. Ken had died the previous day and he had just finished covering the huge assault on the hostel, he had good pictures – he did not want to push his luck and

he was leaving. In fact, Mikey never shot news again. He moved to California and hung out with tattooed women, taking pictures of Harley Davidsons. He told me that he sometimes missed the adrenaline, the thrill of a big, happening story, but then he recalled Thokoza and other equally bad days in other equally bad wars, and the itch subsided.

Joao and Brauchli returned to the AP office in Johannesburg to drop off the latest films and look at those they had sent back earlier in the day. A picture editor, who had flown in from London that day to help on the rapidly escalating story, had selected many pictures from Joao's take to transmit. The editor did not choose even one of Brauchli's pictures, angering him, even though he knew they were not as good as Joao's.

Brauchli stormed out after losing his temper. Back at home, all of his suppressed emotions unexpectedly came tumbling out while listening to a sentimental song, and he began weeping. 'I loved Ken. I loved Joao, Greg, Kev, Gary, Mike, Jim. We had a crew. Close, tight, caring, special. We cared about pictures but most of all we cared about each other, forcing each other to make better and better pictures, stay informed and beat the shit out of the competition. It was the tightest group I've ever worked with and it hurt the most.'

At a popular restaurant that night, dozens of journalists had gathered in response to a 'press alert' pager message announcing a wake for Ken. Everyone was drunk, or working at it, except me – I was tripping on the intensive care unit's morphine. Ken's death was foremost on Kevin and Joao's minds, and they were intent on getting drunk. But instead of quieting the pain, the liquor fuelled the rage Joao was feeling. The aggression kept building, and he wanted to lash out at someone. He became abusive and tried to pick a fight with a waiter. BBC cameraman Dave Spira half-led, half-dragged him outside and tried to pacify him. Joao responded by telling Dave, a good friend, that if he did not leave him alone he'd fuck him up. Dave, closer to seven than six foot, towered over Joao at five foot four. He laughed good-naturedly and walked away.

Meanwhile, Joao swayed drunkenly in the middle of the deserted road, shouting abuse at no one in particular. Kevin, also outside, went

down on all fours, looking for a brick to throw through the restaurant windows. Brauchli, also drunk but at least in better humour, came out carrying the cameras which Joao had left inside. Jim arrived, freshly showered and clean-shaven. He and Brauchli managed to talk Kevin out of throwing the brick.

After Joao calmed down, Brauchli handed him back his new cameras, which had not yet been paid off. With an alcohol-induced clarity he suddenly came to the conclusion that it was all the cameras' fault: if it weren't for them, Ken would not be dead and I would not be in the hospital. Maybe there was more he could have done, instead of just taking pictures of Ken lying dead at his feet. He screamed out and smashed the cameras against a billboard. The flash broke into pieces that flew off into the dark and Joao swung again, trying to destroy them. Brauchli jumped in the way, the cameras hitting him in the head, then he and Jim wrestled the cameras off Joao before he could do more damage.

When Joao finally calmed down, Kevin took him home. At Joao's flat, Viv let them in and, seeing the state they were in, retreated to bed. Unable to find more alcohol, they settled down to make a joint. They were getting even more wasted, becoming truly maudlin. The conversation turned again to Ken, Thokoza and death. Kevin said he'd seen the footage on television and told Joao he'd acted like a professional – shooting pictures, shouting orders, carrying friends: 'Ken would have been proud of you.' But Joao felt overwhelmingly guilty and it hurt. 'How could I have taken pictures of him? Have I truly lost my soul?' he sobbed in Kevin's arms. Kevin held on tight and said, 'At least you were there.'

The previous day, Monica had seen Joao's picture of her dead husband in the newspapers, and she focused some of her anger at her loss on Joao. She was in pain and confused, and she felt a hatred of the pictures, and of the photographer. She refused to allow Joao to carry Ken's coffin. Joao was hurt – he needed to be next to Ken, but he understood and was prepared to honour her wishes. That night he considered giving up photography. Monica was not to get her way –

Robin, from *The Star*, who was organizing the funeral, flatly refused to take Joao off the list. She knew that Ken would have wanted Joao as a pallbearer. In the end, Joao and Gary were at the front of the coffin, carrying it shoulder high, tears running down their faces. After Ken's body was put into the hearse, Joao moved away, far enough from the crowd to not have to speak to anyone. Viv followed anxiously; the events and trauma that Joao had deliberately kept out of her home had now broken in, swamping them both. Monica came to him, in tears, and hugged him. She said that it was OK, that he had done the right thing, and that she forgave him.

As he and Monica clung to each other, a strange memory from just a few weeks earlier forced its way into his consciousness. Ken, Kevin and Joao had come for a braai at my house. We were unwinding with a few drinks and a joint, enjoying a brief break from the violence and the campaigning, and Ken had startled us by saying, 'One of us is going to get whacked, one of these days.'

# THE LAND OF MILK
# AND HONEY

If I had wings, I would fly.

An elderly woman returning to her home after decades of being
forced to live in the homeland of Bophuthatswana, to which she
had been removed under grand apartheid's social engineering.

‖

*22 April 1994*

On the day of Ken's funeral, I underwent my fifth operation in five
days. It was difficult to concentrate and even more so to differentiate
between reality and hallucination. My points of reference were the
operations: the surgeon would loom over me saying that the flesh
around the wound had continued to die off, and that he needed to
operate yet again. The nauseating gurney-ride through the corridors to
the operating-theatre would dissolve and the next lucid moment was
one of emerging from the anaesthetic, pain eating into my chest, until
the next blessed injection of morphine would ease me back to a
dissociated, narcotic world.

Every day, friends would come visit, but the stream of visitors
blurred. I forgot who came to see me, and what they said, what I said.
I was drifting between substance and illusion. But there was one
moment of absolute clarity, when Ken's mother, Geri, came in with a
bunch of red roses from the funeral, their buds on the point of opening,
and said, 'Ken would have wanted you to have these.' Though I don't

particularly like roses, I kept them for months.

After two further operations I was finally able to move out of intensive care. The crisis to survive was over and I began to fret about missing the most important story of my life: Inkatha's final inclusion in the electoral process, which required the last-minute application of stickers bearing the beaming face of Inkatha's leader Mangosuthu Buthelezi and the Inkatha symbol on to the bottom of the lengthy ballot papers, a reminder of how close we had been to civil war. Inkatha's participation had at length been secured by means of gerrymandering in their Zulu heartland, which would ensure them a majority there. It was a small price to pay to avert disaster, but the deal did not please those right-wing whites and security force elements who had thought that they could use Inkatha as part of their strategy to preserve white power. Every day, explosions reverberated through the Reef cities, a last attempt by the right-wing to derail the elections.

Every afternoon and evening my ward was a meeting place for dozens of photographers, journalists and friends. People started bringing food. When Joao and the others came to visit after a day in the townships, they would always find a crowd already there. It was like a subdued party to celebrate that we were still alive and to forget the sad times which surrounded us, if only for a while. Late one night I was already asleep when Ingrid Formaneck and Cynde Strand from CNN crept in, wearing blonde big-hair wigs. Soon we were giggling and laughing, and the night-sister, having taken one look at us, retreated without a word to her station.

One day Kevin visited. His face was mobile and his eyes would not meet mine for more than an instant. 'I've got your cameras – I've borrowed them.' I said fine, but I was surprised. I could not understand why he was acting so strangely – our friendship was such that he knew that I would have lent him the equipment without hesitation, as he would have lent me whatever I needed. Perhaps he had been in a rush when he told me, but he must have known how upset I was at not being able to shoot the elections I had waited so many years for – what it meant to me to be stuck in hospital while everyone else was out

shooting pictures. And here he was, taking the cameras I should have been using, without even a word of consideration. It was unusually insensitive of Kevin. I was also puzzled by the fact that he did not visit me as often as the others. Deep down, I had the feeling Kevin was avoiding me, but I couldn't understand why.

In that period Kevin was confused and angry. In the space of just two weeks, he had been arrested for drunken driving, kicked out by his girlfriend, lost his job, won a Pulitzer, been reinstated in his job, only to have his best friend killed. Kevin – and the rest of us – were convinced that Reuters had only rehired him because of the Pulitzer. This was not Reuters' version of events, but Kevin was deeply angry with them and the relationship was clearly poisoned. I suggested he try the AP and they readily agreed to take his pictures, even though his name was at that time associated with Reuters – the wire constantly needed to be fed pictures. So, just a few days before the election, Kevin resigned from Reuters, and did a couple of freelance jobs for the AP, but then Mikey got him a more regular gig with the French wire service Agence France Presse, and so it was for AFP that he covered the election.

But Kevin was struggling with more than just employment. I heard that he had started saying, 'It should have been me instead of Ken who took the bullet,' though he never said anything of the kind to me. In front of me, he seemed to be the least affected by Ken's death, which was strange, as I knew that Kevin loved Ken like a twin brother. I knew too that he was a dramatic person, capable of intense emotion and of showing it.

I later understood Kevin's distancing himself from me as a strange form of envy. To have suffered Ken's fate would have been Kevin's first choice. Apparently, Kevin constantly talked about getting killed during that time – he did not want to be shot and wounded; he wanted to be killed. He wanted to take the bullet that had killed his best friend. He resented me as I had won second prize. I was there and I took the second bullet, but had survived, so I had a special bond with Ken that nobody else could match.

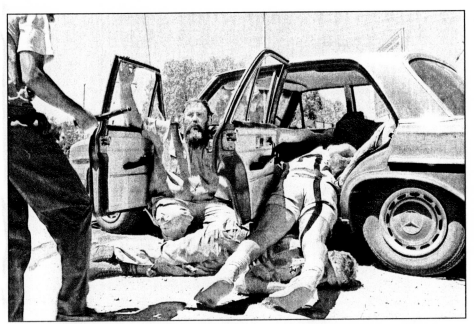

Alwyn Wolfaardt, a member of the extreme right-wing Afrikaner movement (the AWB) begs for his life shortly before being executed by a Bophuthatswana policeman after an abortive attempt to prop up the tyrannical regime of the homeland of Bophuthatswana, March 1994. (Kevin Carter/Corbis Sygma)

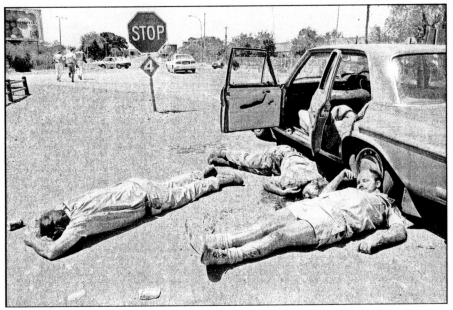

Journalists run from the scene of the execution of the AWB members, March 1994. (Greg Marinovich)

A young boy races past the words 'No Peace' in the dead zone near Thokoza's Khumalo Street, shortly before South Africa's first non-racial election in April 1994. (Joao Silva)

ANC self-defence-unit members duck gunfire during a clash with Inkatha militants from the hostels and houses of 'Ulundi' in the dead zone near Khumalo Street. (Joao Silva)

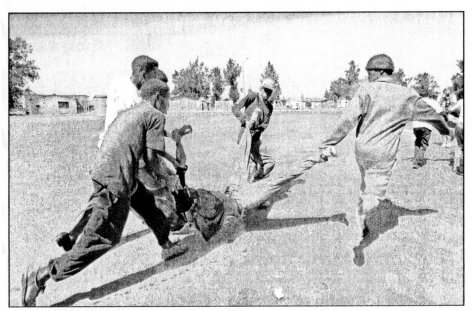

ANC fighters carry a wounded comrade, spouting blood from his side, during an attack on the Inkatha stronghold of Mshay'zafe Hostel in Thokoza on 19 April, 1994 – the day after Ken Oosterbroek was killed in the same area. (Joao Silva)

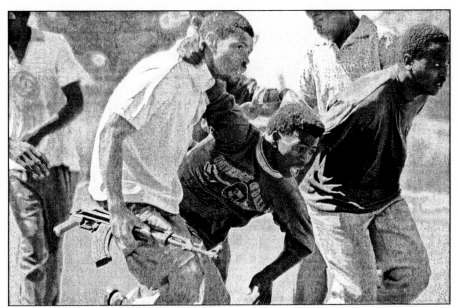

ANC fighters with an AK-47 carry a wounded comrade during an attack on the Inkatha stronghold of Mshay'zafe Hostel in Thokoza. (Joao Silva)

A wounded Greg Marinovich is assisted by James Nachtwey, while Joao Silva takes pictures of Gary Bernard and an officer from the National Peacekeeping Force as they carry the fatally wounded Ken Oosterbroek in the background, 18 April 1994, Thokoza. (Juda Ngwenya / Reuters)

An officer with the National Peacekeeping Force assists Gary Bernard with a fatally wounded Ken Oosterbroek. (Joao Silva)

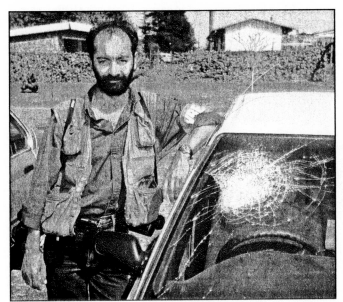

Abdul Shariff, photographed in 1993 next to his car which was damaged during township clashes. Abdul was killed in cross-fire between ANC and Inkatha militants in Kathlehong township on 9 January, 1994. (Kevin Carter)

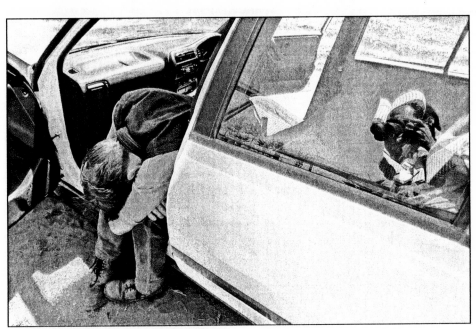

An exhausted Gary Bernard during a break from covering violence after South Africa's first democratic election in 1994. (Joao Silva)

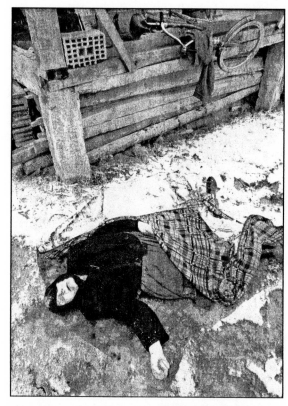

A Serb woman lies dead in the snow just hours after she was given protection by Croat soldiers during an offensive on 26 December, 1991 after Croat forces retook parts of the Papuk mountains – traditionally an ethnically mixed area. Some Croatian units were trying to protect civilians (as in the case of this woman) but others were intent on killing them. (Greg Marinovich)

An Afghan man carries his fatally wounded son into the hospital in Kabul after an artillery attack on their residential neighbourhood, 1994. (Joao Silva)

A Somali woman weeps as her child dies in her arms at an NGO centre in the town of Baidoa where thousands died of a war-induced famine in 1992. (Joao Silva)

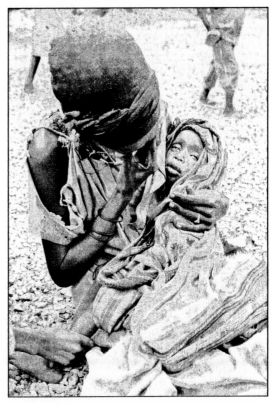

Below:
A starving and ill Somali child waits to die in an NGO centre in Baidoa. This room was for children who were too far gone for the aid workers to waste precious food and medicines on them. (Greg Marinovich)

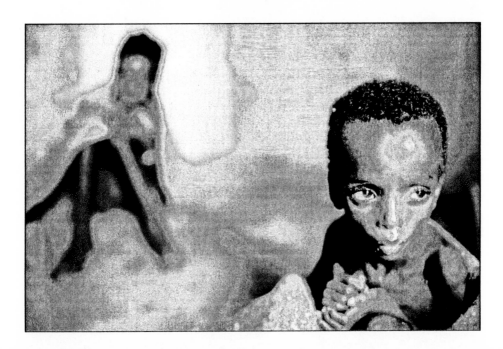

A colleague reaches to assist Greg Marinovich, wounded by police during confrontations between police and 'coloured' residents of Westbury, Johannesurg, who were protesting alleged discrimination by the newly-elected majority black government, September 1994. (Joao Silva)

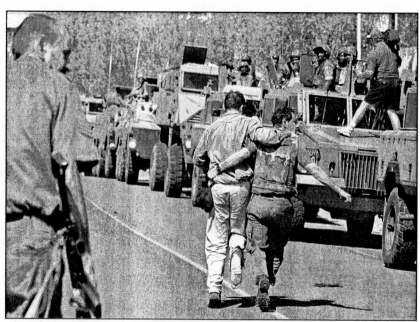

Greg Marinovich being assisted to a South African armoured vehicle after being shot in Lesotho, September 1998, when the South African forces went in to quell a coup, and met stiff resistance from BaSotho troops. (Joao Silva)

## 27 April 1994: Election Day

Before the shooting, I had been planning to spend election day with the Rapoo family. For me, that family was a symbol of courageous people overcoming what had befallen them. They had suffered greatly under the oppressive apartheid system and I wanted to share with them the moment when they voted. But I was in hospital, missing out on what generations of South Africans had been waiting, fighting and even dying for – the first non-racial, fully democratic election. I suggested to Joao that it might be a good idea if he spent the morning with the Rapoo family – the pictures could be really good, at least as good as anywhere else. He immediately understood that I wanted him to be my substitute. I was not sure if he thought it was a good idea for pictures, or if he was doing it for me, knowing how much I wanted to be with the Rapoos. 'But what if shit goes down?' he asked, referring to the possibility of violence, thinking about Thokoza. 'It could go down anywhere,' I replied, rather disingenuously. He and Gary agreed to go to Soweto for the first day of voting, while Kevin, Jim and the rest decided to go to Thokoza, where the potential for conflict was the highest. But, other than the right-wing bombing campaign, which continued in an attempt to disrupt the election, the level of violence had dropped right off – it had ceased the day after Ken was killed, when Buthelezi had cynically announced that Inkatha would, after all, participate in the election. Responding to the announcement in a press conference, Mandela had said that he hoped Ken would be the last person to die.

Joao and Gary arrived in Meadowlands, Soweto, at dawn, and then joined the Rapoos in their bus as they went to collect people from old age homes. Tarzan had planned to paint the vintage bus that they used to transport fellow church members to services in bright colours for election day, but its notorious gearbox had kept him busy most of the previous week and so they had to collect the pensioners with the bus in its drab sand-coloured paint. These were people who, as youngsters, had experienced the beginning of apartheid and had lived all their adult lives under its shadow – but they had now lived long enough to vote for its demise.

The day had begun hours earlier for the Rapoos. The old man, Boytjie, had had a restless night and got out of bed at four to make himself a pot of tea. While the water was boiling, he heard noises from the street. He went out into the yard and looked through the iron gates. A group of old men in coats were standing in the street. 'What's wrong?' he called, worried that something had happened, that there had again been violence. 'Nothing's wrong. We've come to queue,' they told him. The school in the Rapoos' street was one of the designated polling-stations.

Boytjie invited them in for tea. For all of the old-timers, it was the dawn of the restoration of their civil rights which had been so un-equivocally removed by volumes of discriminatory legislation. Thirty-nine years before, the police had forcibly moved thousands of these urbanites to the empty veld that would become a part of sprawling Soweto. The matchbox house they were allocated had at first been the symbol of their loss of personal freedom, but in that house, at 1096a Bakwena Street, the cycles of life and death had permeated the very bricks of the house, making it a home. It was in that tiny kitchen, where his family had cooked thousands of meals, that Boytjie had been doused in petrol and awaited a fiery death as he helplessly watched his son Stanley being taken away for execution by hostel Zulus. It was in that kitchen that he had heard the news of his grandson Johannes's death at the hands of the police. There were many memories to occupy Boytjie and his friends while they silently drank tea. As the break of day approached, the old men put on their heavy woollen coats and joined the lengthening line outside the primary school. The old folk wanted to vote quickly, just in case something happened to upset the miracle.

Tarzan was the next to rouse himself that chilly morning. It was barely five o'clock, but when he went to open the yard he saw a line of people stretching around the block. He rushed back in and shook his wife by the shoulder, 'Maki, wake up, wake up! You said that since we were next to the school, we'd be first to vote. Have you seen the queue outside?'

This was the day on which decades of disempowerment would fall

away as people made their mark on the ballot – they could finally choose who would govern them. The four years of pain and sacrifice they had experienced living in one of the dead zones – ever since the unbanning of the ANC – had made them even more determined to vote for Nelson Mandela and the ANC. They had watched former State President F.W. de Klerk tour Soweto as his National Party attempted to buy black votes in a frantic campaign circus. But few could forget a half-century of the National Party's apartheid for a free T-shirt and a boerewors roll.

The whole family queued to vote together, led by Boytjie. The identity documents that had for so long been their burden were now their passport to vote. When it was Maki's turn to enter the curtained booth and make her choice, she told me later, her heart beat faster: 'It was as if something has been lifted off my shoulders. I felt as if there was something magical about it; as if God had made the school holy for everybody who was going in. I felt happy that at long last we were asked to participate in who must govern the country.'

Maki and other neighbourhood women had prepared food and drinks for the voters. The morning had started out cold, but by ten o'clock the sun was hot and the old folk were feeling faint from the heat. Maki was concerned that the older people would collapse from the hours of waiting. But there were so many people that the neighbourhood women could only give each a plate of mielie meal porridge, soup made from bones, a bread roll and a glass of orange juice mixed in a bucket. When the ANC activists saw what the women were doing, they rushed out and bought barrels of take-away chicken for everybody in the queue.

Maki continued preparing and handing out food until dusk and then went with Tarzan to the church for a special service. There were far fewer people attending than was usual, but for Maki 'The service was also magical. Everybody felt as if Nelson Mandela has given us the land of milk and honey, we had that feeling. Even the sermon spoke of that – the vote had come, we had been led to the land of milk and honey.'

The vote had come ten days after the shooting in Thokoza and I had

recovered enough to be able to cast my vote in the polling-booth at the hospital. As I approached the rather incongruously simple tin ballot-box, I felt elated. The AP had lent me a point-and-shoot camera. I shot pictures of my plaster-cast hand pushing the ballot-paper into the box. I was hoping the AP would put a picture out on the wire, because like a naughty schoolboy I had written, 'Fuck the Nats (National Party)' on the plaster. The AP had better pictures to move that day and my little dig went unnoticed. They had given me the camera because they knew how strongly I felt about missing out on photographing the election. And they were right, the chance to vote and to shoot some pictures had lifted me out of my depression, if only for a few hours.

Kevin was at a voting-station in the extremely affluent northern suburbs where white home-owners voted alongside their maids and gardeners. Kevin wanted to vote too, but he had forgotten his identity book. He argued and tried to cajole the officials into letting him vote anyway, but they refused. Kevin became angry, abusive, running his hands through his hair in frustration. I never did find out where Kevin eventually voted, but he must have done so – for there was still the next day in which to vote.

The second day of voting was quieter, and Joao, Gary and Brauchli spent it in Thokoza. They eventually ran out of fresh scenes to shoot and they just hung out as the lines dwindled and polling-stations closed. Dusk was approaching and they idly played Frisbee. Being in Khumalo Street, near the spot where Ken had died, made them sullen. The excitement of that historic vote had been much reduced by Ken's death. Joao could not find the emotion he wanted to feel while photo-graphing. While they were idling at the garage, it suddenly struck Brauchli that the South Africans, Joao and Gary, had photographed hundreds of votes being cast, but had themselves not yet voted. It was late on the final day and the first polling-booth they went to in Thokoza was already shut. They wanted to vote in the township, felt that it was right. They eventually found one that was still open. It was a school in the southern part of Kathlehong, where the ANC fighter Distance had told us that he was glad that Abdul had been killed. That had been just

three months before, but so much had happened since that it felt like years. Brauchli thought it a great moment, watching his friends cast their votes: he clowned with the women and made the boys laugh for the camera, but when Joao entered the cubicle to make his mark on the ballot-paper, he stopped smiling. His thoughts turned to Ken and me. 'I was in so much pain that I did not savour the moment when I voted for Nelson Mandela.'

For Joao, the period following Ken's death was dark and blurred. He worked like a machine, up at dawn to go into the townships and shoot pictures, and then come to visit me in hospital. He would invariably drink heavily before going home to sleep and start the cycle again the next morning. For Viv, it was a miserable period: Joao was aggressive and in pain, but he would not share it with her. It was as if he could only relate that pain to colleagues who had been in the townships. He felt that Viv should be shielded from the details. Viv had grown used to being excluded from what Joao experienced, but now, instead of home being a refuge, it had become a part of Joao's hurt-filled world. He didn't laugh any more. The weeks dragged on, in what seemed like one long, cheerless day. For the first time in their seven years together, she contemplated leaving him.

## 10 May 1994

Nelson Mandela was sworn in as president behind bullet-proof glass because a right-wing assassination plot had been uncovered. But despite that, hundreds of thousands of people gathered on the lawns of the Union Buildings in Pretoria to cherish the moment. After decades of apartheid, and several hundred years of racial discrimination, South Africa finally had a democratically elected government. Kevin was there somewhere, and the others were spread out at different celebrations. I was out of hospital, back home and well enough to feel thwarted at not being able to participate in the day. My joy at watching Mandela dance his little jig to the roar of the huge crowd gave way to weeping and depression. I was worn out, thinking about Ken a lot of the time. Waves of self-pity swept over me – when would I be able to work again? The

AP had offered me a desk–job while I recovered. I had refused, but was touched that they were treating me like family. They had also offered to pick up my large hospital tab, but *Newsweek* had paid for that and the *Newsweek* photo director had promised me a contract – unlike doing piecemeal freelance work for them, a contract is one of the most lucrative and prestigious gigs in the business. Once I was back on my feet, things were going to be good.

Joao and Gary came round to visit me after photographing street-celebrations. They told me that the townships were just one big party, everyone having a great time. I insisted we go to a party and they took me to Soweto. Balloons were strung low across the section of the street that had been closed off. People who had television sets had brought them out into their yards so their neighbours could also watch. Others had gathered around braais, barbecuing meat, and people were coming up and forcing drinks on us. Everyone wanted their picture taken. After a while we left that drunken street bash and went to visit the Rapoos. I was happy that at least I had experienced a little of the euphoria.

# UP AND DOWN

God has put his jealousy on me
God has greedy eyes

<div align="right">Traditional Acholi funeral song</div>

|||

*May 1994*

After Mandela's inauguration, things slowed down. The constant adrenaline rush eased, as did foreign interest in the story. There was a sense of anti-climax among journalists; almost all of our foreign photographer friends and colleagues had moved on, and, while the story of the transition to an ANC-led government was interesting enough, the global news focus had shifted to the genocide of the Tutsis in Rwanda. South Africa was, after all, an African story and there was not enough room for too many of those in the world's headlines every day.

Unlike the rest of us, Kevin had some immediate excitement to look forward to. He was going to New York to collect his Pulitzer. He prepared carefully for the trip, researching how best to capitalize on the prize. Jim Nachtwey gave him a lot of advice and introductions at *Time*, so he wouldn't go not knowing what to do nor whom to see, and also arranged with Canon to give Kevin a set of new cameras.

Kevin wanted to find a good agency and to make Africa his beat. Sygma seemed the best for that and they were keen: they had offered

him a contract and guarantee. Having parted ways with Sygma some years before, I warned him that agency guarantees are merely an advance and if you do not make enough money to cover them, you go into debt with the agency. One great French war-photographer was reputed to owe Sygma hundreds of thousands of dollars.

Kevin wanted to meet as many magazines as he could, to make personal contacts, to act for himself without going through the agency, which would take half the assignment fee. As best I could, I gave him a rundown on the picture editors he might encounter. Kevin was full of story ideas, he wanted to meet people in New York who would assign him or fund the ideas. It was a chance to start anew, the bad days of violence in South Africa were behind him and he had great career prospects ahead. Joao and I were concerned about his drug-taking, and we both separately told him to take it easy with the drugs so as not to blow the opportunity. He seemed entirely positive; that everything was clearly going to work out for him – how could it not?

The night before he was to leave for New York, he dropped in at the Reuters office to see Judith, who had told him a few days earlier that she was going to resign. He again brought up the idea he had first proposed a few days previously that they form a freelance writer-photographer team. The idea was that they would go to conflict zones together. Kevin admired Judith, an American Harvard graduate who was sexy, vivacious and smart. The relationship had not progressed beyond a work friendship, but two days before he was to leave, he revealed strong feelings for her. Although she was attracted by the intensity and commitment he put into his work, she kept her distance – his wildness was fascinating, but also scary.

Though it was *The New York Times*'s first ever Pulitzer for photography, Nancy Lee had been cautious about inviting Kevin to pick up the prize. She could hardly forget the incoherent phone call on the night that he had won, but in the intervening months there had been no problems, so she decided that Kevin should be the one to collect the prize. Lee and Buirski were determined that Kevin have a great time. They made sure he had a full New York experience, taking him to plays

and the best restaurants. Kevin was captivating and fun, and his excitement at being in New York for the first time was contagious.

Nancy Lee recalled, 'We fell in love with him. I mean, he talked to us a little bit about his former addiction problems, and seemed very open and honest about it, while at the same time, very nervously needing to cash the Pulitzer cheque in New York for money so he could "buy equipment". Maybe he did buy equipment, I don't know. But when he insisted on the cash, I thought, "Why does he not just charge it?"'

The Pulitzer award ceremony is traditionally a lunch at Columbia University, and so on 23 May Kevin and Nancy Lee took a cab up Broadway running north past the plush apartments of the Upper West Side, to the stone entrance of the university on the fringe of Harlem.

Kevin was totally manic. To Nancy, it seemed as if he was on something, as though he was speeding. 'He was, like, zing-zing-zing. He literally bounced up to the stage.'

All Kevin noticed was the applause he received. He was by now fully aware of the significance of the prize, writing to his mother that 'I swear I got the most applause of anybody. I can't wait to show you the trophy. It is the most precious thing and the highest acknowledgement of my work I could receive.'

At the lunch that followed the ceremony and speeches, Nancy later told me that Kevin was loud, too loud; but Nancy put it down to his being excited, who wouldn't be? In combination with all the other quirks of Kevin's behaviour, she made a mental note. But receiving the Pulitzer is such a great honour in journalism, and Nancy really liked Kevin by then, so she put aside her reservations and enjoyed being with him at Columbia that day.

The trip was not without its difficulties. People began to pepper Kevin with questions about the ethics of the shot, about his feelings and actions when he photographed the child. A Japanese television crew had been following Kevin around the entire time, and he was getting irritated by them. The Japanese had fallen under the spell of the vulture picture like no other society. The image had clearly struck some deep

chord there and had been published again and again; programmes on the picture were aired. Schoolchildren discussed it in classes on ethics. They wanted to understand his actions and his thoughts when he photographed that Sudanese child. Questions about Kevin's ethics and his humanity were beginning to be asked more frequently; the pressure on him was building. The strain was only greater because Kevin also had his own doubts about his actions that hot day in Ayod, and wrestled with them almost every day.

That night, Nancy Lee and Nancy Buirski took Kevin to a trendy café, with a spectacular view over the East River and downtown Manhattan. Kevin began talking about himself and Ken: how he looked like Ken, how he would frequently be mistaken for Ken. And that he was devastated by Ken's death, because he was not there when it happened. Nancy said that it was as if Kevin felt that Ken was his good twin, that he was what Kevin should have been, a good person, with a stable home life. Kevin was spinning an idealized version of Ken, but after his death it was easy to make an icon of a loved friend – we all did.

In between showing his pictures to magazines and agencies, meeting and partying with friends and photographers, Kevin had also met a woman in New York that he told people he was in love with, that she was wonderful. If ever there was a moment that he could have turned his life around, this was it. He had made many contacts and people really liked him – Kevin was at his best: fun, energized and bubbling over with enthusiasm.

During that time, Nancy Lee again asked him about the picture. He talked about how he had worked the situation, walked all around the child, working the scene from different angles. What he had really wanted was for that bird to flap its wings, he said. He was describing it to her in a macho way – all Nancy could think was it was the kind of situation where most people would snap a few pictures but then see what they could do for the child.

'There was something cold in the calculated way in which he was waiting for the bird's wings to flap, for heaven's sake,' Nancy Lee said. 'I was a little surprised by that, but as time went on, I heard him telling

the story to other people. It metamorphosed into: he took the picture and sat down under a tree and cried, and that he felt he could not go back to that feeding-centre. He had just come from there and everyone was screaming in hunger and there was nothing he could do to help them and he just could not even bear to take her there. But he was sure she made it to the feeding-centre because he could not hear the screams of hunger any more.' It was an illogical explanation, but Kevin was trying to find a story that he felt comfortable in telling, that was comfortable to hear.

The first version of the story which Joao had heard from Kevin – in Sudan just minutes after he had taken the picture – did indeed mention that he had chased the vulture away. But he had not mentioned the child getting up and walking towards the feeding-centre. He had sat under a tree and wept. Joao remembered how he mentioned Megan and that all he could think of was holding her. Kevin had told a little more to his friend and confidant, Reedwaan, immediately on his return from Sudan, except to Reedwaan he said that, while he was framing and shooting the picture, the thought was going through his mind, 'Should I chase the bird away?' One part of him said chase it away, but another said, 'Just shoot, you're here to work.' He told Reedwaan that he did try to shoo the bird away after he had finished taking pictures, but that it wouldn't go far away and he just couldn't deal with it, so he walked away and started crying.

It was only really once the questions began that Kevin elaborated on the incident. In response to readers' letters to *The New York Times*, Kevin told the editors, 'that she recovered enough to resume her trek after the vulture was chased away'. That was fourteen months before he was to collect the prize in New York.

In an interview with *American Photo Magazine*, Kevin said that he had come upon the chilling scene after wandering alone for two days in the desert, 'freaked out and sunburnt', as he attempted to cope with the tragic situation he had been covering. 'There were hundreds of children starving like that and worse, you just meander from one horror to the next.' In answer to what he did after taking the picture, he said, 'I

walked away, damnit!' still upset by 'the horrible pornography' of the death and destruction he had witnessed.

But whatever Kevin felt he had to say to combat criticism about his not helping the child, I – and some of his friends – felt that the picture was something that he had done which he hoped would be free of the negative sides of his personality and character. It was an escape from his perception of himself as a failure. It was a pure moment when he shone, a moment of perfection. But the picture was not free of him – the questions were always there, and it gnawed at him. Kevin stated, in *American Photo*, 'This is my most successful image after ten years of taking pictures, but I do not want to hang it on my wall. I hate it.'

Kevin called South Africa regularly from New York. Mostly he called Julia Lloyd to speak to Megan. He would chatter away to 'his baby' and ask her if she had been brushing her teeth. But Julia also received calls of a different kind, from pay phones in the early hours of the morning: 'You can't believe the drugs here, so amazing and cheap, $40 a gram, it's incredible.' Julia kept saying, 'Kevin, shut up over the phone. What's with you?' She recalls that he had difficulty speaking as he was so stoned.

Winning the Pulitzer had given Kevin a confidence he had never had before. He felt that he had finally earned his parents' respect by achieving a triumph that was acknowledged world-wide. It was as if winning the Pulitzer made up for his failures: not finishing his pharmacy degree; his military years and the shameful suicide attempt; not managing to make a life with Julia and Megan. But mostly it would make everything okay with his conservatively Catholic father, who – in Kevin's mind – thought of his son as an aimless loser. He planned to be a perfect father to Megan. He had always struggled with money for his daughter, but now he was going to be more than just a loving father (the only picture he ever carried in his wallet was of Megan), he was going to be a good provider too.

Kevin returned from New York with his Filofax filled with new contacts and a deal with Sygma. He had made all the steps to complete

his transformation from a little-known photographer at the southern tip of Africa into a leading professional. He had always wanted to be taken seriously, and, suddenly, with his winning the Pulitzer, people were indeed taking him seriously. He had even received a congratulatory letter from US President Bill Clinton and Hillary. But the success also placed him under massive pressure to succeed. Every time he lifted a camera, he felt he had to attain the levels of the vulture picture. The photographer's cliché that you're only as good as your last picture haunted him. He knew of all the snide remarks being made about the 'budgie' picture (as the famous shot was jokingly referred to by photographers) being a fluke. Of course there was luck involved – all photography involves luck, but Kevin had gone to Sudan on his own money and had been in the right place at the right time to get that picture. And he had taken it. He deserved whatever acclaim came his way.

Kevin arranged with his father Jimmy to pick him up from Johannesburg airport on 23 June. He was euphoric and for once completely at ease with his father, with whom he had always had a difficult relationship. Back in the city, he proudly showed off his new cameras. Then he produced a bottle of wine. He knew how much his father enjoyed a glass of red wine and had selected a good Cabernet from the duty-free. Jimmy was touched by the gesture, but by the time he left, he forgot the bottle. Concerned that Kevin might take this as a rejection of the gift, he left him a message: 'Kevin, don't you drink my wine! I want it next time I see you – you'd better bring it along.'

A day or two after he had returned, Kevin called Judith and they agreed to meet for lunch. Judith, like most South African-based journalists, was in the throes of a post-headline-hogging depression. All the excitement of the elections, the thrill of reporting on history as it happened, had dissipated. The let-down of normal life – after the surreality of the previous years – combined with delayed exhaustion; she was emotionally flat, discharged. And there was Kevin, full of energy, exciting and kinetic. He was tanned and had lost his gaunt, cadaverous look. He was not as jumpy as usual and did not seem to be

stoned, which was surprising after the coked-up calls she had received from New York. People were coming over to their table to greet him. Judith felt vaguely envious.

They mostly discussed New York, but the big theme of the lunch was how he and Judith were going to team up. He was looking forward to going to Cape Town to do pictures of Mandela and to cover French president Francois Mitterand's visit – both assignments for Sygma clients.

The French president arrived in Cape Town on 4 July and then flew to Johannesburg the following day. Kevin followed him up and late on the afternoon of 5 July Kevin, Joao and Gary trailed the presidential convoy to Soweto. The street was packed with well-wishers and curious people crowded the narrow bridge over the polluted Klip River to watch the cavalcade of bullet-proof limousines slowly make their way through one of Soweto's poorest shanty towns – Kliptown. It was here in Kliptown that the ANC's manifesto, the Freedom Charter, had been drafted and signed 49 years before, and Mitterand had come to make a pilgrimage to one of the Struggle's cornerstones. The sun was sinking to the horizon through the pall of winter smog blanketing the township, and they paused long enough to make a few frames before catching up with Mitterand and Mandela. Kevin was thrilled with his shots, sure that Sygma would love them. But within days Kevin would be down again – Sygma complained that he had shipped too late for French deadlines and that the images were too poor to show to the client.

A few days later Joao was watching television at home when the phone rang: it was Kevin. His mood had changed drastically for the worse from a few days before when Joao had seen him in Soweto. The transformation, even for one who'd witnessed it so often, bemused Joao. Almost in tears, Kevin complained that his life was once again a mess. Joao listened for a while, eventually losing his temper, and told Kevin to 'Get on with it.' He berated Kevin uninterrupted for a few minutes, reminding him that he had been somewhere close by in Sudan when Kevin had stumbled on to the vulture picture, yet he had little to show for the trip. This started Kevin off on The Picture and how it had

changed his life. He felt that everything he'd done in the past had been overshadowed by this one picture. The expectations that came with the Pulitzer paralyzed him to the point that he was afraid to perform, afraid to take pictures in case he fell short.

It was a bad time to seek sympathy. Joao was nowhere near recovered from the shock of Ken's death. Neither was Kevin, and Joao knew it, but he'd had enough and all he wanted to do was deal with his own pain: 'You won the Pulitzer,' he told Kevin. 'Only you can deal with that.'

The next day Kevin called Judith, pleading with her that he needed to see her. When he came to pick her up, he was so stoned that she insisted that they go in her car to Rocky Street, a trendy, rather downbeat street lined with bars and live-music venues. Over several whiskies, Kevin described how he hadn't been able to leave his place in Troyeville for two whole days, too depressed to do anything except drugs. 'I've fallen into a black hole,' he said miserably and telling her about his 'fuck-up' of the Mitterand assignment and beginning to cry. Judith later told me that she had never seen him look worse. His skin was yellow and waxy, his eyes were glittery and red, and his hands shook as he lit one cigarette after the other. Another photographer friend came to their table shortly after and suggested they go to a third photographer's house to do drugs. There, the guys snorted line after line of cocaine, and started passing around photographs. They were all talking nostalgically about the good old days, but the good old days were only one month old.

Judith felt distinctly out of place – she didn't like what the sad memories and cocaine were doing to Kevin. She nevertheless felt responsible for him. When she finally succeeded in dragging him away, she took him back to her house. The night was cold and they stretched out with the dogs next to the fireplace, drinking coffee. Kevin asked if she would take him in for a while. He told her how he was scared to be on his own, scared of what he might do to himself early in the morning and late at night, when the panic attacks set in. If she would only let him stay for just a while, he could get himself together.

Realizing that he was on the edge, Judith agreed to let him stay with her, on two conditions: that he not use drugs in the house and that he seek professional help. 'I'm giving you three weeks,' she said, telling him not to give up his place. 'You're staying with me because it's a crisis situation, but you're not moving in with me permanently.'

# LIFE SHOULD BE ROARING

I have got to a point where the
pain of life overrides the joy
to the point that joy does not
exist . . . I am haunted by the vivid
memories of killings & corpses & anger
& pain . . . and I am haunted by the loss of
my friend Ken.

Kevin Carter

|||

By the time that Kevin moved in with Judith, I had lost patience with him. We were dealing with so many other issues that we did not have a clue about resolving, yet I felt that Kevin had been complicating the most simple matters, inventing extra drama. I didn't want to be a part of it, and I let him know. After Ken's death, I had my own fears to contend with. I had always been a physically able person and now my body was unreliable. My right thumb had been shattered, I had lost half of the muscle in my left breast and my one lung was dodgy. I didn't have energy to spare for Kevin.

Kevin was certainly quite selfish emotionally. He needed to share his pain and at that time Joao could share it with him, so the bond between them strengthened. Kevin would often tell Judith how much he loved Joao – he was an anchor for Kevin and had become a substitute for Ken. Joao was like a brother, but Kevin did not describe me like that. He

didn't feel close to me that way any more – to me it felt as if he could no longer trust me, though back then I could not understand why.

Kevin showed different faces to different people. He was living in a fragile world of make-believe that only added to the strain he was under. He had been completely open with Judith when he had asked to stay with her, but later he gave her no real indication of how bad he felt things were; he acted as if things were back on track. He was having financial problems, and had had to borrow money from Gary and Joao for the Mitterand trip to Cape Town. But he was perversely exacerbating the crisis – there were cheques owed him that he didn't collect for weeks.

Kevin kept talking to Judith about their future as freelancers; he had story- and project-ideas that he was trying to sell. He was also trying to help Gary out of a deep funk. Gary was really depressed after the death of his mentor, Ken, and his relationship with his girlfriend was falling apart. Kevin spent a lot of time with him over that period, and he told Judith that Gary was desperate and that he feared he would do something to himself. Joao and I did not know about Gary's crisis, but we suspected that Kevin was going through another bad drug patch.

Kevin was also avoiding speaking to his agency, Sygma. Their New York office had been trying to get hold of him for days. They had left messages on his pager, messages on the answering machine of a contact number he had given them, but he had not responded. They eventually asked me to contact Kevin: it was urgent as he had an assignment. I promised to try, but was not optimistic of finding him. I spread the word to Joao, Judith and others that Kevin should contact Sygma urgently, and then I left for Zaïre on my first significant assignment since being wounded in April, three months before. I was nervous about my physical readiness, but I needed to start earning money again. I was getting edgy as the weeks slipped by and the contract that *Newsweek* kept promising didn't materialize. Soon I would discover that my unease about working for that magazine was well-founded: they did not offer even one day's pay for the weeks in hospital or the months of recuperation. The last day they paid for was the one I had been shot on.

Kevin eventually made contact with Sygma and discovered that the agency had secured him a *Time Magazine* assignment to Mozambique. It was Nelson Mandela's first state visit to another country as President, and a good peg on which to hang a Mozambican reconstruction story. It was a great assignment, the kind he wanted and that the Pulitzer had made possible.

He was to leave for Mozambique on 20 July. The night before, Kevin set three alarms to ensure that he woke up in time for the flight. But he wouldn't get out of bed, even though the final alarm did wake him. He asked Judith to take him to the airport, saying his car was acting up and might not get him there. Judith had been on night shift and she was tired, but she did briefly consider taking him, knowing it was vital that he make that flight. But then she thought, 'If he misses the assignment, it's his problem,' and said, 'It's your life Kevin, take a cab.' Kevin eventually took his own car, but he was late and missed the flight. Fortunately, he managed to get on to a later flight and still made it to the Mozambican capital of Maputo the same day.

Kevin had confided to Judith that he was scared to go on the assignment. He was scared of fucking up. Looking back now, perhaps not getting up in time was a way of shifting the failure – if he failed to make the assignment, then he could not fail photographically. Kevin was heading for disaster.

When he arrived in Maputo, there were no hotel rooms available. Joao was already in Maputo, covering the Mandela trip for the AP, so Kevin hung out with him in his hotel room. While Joao souped the day's film in the bathroom, Kevin told him and Gary anecdotes from his trip to New York. He'd enjoyed his visit, partied hard and been treated like royalty, he said. Sygma had promised to help him fulfil any ambitions he might have – almost any story he wanted to cover, they would swing a deal for him. The negs were processed and dry, and now Joao had to 'file'. Kevin kept fingering his new cameras and he continued to entertain them with stories from New York as Joao got on with the tedious task of scanning and transmitting his pictures. Kevin seemed happy and Joao felt that he was over the worst.

The next day, Joao and Gary returned to Johannesburg, and Kevin headed north with *Time* correspondent Scott MacLeod. They spent six days with the UN forces, who were there to help ensure that the peace accord between the government and the Renamo rebels held. The night before he was due to return to South Africa, Kevin called Judith and promised to bring home a bag of the 'LM' prawns that Maputo was famous for. Kevin landed in Johannesburg late on Monday afternoon, 25 July.

He collected his pick-up from the airport parking lot and drove to Reedwaan's flat in Yeoville. They had been close friends since meeting in 1990 when Reedwaan was production manager at the *Weekly Mail* and Kevin was picture editor. Kevin had stopped by because he hoped to score a hit, to smoke a white pipe, but Reedwaan had given up some time ago, and he was not interested in doing buttons again. Kevin seemed intense and broody, like something was on his mind, but Reedwaan thought it was the need for a fix. In late 1993 and in 1994, Kevin had started doing a pipe or two every day. Reedwaan knew that Kevin's Mandrax addiction had reached an uncontrollable level: 'It got worse and worse. Before, I would go and score. Then we'd go together. Then he was scoring on his own and that was it.'

Reedwaan and his wife Pippa were preparing to eat dinner, and they invited Kevin to join them. He said he would just go get his gear from the car. When he returned, he was ashen. He said, 'Fuck, I've just made a big fuck-up. I've just fucked up completely, I've left my film behind on the plane.' Reedwaan went with Kevin to his car to make sure the film had not fallen behind the seat or something, but all he could see was a roll of silver gaffer's tape and a length of coiled green hosepipe on the floor in front of the passenger seat. He registered that this might be a suicide kit, but he rationalized that the tape could be for patching a camera bag and the hose in case he ran out of petrol.

Kevin and Reedwaan raced back to the airport, but the plane had already been moved to the hangers and cleaned. They spoke to several people, but no one was very helpful. After an hour, Kevin just let it slide, he gave up. 'As if someone had deflated him,' Reedwaan recalls.

He tried to buoy Kevin's spirits up by saying that all was not lost; the film would turn up. On the drive home Kevin talked about how his life was spinning out of control and confessed that he was using more drugs. 'All the doors I've opened since winning the Pulitzer are now slamming shut in my face. No one is going to want to use me because I'm unreliable.' Kevin was getting more and more agitated, he then told Reedwaan that he was going to kill himself. He had thought about suicide so often that he had even planned how it would happen: he was going to do a skuif and then gas himself: 'I've worked it out, you know, hosepipe in the car.' Reedwaan said, 'Oh, Kevin, come on.'

Kevin had spoken about suicide before and Reedwaan used to say, 'Kevin, stop it, stop talking shit. What do you want to kill yourself for? You've got so much to live for. What about your daughter?' Mentioning Megan was always the thing that pulled him back. Reedwaan later told me that he did not want to think about the possibility of Kevin killing himself, but he could feel the hosepipe under his feet.

Kevin had dinner with Reedwaan and Pippa. Before leaving, at around ten, Kevin pulled himself together enough to go home to Judith. He carefully divided the prawns he had brought, one half for Pippa and Reedwaan, and the other half for Judith. He was determined not to reveal that anything had gone wrong. There was no way he was going to show himself up in front of Judith.

The following day, Tuesday, Kevin came up with the idea of going to the dump where the airport took its garbage and paying the dozens of garbage-pickers to search for the missing film, but he never saw it through. Kevin called the *Time* Johannesburg office and said that he would drop the film off later.

That night, Kevin and Judith cooked the prawns according to her favourite recipe: the prawns were soaked in a marinade of garlic, peri-peri and beer, and then cooked until they were transformed from see-through grey to a delicious pink. The normality of the meal belied Kevin's underlying despair. Even though Kevin was sharing the house with Judith and had told her so much, he felt that he couldn't tell her

about the film. Perhaps it was something to do with the distance she was maintaining between them, her wariness in not allowing him too close. But mostly, I think it was that he was ashamed – he had put her in the camp of the achieving disapprovers – and he could not tell her about yet another failure.

The next morning, Wednesday, 27 July, Kevin and Judith woke up late, near noon. They had an argument because Judith refused to let Kevin accompany her to a dinner party that evening. She told him that they were not a couple and he got angry. But they reached a compromise: he would have dinner with his parents and she would return early so that they could meet back home around midnight. Kevin said he was going to take his film to be processed and get his car fixed.

Judith returned home from doing errands at about 2.30 that afternoon, shortly before she was due at work, and was surprised to find Kevin there. He was even more startled at her arrival, saying he did not expect to see her there. He was completely different from the relaxed, calm man she had said goodbye to at noon: he was wearing his sunglasses and was extremely jittery. He was on edge, defensive, and seemed guilty that he had been surprised by her unexpected return. Saying that she would see him later, she went off to Reuters. She did not hear from Kevin again that day. After the dinner party, she came home, but he was not there. She tried to stay awake, but eventually fell asleep.

Kevin's parents, Jimmy and Roma, had also waited in vain for him. They had arranged to meet for dinner at seven, but Kevin had warned his mother that he might be a bit late. By nine o'clock, Jimmy and Roma were annoyed, wondering if he was late or not going to come at all.

None of us would ever see Kevin alive again. He had parked his pick-up next to a bluegum tree in a park near the house he had grown up in, and had used the silver gaffer's tape to attach the green garden hose to the exhaust pipe of the idling car. He slipped the hosepipe through the narrow opening at the top of the window and smoked a white pipe as he began to write a suicide note.

Early on Thursday morning, Joao was startled out of sleep by the

telephone ringing. 'Mr Silva?' Joao hesitated, waking up fast. 'Yes?' he answered. 'Do you know a Kevin Carter?' the voice asked.

Oh shit! What the fuck had he been up to now? Joao had a flashback to the time Kevin had been arrested for drinking and driving. Maybe he was in jail; and the caller's voice had the ring of authority, perhaps a policeman. 'Yes, what has he done?' 'He killed himself last night. The note is addressed to you, sir.'

Joao cradled the handset, not sure if he was still dreaming. Could it be possible? Now? Maybe it was a sick joke. He called Kathy, to ask if she had seen Kevin. She had not heard from Kevin in a while.

Next he called Judith. She was already awake. The tone of Joao's voice alerted her that there was something wrong. She caught her breath. Joao said he had received a call that he thought might be a hoax – speaking in the subjunctive and the provisional, he was trying to remain cool. Joao said he would call Judith once he knew one way or the other. She had an overwhelming feeling that something terrible had indeed happened – she had had the feeling ever since she had woken in the early hours and Kevin had not yet come home. Finally Joao called the morgue to check. The attendant confirmed that they had a corpse they thought was Kevin Carter, and asked Joao to come to identify the body.

Joao and Viv picked up Gary and Kathy and made their way to the Johannesburg morgue. It was cold inside. They clustered at a small glass window and looked into a room where the deceased was wheeled for identification. A heavy, maroon curtain was drawn to reveal Kevin lying on a chrome tray. He was naked, covered only by a white sheet up to his waist. His face was gaunt, mouth wide open and his eyes closed. Kathy and Viv held each other, both crying audibly. Gary pressed his face against the concrete wall. Joao turned away from the window and went to stand outside, oblivious of the early morning traffic rumbling past. He stared up at the pale blue winter sky, tears running freely down his cheeks. On leaving, the morgue attendant handed Joao a pair of jeans, a T-shirt, sneakers and a suicide note that ran to several pages.

The next call Joao had to make was to me in Nairobi. I had just returned from Goma in the east of Zaïre. I was nowhere near fit enough to be covering a cholera epidemic that was killing tens of thousands of Rwandan Hutus as they fled Tutsi retribution. I had come down with a lung infection inside of a week and was recuperating in a hotel, planning to return to Zaïre as soon as I was well. Joao's voice sounded flat and distant over the echoing phone line: 'I've got bad news. Kevin killed himself.' I was shocked for a few seconds, then I grew increasingly furious that Kevin had done this. I packed to return to South Africa, cursing Kevin as I threw my gear and clothes into the bags. Why the fuck had he done this now?

Back home, we tried to understand what had made him commit suicide. Why had he finally done it without calling any of us to talk him out of it as he had on previous occasions? His suicide note did not help much, really. It was a rambling, occasionally lucid, mix of regret, anger and hopelessness. The writing changed constantly, sometimes illegible: the effect of the Mandrax as well as the carbon monoxide which was gradually replacing the oxygen in the cab of his pick-up. The letter was addressed to his parents, to his best friends and to Ken. It was an angry letter – anger at Ken's death, anger at his feelings of being let down by society at large, but mostly anger at himself. He wrote of drugs, how he had not wanted to become an addict, but that he had chosen that easy escape from the pain he felt. He knew that he needed more help than any of his friends or lovers could give. Sometimes, the writing allows one to imagine that perhaps he hoped to be interrupted. But in the end, the note posed more questions than it answered. He inexplicably itemized practical things he needed to do, like getting his own apartment, telephone and fax machine. He wrote of not giving in to suicide. 'May help be at hand & the 9mm parabellum on my mind becomes a line I just won't cross.' Yet that resolve seems to have faded; at the age of 33, he was finally overcome by the perception of his own failings. 'I have always had it all at my feet – but being me just fucks it up anyway.'

★

On the day of Kevin's funeral, Monday, 1 August, Judith's dogs went crazy. People were coming in and out of her house wanting information on Kevin's last days, to collect things of his, and looking for emotional support. Judith was emotionally overwrought. She kept replaying the last two days in her mind. The dogs were disturbed by the visitors and picked up from her mood that something was very wrong. Minutes before Judith was to leave for the funeral they began fighting in the enclosed yard. She usually separated them by spraying them with water from the green garden hose. But the hosepipe wasn't there. It was the hosepipe that Kevin had been carrying around in his car for over a week and that he had finally used to commit suicide.

I suffered through a difficult funeral service, during which the Catholic priest said he was sure that Kevin had been to Mass in New York City and had surely made his peace with God. Joao got up and walked out, livid at what he took to be hypocrisy. I thought that Kev had not stepped into a church for religious reasons for more than a decade, and felt angry. But we were too harsh – the priest had wanted to soothe Kevin's parents with a Catholic funeral service; and perhaps we were wrong – Kevin had told his parents that he had indeed been to Mass in New York. Joao, Gary and I, along with family members, carried Kevin's surprisingly heavy coffin to the hearse. We slid it on metal runners into its dark interior and the attendant shut the door, then drove off. I was confused as the hearse disappeared. Weren't we meant to follow it to the cemetery? But he was to be cremated, and his ashes would be buried among the roots of a rosebush at the church in a family ceremony two weeks later.

At first, Julia told Megan that Kevin had had an accident in his car, and gone to heaven. But Megan watched the news on television and had heard the presenters say that he had gassed himself in his car. Megan wanted to know exactly what he had done and how: she was worried her dad had died in a terrible place. So Julia took her to the Sandton Field and Study Centre and showed her. Megan was relieved. 'There are nice birds here.'

That was one of a series of closures on Kevin, farewell rituals that

were prolonged as we tidied up his loose ends. When Kevin's father, Jimmy, went to collect his son's pick-up, he found laundry for Roma to wash and, to his surprise, the bottle of Klein Constantia Cabernet that Jimmy had left behind at Kevin's place, the wine that Kevin had bought him when he returned from New York, a sign of his having made his peace with his parents, of their rediscovered affection.

On the morning that Kevin killed himself, a packet of letters from Japanese schoolchildren, written to Kevin and telling him about how his Sudanese picture affected them, arrived at his parents' home. The letters were written by students at the Dai Roku Nippon Primary school in Arakawa Ward, Tokyo. Extracts were read out at the funeral:

'If I will be caught in a bad or hard situation, I will remember your photo and try to get over the situation.'

'I have been a selfish person until now.'

'Since I saw this photo, I make an effort to eat everything.'

'I would not take the picture and rather give water to the girl.'

'I would take a shot with shivering hand.'

The news of Kevin's death prompted one Japanese reader, Hisaye Nakajimaa, to write to the newspaper *Asahi Shimbun*, a letter that could stand as Kevin's epitaph: 'I can hardly believe that I was the only person who felt it too harsh to criticize Mr Carter for "not having saved the girl before taking the picture". I cannot stop praying that Mr Carter have a peaceful mind in the heaven. He left us with a picture that exposed us to a scene that is too sad to be passed by.'

# A NEW SOUTH AFRICA

Nobody listened to us.

Sylvia Dlomo, a mother of a murdered activist

|||

In the wake of the 1994 elections, South Africa was changing fast. The violence was over and we were doing stories about the transformation from white supremacist rule to a non-racial democracy. Despite set-backs, the ANC-led government set in motion ambitious plans to eradicate the vestiges of apartheid. The homelands were being disbanded. A remarkable new constitution was being written. Clinics and schools sprang up in remote rural areas and townships. It was an exciting time, but we spent a lot of it dwelling on Ken. We built him up into a hero, even though he had done nothing heroic – he had been shot by accident while doing his job. We were consumed with ensuring that he not fade from the public memory.

Joao and I did not realize it at the time, but now, looking back, we made a hero out of Ken to assuage our feelings of self-doubt. If we could feel good about Ken, we could feel good about ourselves. At the time we felt we were guilty, but in retrospect I think this guilt was substituting for a more nagging emotion. What exactly had we done to earn the guilt? At times, we felt like vultures. We had indeed trodden

on corpses, metaphorically and literally, in making a living; but we had not killed any of those people. We had never killed anyone; in fact, we had saved some lives. And perhaps our pictures had made a difference by allowing people to see elements of other people's struggles to survive that they would not have otherwise known about. There were times, like at Nancefield Hostel, when I was guilty of inaction, of just taking pictures; but I was not guilty when tens of thousands of Hutus had been dying of cholera in eastern Zaïre or when I had photographed police opening fire on unarmed civilians in Boipatong. The feeling of guilt is surely more to do with inadequacy, an inability to assist. We should feel bad after witnessing each suffering even though we are not responsible for it. But real guilt can be dealt with: we can confess, or flog ourselves every morning before breakfast. Dealing with an intrinsic inability to help, our own inadequacy, is much more difficult, even impossible – we are always going to be inadequate to help all those who need it.

A group, consisting of Monica, Ken's mother, his colleagues and friends – and including Joao, Robin and I, helped arrange an exhibition and began planning a book of Ken's photographs. All of us had our own motives; there was a possessive, slightly jealous aspect to each of our endeavours to preserve 'our' Ken.

It was different with Kevin, however. We were inevitably more ambivalent about his death, and I remained angry with him for a long time. We spoke to journalists who were doing stories about the 'Kevin Carter tragedy' – but with a certain reluctance. In addition to the numerous articles, a rock band wrote a song about him, and he was the subject of a minor play. The theme was generally 'the man who had seen too much'. But there was a part of me that saw his death much more in the light that the young fighters in Thokoza did. One day, when Joao and I had gone to the dead zone in Khumalo Street close to where Ken had died, we had run into a group of coms who remembered us. The houses there were still uninhabitable, burnt-out shells. The former self-defence unit members still hung out there though, because they had no place else to go. One of them had read of Kevin's suicide in the papers, and he sneered: 'Why did he kill himself,

was life too tough?' I could think of no suitable response.

It took me a year to recover fully from my physical injuries. But all that time I had a heightened sense of urgency, a desperation about time. I wanted to cover every news story around the world and document every aspect of society in South Africa. I was angry with myself about the time I had wasted, frustrated at what I had not achieved, astonished at the thought that if that peace-keeper's bullet had been angled a degree more acutely into my chest, it would all have been over. As soon as I could, I went on a flurry of stories around the world, covering life in Chechnya's liberated zone, a village caught up in a caste-war in India, the legacy of fear among Rwandans who had survived the genocide. I also regretted every woman I had let slip through my fingers. I was as unsatisfied and fretful as a greedy child and I broke up with Heidi early in 1995. It would be generous to say I was having an early mid-life crisis.

Joao also focused on overseas assignments – and on regaining the closeness of his relationship with Viv. But he found that he had changed too. In late 1994, when he was in Afghanistan for the AP, he followed the old caravan-route from Pakistan through the Khyber Pass into Afghanistan. The road to Kabul was littered with the shattered wrecks of Soviet tanks and vehicles. The city of Kabul was suffering frequent artillery and rocket attacks, and one day, soon after he had arrived, a barrage of rockets landed close to where he and the AP's Afghan reporter were driving. They turned a corner just seconds later and Joao saw brown clouds of dust from the explosions still hanging in the air as people ran for cover. It was potentially one of the most powerful war scenes Joao had ever witnessed. He told his colleague to stop. But as he got out of the car, a man emerged from the dust. An injured child was draped limply across his arms and he came straight to the car, holding the child out in a mute plea for help.

Without hesitation, Joao helped them back into the back of the car and they raced for the hospital. When they got there, Joao finally took pictures as the man carried his child into the casualty room. He stayed to watch the doctors try desperately to save the little boy, but he died on the operating table. Joao often thought about that day: how he had

chosen not to take pictures, but had rather tried to save a child's life. It would have taken just 1/250th of a second to take an image, but his instincts had changed. At one time, he would have taken the pictures and then, maybe, got around to helping the child. 'Those were good war images which I chose not to shoot. I had never done anything like this. But . . . the child's dying made the humanitarian deed seem somehow pointless.'

I was finding the new South Africa very liberating. Hundreds of years of social engineering on the basis of race was, however, proving difficult to overcome. But I saw hope and progress wherever I looked. I found that I had mellowed too – where I used to bristle and sometimes confront racists, I gradually began to ignore them. It was their problem. They no longer held the country's fate in their hands.

But we couldn't quite leave the past behind. For one thing, the inquest into Ken's death began in July 1995. Every unnatural death in South Africa has an inquest, though they are sometimes perfunctory. But Ken's mother and Monica wanted to ensure that the inquest – which would determine who was at fault for the shooting – was properly conducted and they hired an expert criminal lawyer. I had always known that it was the peace-keepers who had shot me and killed Ken. I had heard the gunfire all around me, and knew which direction we had been hit from. It also seemed obvious from the video footage and Ken's final pictures of the soldiers against the wall, and then the last frames, blurred as he fell, fatally wounded, with his finger locked on the motordrive. Neither Joao nor I particularly wanted to recollect that day in the detail that an inquest would require, but we came around to doing it for Ken's family.

Initially, it seemed that the matter would be uncontested, but on the third day of the inquest, a team of white lawyers hired by the army (now a volunteer force that had been integrated with the former liberation armies; but it was still the military, and as protective of their own as they had ever been) arrived at the Alberton courthouse. As they unpacked their briefcases, one of them initiated a snide little racial exchange with the Afrikaans magistrate. I knew we were in for trouble – we

represented the part of the press who they assumed had helped ruin their paradise. Worse yet, as whites ourselves, we were traitors. The case was now going to be about more than just who had shot Ken. The undercurrent which emerged was that we deserved to be shot. 'What were you doing there?' was one of their key arguments. It infuriated us.

One of the issues at stake was the possibility that Ken's heirs and I could sue the government, but it was far more than that for all of us. The inquest, which should have been a dignified rite of passage, a way of closing the Ken-chapter in our lives, became instead a means of laying the blame for Ken's death at our door; on his, and our own, actions. Somehow, the proceedings went beyond any sense of getting at the truth for Ken's sake. It had become our own little battle with the vestiges of the apartheid authorities. It was personal and very nasty. Some of our friends thought we had become obsessed.

One of the most important witnesses was Gary Bernard, who had held Ken in his arms in the seconds after the shooting. Gary had never been quite the same since that day – he had always been too fragile to have covered the violence, and the death of his mentor and friend had been a final straw. He was terrified of testifying, of reliving that day. In light of the grilling the army's lawyers had given me, it was clear that he was in for a rough time on the stand. Gary did not think he could withstand it. I was unsure if the trauma of reliving Ken's death would be too much for him, but I was also convinced that if he did not do it, he would forever feel that he had betrayed Ken. The days before he was to testify were tense and the last hours almost unbearable. In the echoing corridors outside the courtroom, I told him that testifying was a test of friendship that would not be offered again. When Gary did get up on the stand, it was clear from the first minute that this was a man on the verge of breakdown – the cross-examination was mercifully easy and without malice.

The inquest dragged on for 15 months and, in that time, Joao drew a collection of comical cartoons of the opposition defence-team and the magistrate; during Joao's cross-examination, one of their lawyers complained to him about the satirical drawings, saying they were

insulting. Joao said he didn't give a shit and, again, our lawyer had to calm things down. In April 1996, in the middle of it all, I went to Jerusalem to be the AP's chief photographer. I was glad to get away, and I was hoping it would be a chance to make an emotional break with the past. But seven months later, in October 1996, when the magistrate was due to pronounce his findings, I found that I was still bound to that period. I could not keep my mind on work and kept calling Joao on his cell-phone to see if a conclusion had been reached. I was pessimistic about the outcome, despite overwhelming evidence and the ballistics, which showed that the peace-keepers were the only ones close enough to Ken to produce the wound he had suffered. That afternoon, Joao called. His voice was flat. We had lost.

The magistrate had ruled that no one could be found responsible for Ken's death. I was not surprised, but I was still swamped by a mixture of anger and despair. Beaten, I left the office and spent the rest of the day on the phone to friends in Johannesburg. Joao said he had never felt so defeated in his life.

A couple of months later, I was watching the last rays of the sun warm the ancient stone of Jerusalem's walls. The breeze from the desert was dry and crisp, and all of a sudden I was angry with myself. How could I not have gained any wisdom from what I had gone through? Surely anyone who witnessed and lived through what I had should be wise? But all I had was knowledge, a collection of jumbled images, smells and sounds buried deep inside. These were memories that I was too afraid to approach. Had all the work I had done just been a form of voyeurism, and escape from my own demons? Despite my dread, I knew that the time had come to begin unravelling those experiences, and that the only place to do that was back home.

While I had been away a far more important process had begun in South Africa. The new government had set up an independent Truth and Reconciliation Commission, led by the Nobel Peace Prize-winner Archbishop Desmond Tutu. The Commission was mandated with uncovering the truth about South Africa's past, as well as reconciling seemingly irreconcilable enemies. To all appearances, it was an

impossible task – how could a commission uncover all the lies, deceit and midnight burials that took place during 35 years of authoritarian rule? How would it open up what had happened in the underground world of the guerrilla movements? The process began amid much controversy: some wanted Nuremberg-type trials and others wanted a general amnesty in order to close the chapter on the past as simply as possible. My thoughts were that the Truth Commission would be a white-wash, with a lot of kissy-kissy-let's-all-make-up. But the process turned out to be remarkable. It allowed victims of gross human-rights abuses to finally tell their stories. Mothers heard men confess to having killed their children; victims of torture had the chance to confront their tormentors in public. Many people came forward to confess to crimes they had committed: unbelievable atrocities and acts of petty hatred that finally belittled the perpetrators much more than the victims. The worst we had thought of the apartheid regime was far surpassed by the truth.

There was the chilling scene of a police torturer demonstrating how he did his work. It was clear that he was a man broken by what he had done, by what he had been so skilled at. At a police conference a few months after his testimony, all his white police-colleagues shunned him because he had revealed the truth, broken the code of silence. The only person who would speak to him during the tea breaks was one of his former victims, a guerrilla he could not break, who in the new South Africa had ended up becoming a policeman.

The commission also wanted to promote healing, a national reconciliation, through revealing the truth and allowing forgiveness and closure, but that was only partially achieved. It became clear that, unlike the torturer, most South Africans were not always willing to trust the amnesty offered for full disclosure. Most perpetrators did not come forward, but enough did to verify that the white regime had used hit squads and ordinary policemen and soldiers to kill blacks and undermine the liberation movements, even while it was negotiating 'in good faith' with them over the gradual retreat from apartheid. It was also clear that many in the ANC and the liberation movements felt they should be regarded as above criticism, despite the fact that their members and

leadership had committed crimes in the fight against apartheid which were far from compatible with retaining the moral high ground – even though they had committed a fraction as compared to the regime and Inkatha.

The big fish never confessed, however. Everybody in South Africa knew a little of what was going on and many knew a lot. The commission did not believe that the top Nat politicians involved with security portfolios and the generals did not give the orders or knowingly lay down the parameters that led to the carrying out of extra-judicial executions and other illegitimate acts by their subordinates. Of course they never donned balaclavas or carried guns in Boipatong on the night of that massacre, nor was it likely that the President actually gave specific orders for any individual killing, but they certainly created the framework for it all. They made and approved the budgets that paid the killers, that trained and armed the Inkatha hit squads, that allowed doctors to research chemical and biological weapons that would only kill blacks and leave whites unharmed. Former President F.W. de Klerk, who had jointly received the Nobel Peace Prize with Nelson Mandela, refused to acknowledge that he had known about any of the dirty tricks or illegal killings carried out by his security forces. In fact, on page 225, volume five, chapter six of the commission's report, there is a heading, 'Finding on former State President F.W. de Klerk', and the space below it is a solid, inky black. He had managed to get a court to order that the findings on him be concealed. Typical, considering that the government he presided over had launched a frantic effort to illegally destroy as many incriminating documents as possible before the ANC took power. The politicians let the foot soldiers take the heat. Ironically, by not confessing to responsibility for any crime, they were unable to apply for amnesty and so have left themselves open to possible prosecution.

In the period from mid-1990 to April of 1994 – when Ken, Kevin, Joao and I had covered the Hostel War – 14,000 people died in the low-grade war between the ANC and Inkatha. Yet none of the Inkatha leaders came forward for amnesty. The Truth and Reconciliation

Commission's figures tell the story: Inkatha was the primary non-state perpetrator of human-rights abuses and was responsible for a third of all violations reported to the commission (just ahead of the state). Commission statistics show that for every Inkatha supporter killed, more than three ANC supporters died in political violence.

The wounds were healing nevertheless. The single most violent place we photographed, Thokoza, had managed to recover from all the bloodshed. There was no longer a deadly no-man's-land, even though the political boundaries still existed. The Inkatha supporters who once occupied the homes abandoned by fleeing residents had been forced to make way for the original owners, who gradually moved back in, repairing and cleaning. Interior walls that were once blackened by cooking fires were repainted and the rotted ceilings replaced. But the walls and fences still bore the bullet marks from the years of war – from 'the Violence', as people referred to that era. The shops on the corner of Madondo and Khumalo Streets were still burnt-out husks, but the petrol station on Khumalo Street, where Ken had died, had been renovated.

The dead still cast a shadow over the living. A little further down Khumalo Street, a monument has been erected to those who died in Thokoza. The mass of names is startling, all etched in black stone. Ken's name is there, as is Abdul's, though Joyce's granddaughter Mimi is not named on the granite. Nine years after Mimi was murdered, Joyce – who still comes in once a week to clean my house – continues to hope that Mimi will one day be freed from the control of the zombie-mistress and return home.

Tarzan and Maki Rapoo bought a plot of land on the former front-line facing the Meadowlands Hostel, on the 'shortcut to heaven' road, shortly after the 1994 elections. The passing of the apartheid era was the start of a new life for them. They felt they would never again have to endure the violence and loss, and they were confident enough to put down roots in a South Africa that they truly belonged to.

When I was invited to celebrate Boytjie's 75th birthday in February 1999, it was in the yard of a modern, spacious house and not the cramped Soweto matchbox in which most of the Rapoos had grown

up. Boytjie wept as he blew out the scores of candles on an oversized cake. I took pictures. I am still the family's official chronicler.

Joao had been part of the AP's pre-election build up in South Africa. After the elections, however, the AP began down-sizing and reorganizing. They were cutting their budget and no longer needed someone to cover the bang-bang full time. Joao was offered jobs he did not want, and was not getting most of the foreign war assignments he asked for, and he resented it. After risking his life over and over for the agency, he had naïvely expected they would reciprocate that commitment. He did little to help the situation, choosing simply to withdraw when the AP cut its rates and asked him to stand by for days on assignments that never materialized. He also struggled with a nagging guilt about the pictures he had taken of Ken on the day he was killed. Joao had taken those pictures because it was what he had learned to do and what he knew Ken would have wanted him to do, but those pictures had moved on the wire. A personal moment had become a business moment. He didn't feel good about it.

Before I left for Israel in 1996, I had encouraged Joao to take over the gig that I had developed with *The New York Times*. It was not the kind of work he usually did. Both he and the *Times*'s chief correspondent, Suzanne Daley, had their doubts that photography without the excitement and compelling uncertainty of conflict would hold his attention. She was worried that he would be sullen and unenthusiastic. But from the outset, he worked hard for his pictures – no matter what the subject – and was good company. He would still leave for the occasional war, but he took increasing pleasure from the assignments he went on with Suzanne.

After I returned from Israel in 1997, much of the euphoria about the new South Africa had faded. While the big picture was good – we had avoided the civil war everyone thought inevitable, and a racially divided society was slowly normalizing – there were nevertheless major problems. The Struggle had been won, but there was no economic miracle to accompany the political one. The new government had to repay massive loans that the previous regime had taken to finance

apartheid. The poor found their lives more difficult than ever. Employment in the lowest wage-earning sectors was on the decrease. And many of the former self-defence unit fighters felt abandoned by the ANC: they saw former exiles and the political elite driving fancy cars and living in wealthy formerly all-white suburbs, but most of the poor and the militants, the young lions, had been left behind. In a country awash with weapons, some turned to crime to make a living. I had become close friends with a former comrade, a hero of the Hostel War, and in the years after the war he was regularly approached to do assassinations. He was upset that everyone assumed former self-defence unit combatants were now all criminals, and he was angry that his being unemployed allowed people to think he would kill for money. Like many of the informal ANC fighters, he found that he had been deserted by the movement. Despite being wounded and partially disabled in the conflict, he was not eligible for a state or an ANC veteran's pension. On the other hand, the majority of the most notorious secret police agents and policemen still had their jobs. Other apartheid bad boys were given golden handshakes.

Despite the problems, I was happy in the New South Africa, and for Joao and me, life had settled into a manageable rhythm. But Gary Bernard was in trouble. One winter afternoon in 1998, Joao and I received a call from Gary's housemate telling us that he had come home to find Gary unconscious. He had taken an overdose of anti-depressant tablets while on a crack binge. Falling unconscious was the only thing that had prevented him from killing himself in the same way Kevin had – there was a length of hosepipe and gaffer's tape in his car. We took the hosepipe and tape, but there was an awful sense of this having been played out before. Gary had become addicted to crack as a way of escaping his demons. With Robin – his boss at *The Star* – we spent hours in his bedroom trying to talk to him about the attempted suicide, telling him he could not do a Kevin on us, but he just lay underneath the duvet, refusing to speak to us.

We eventually forced him to go to hospital, where he spent three days in intensive care. After Gary was discharged, we drove him to a

drug rehab centre. He did not want to go, but Robin told him that unless he went for treatment he would lose his job. During the entire six-hour journey he said no more than a few perfunctory words to us. We had become the enemy, we were trying to come between him and his fix. Within an hour after we had dropped him off, he left the centre and returned home. He went on a binge but then checked himself into a Johannesburg centre, where he made a real attempt to kick the crack. Some weeks later, he began talking to us again, explaining his addiction and the things in his life that had so fucked him up. He was going regularly to therapy and Narcotics Anonymous meetings and was doing well at work again – he had even won the same top South African press award that Ken and Joao had earned. It seemed to me that he was beginning to turn things around, but I was disappointed with him and had decided to keep my distance.

On 12 September 1998, Gary would go on an all-night crack binge. In the morning, he carefully arranged a duvet and pillow on the floor of his kitchen, attached his vacuum cleaner hose to the gas stove outlet and then opened the tap fully. He lay down and put a plastic bag over his head and slipped the hose into his mouth. When Joao and two other friends got to the flat that night, hours later, Gary's eyes were open and his hand stiffly frozen in the position in which he had held the pipe to his mouth. It was a rainy Saturday night in spring and I was on assignment out of town, some 300 kilometres away. Yet again, it was Joao who had to call me with the news of a friend's death. I raced back along the highway slick with rain, I wanted to get back in time to say goodbye before the body was removed. The endless back and forth motion of the windscreen wipers and the hiss of the tyres kept my thoughts going round in circles. I kept thinking about the decision I had made after his previous suicide attempt. I had decided that I would not help Gary any more, that I could not do any more for him. I had mentally played through a scenario just like this, in which I would hear that Gary was dead. In that make-believe rehearsal I felt I could justify my withdrawal – I could not watch him 24 hours a day nor could I force him to choose life over death. But I still felt like a shit.

# FINISHED BUSINESS

Redemption is living with one's self.

Joao Silva

|||

*24 January 1999*

I was sitting low in the drainage ditch, bullets whizzing several feet above me. I had been eyeing possible cover throughout the morning and when the inevitable gunfire broke out I immediately knew where I wanted to be. The handful of journalists and photographers with me in Ndaleni township in Richmond, KwaZulu-Natal, that misty summer's morning, were amused, but theirs was an uncomfortable laugh.

They were not sure whether to join me or to keep well away from me, because, despite being wounded twice more since the Thokoza shooting, I had survived. My thoughts were not quite the same as theirs. 'What the fuck am I doing here?' ran through my mind several times – I had half-promised myself to stop covering this kind of stuff. Doing cat-portraits was something I recall mentioning. One reason was that the bloody political turf battle going on in this small town was too interesting to resist, but there is no single, simple answer – perhaps it is just the way I'm wired.

In the years since 1994, I had been shot once with buckshot during some riots in a township and once more seriously just a few months previously, when South African troops had entered the tiny land-locked kingdom of Lesotho to restore order after a partial military coup. Joao had been with me on both occasions, as we continued to work together whenever the bang-bang went down. He had always escaped un-scathed. The Lesotho episode had, however, been one of the scariest moments in both our careers.

Lesotho had been brewing a coup for weeks and, as we made plans to visit this mountainous rural country in the middle of South Africa, the *NYT* bureau chief Suzanne, Joao and I were expecting to cover a charged political story with perhaps the chance of the occasional shot being fired. As it happened, South African troops, as part of the regional mutual defence agreement, had invaded during the night. But we still did not take the situation too seriously, expecting the vastly superior South African army to have the little country under control by the time we got there. Our biggest fear was, in fact, that we had missed it all. As we got nearer to the Lesotho border, we saw massive palls of smoke rising in the distance.

Lesotho's capital, Maseru, is not far from the border post and soon we were amidst the looters ransacking the downtown business area, carting away as much as they could carry and setting the rest on fire. We heard on the radio that the Lesotho army had made a last stand and had then surrendered at the army barracks just outside of town, so we decided to drive out there and see. Suddenly at the entrance to the base, which looked deserted, we started taking sniper fire. We scrambled out of the car and ran for cover behind a guard-post.

After a while an armoured South African column came by, the soldiers looked at us and left. They had taken no fire, so we dashed back to the car with the idea of getting out of there. But, just up the road, we ran into the column again. This time they had been stopped and were taking heavy fire. It was an ambush and we were caught in the middle of it. We ditched the car and Suzanne took cover in a shallow gully, where she spent the next hour unable to see a thing, just hearing

the sound of the battle raging all around her. Joao and I ran straight towards the action and into a scene of utter confusion. The bullets were whining past us as we tried to find places among the armoured cars that would offer us protection from the cross-fire. That's when we laughed. This was good bang-bang. Right in front of us, a South African soldier roughly pulled a dead comrade out of a light tank and dumped him at the base of the ambulance that was also armour-plated. The medic inside paid no attention, he was too busy working on injured soldiers. The most bizarre part was that he was standing on the corpses of two other soldiers. We were getting good pictures.

The column finally retreated and we were able to use them for cover and leave too. But a few kilometres away, at a South African army staging area, it became clear that a larger and better-armed column was preparing to go back to engage the BaSotho soldiers at the base. They were to replace the bloodied unit we had been ambushed with. Joao wanted to follow it. That's when we had an intense discussion about what to do next. Suzanne though that going back was ridiculously dangerous and argued that Joao already had more pictures than certainly the *Times* would ever use. Joao argued that the story wasn't over and he wanted to see it through. I agreed with him, but there was no way I wanted to go back down that road. So we found a compromise of sorts. We would stay back a couple of kilometres until the battle was over and then go in. We all thought it was a matter of an hour or two.

I selected a safe-looking dip alongside the road to park in and we sat listening to the sounds of the battle. It was hot and we wondered if the shop a little up the road was open. Then a machine-gun opened up on us. The rounds were hitting the earth bank behind us as the gunner began to find his range. I started the car and pulled off as fast as I could making a U-turn. But as I reached the middle of the road, the car stalled. The gunman then had time to correct his aim. A bullet came through the wheel-well of the car and hit me in the leg. I also felt a sharp pain in my solar plexus, and I could not breathe properly. It seemed like I had been hit twice, but I did not want to think about it. I concentrated on getting the engine started, hoping I could still

operate the pedals. I did not want to tell Suzanne or Joao that I was hit until after I had the car going again, then I screamed 'I've been hit.' There was a lot of yelling and screaming going on inside that car, as the bullets cracked and whined through the open windows. As I sped down the road, the fusillade of bullets continued. I was completely terrified, bracing for the pain of more bullets entering my body. The magic bubble of invulnerability had once again been burst, and I felt as helpless as I ever had in my life. I have never been more scared. Yet, even in my state of panic, I noticed that the people who had gathered at the side of the roads to watch the outcome of the battle between their army and the invading South Africans were fleeing the verges of the road as we approached – we brought with us a rain of bullets. But we finally did escape the machine-gunner's range and I pulled over to let Joao drive.

I looked at my chest and saw no wound, nothing. I must have jerked forward as I was hit in the leg and pulled a muscle. My trouser-leg and right boot were soaked with blood. Still, I was relieved to note that I could move and feel my toes. As I hopped around to the passenger side, I noticed that the tyres had also been hit, and that the race for safety had shredded them. Joao took over, but by now the car was struggling, the shredded rubber was wearing down rapidly and Joao was trying to keep it going as fast as possible. The fuel gauge read empty – the tank must have been hit too. We were still about ten kilometres short of Maseru, where the South Africans were presumably in control and we would be safe.

Along the way we caught up with the retreating South African column that we had been ambushed with. We came alongside their armoured medical Casspir, and I caught the driver's eye and showed him my bloody leg, but he just waved us forward. The message was clear – they were not going to stop until they got to Maseru. Suddenly, there was more gunfire. I could hear bullets flying close by us again and could see the dust dance on the walls of houses and shops alongside the road as the South Africans returned fire at their hidden attackers. Joao just kept the accelerator floored as we passed the lumbering column. At

one point he was doing 110 kilometres an hour on two tyres and two bare rims. When we came to a traffic circle it was clear we had lost the brakes too. But in the end, Joao got us in to Maseru. There the South Africans bandaged my leg and agreed to chopper me out with the rest of their wounded. Leaning on a fence, waiting for the helicopter, I fainted. But Suzanne caught me.

After our close call in Lesotho, the word throughout the photographic community was that Marinovich was a human target, a bullet magnet. Word had spread as far as Baghdad, where one of my friends told me there was a debate going on about whether it was dangerous to be beside me or whether that might be the safest place in the world because I always got the bullet. Very amusing. But I had begun to wonder about my luck too. Joao, besides taking far more chances than I ever did while photographing, had also taken up a long-time passion for fast cars and had begun motor-racing. Shortly after Lesotho, he walked away from an 180kmh crash at Kyalami racetrack without suffering even a bruise.

The Lesotho bullet sliced through the back of my lower calf, but luckily missed the tendons. I was basically flat on my back with my leg up and oozing for almost four weeks. But no real permanent harm had been done. Still, my caution under fire in KwaZulu's Richmond just four months after Lesotho was understandable. Let them laugh, I griped to myself.

Whether taking to that convenient Ndaleni ditch had saved me yet another bullet that day, I will never know. But it introduced me to a heavy-set man who huddled near me, a revolver hidden in a shoulder-holster under his shirt. His name was Brian Mkhize and 11 of his relatives had been massacred the night before as part of the feuding that had been going on here between the ANC and an upstart political party, the United Democratic Movement. I kept seeing Brian Mkhize throughout that day, as clashes and an attempted revenge-assassination by the warlord's bodyguards and militants kept the village and the township cooking. Things eased off in the afternoon and I was resting on a grassy bank outside the police- and military-command centre with

several journalists, when a young television cameraman Dave Coles cracked, 'Every time I see you, you're getting shot at.'

Then Mkhize, who was sitting alongside us on the grassy embankment, said: 'Be careful you don't get killed like Oosterbroek!' Dave, the cameraman, jovially responded that I had been shot with Oosterbroek in Thokoza. This was too strange. What did a guy living in a village hundreds of kilometres from Thokoza know about Ken's death? How did he come up with that comment? I began to quiz him.

It turned out Mkhize had not only been a peace-keeper in Thokoza that day, but he was among the soldiers cowering against the wall with us. I tried to hide the emotions churning inside as we talked, but I couldn't help myself. 'Then you were one of those bastards who shot us!' I said. He turned away laughing. 'No, it was Inkatha from the hostel who shot you.'

'No way,' I said, the blood rushing through my ears making it difficult for me to hear myself speaking. Was I shouting? 'We were behind the wall. If the shooting had come from the hostel, it had to go through the wall, and the wall had no bullet marks on it. It was you guys, I know it was you and you know it!' I pulled back, controlling the anger, remembering that he had seen his own family massacred just the night before: 'But it was a long time ago. It does not matter now, and anyway, it was an accident.' Mkhize readily seized at the escape route offered, and agreed that it had been an accident.

I was stunned. Was a peace-keeper actually admitting that they had been the ones to shoot us? It was almost five years after Ken's death in Thokoza but it somehow had remained a festering sore. The pain only recently had begun to lose its sharp edges. I wanted to know more – for Ken's family, for me, for the record – and I asked Mkhize how I could reach him.

Back in Johannesburg, I told Joao about this chance meeting. He and Viv had just announced that they would get married the following month and their happiness turned into a moody retrospection. We began checking up on Mkhize and everything he had said about himself was correct. But his name was not on the list supplied to the

court by the military authorities at the time of the inquest. Was Mkhize an avid newspaper-reader who had inserted himself into an event to gain dubious credibility, or was he telling the truth, and so validating our belief that the military had covered up their role in Ken's death?

There was only one way to find out, and two weeks later Joao and I drove down to Durban to meet him. We were both anxious, tense and testy with each other. I was unsure of how to approach Mkhize. I did not want to say something that would turn him off talking to us. I had earlier cautioned Joao to keep his temper in check – the subject of Ken's death usually made him aggressive, or he would instead withdraw into a sullen, oppressive silence that could be extremely intimidating.

I need not have worried; Joao, of course, wanted to hear what Mkhize had to say as much as I did. We had arranged to meet Mkhize at his family's home in KwaMashu township, outside Durban, but he was not there when we arrived. We waited for two hours, watching cats, dogs and chickens in Ma Mkhize's backyard. We started quizzing her about her son. She told us that he and all four of his brothers had been ANC soldiers in Umkhonte we Sizwe (the ANC's armed wing), and that Brian Mkhize had indeed been in Thokoza as a peace-keeper in April of 1994. After a while the conversation dried up, and we decided to leave: there was no point in waiting at the house if he was avoiding us.

It was 14 February, and Ken would have turned 36 that day. Joao kept thinking about the irony that we might meet one of the soldiers who had possibly killed Ken, on his birthday. Even though Joao reminded me, I forgot – the coincidence did not have much meaning to me. I am not sentimental, nor given to omens. I did, however, want to find out more: I was curious to know what a peace-keeper had been thinking of when he or his colleagues had shot us. I wanted to know if there was a relationship between the person who pulled his forefinger to release those bullets, and myself, on the receiving end. I had always been sure that it had been an accident, but was there more to it? And afterwards, had any of them expressed a malicious glee that journalists

were dead and wounded, even if it had been accidental? Or had there been regret?

We called the Mkhize house at midday, and Brian was there. He said he was tired, and needed to sleep – but agreed to a meeting later that same afternoon. As Joao and I again drove towards his home in KwaMashu township from our hotel in Durban, we were not sure that he would be waiting for us; and if he was there, we had no idea what he had to tell us. The memories of Ken's death had been swamping us ever since Mkhize's unexpected revelation in Richmond. It had been five full years since that day in Khumalo Street. Joao and I had started writing this book almost two years previously, partly from a need to tell what had happened during the Hostel War: so much more than that which we had managed to capture on film. We also needed to understand the people we had been in those years, and while the writing had not provided us with all the answers, it had, at least, clarified the questions. We began to query just why it was that we were so hung up on Ken – on proving that the peace-keepers had killed him and on ensuring he did become an icon of South African photography. There was more to what we had been doing than creating a ritual closure which the inquest had failed to deliver. We had partly been using Ken's death as a shield against having to address why we continue to do work that has brought us so much guilt and pain.

As we approached the Mkhize home, we were hoping that his confession would give us the chance to let go of Ken, to allow us finally to confront ourselves without the filter of Ken's memory. If we could let go of the past, we could move on, cease the morbid obsessions that settled on us from time to time – as Viv had said to Joao back in 1994, 'You don't smile any more.' We wanted to regain the joy we used to get from photography, as well as a full enjoyment from the ordinary things in life – something that had been impaired over the last years. It was time to put things in perspective: we had not personally suffered like some of the people we photographed, but neither were we responsible for their suffering – we had just witnessed it.

We parked on the grass verge outside the house and as we got out a

tall man stepped forward from a group of black youths who had been looking curiously at us and said, 'The guy you want is inside. Go on in and wake him up.'

In the lounge we waited apprehensively on the edge of the soft couch. A soccer match was on television and the sound was turned way up. Then Mkhize came out, rubbing the sleep from his eyes. He suggested we go talk in the car where we could have some privacy. That day in Thokoza had disturbed him for years and he cut through our preamble and came straight to the point. He described the fear that the under-trained peace-keepers had felt at being told they had to storm the hostel. They had panicked and unthinkingly opened fire. 'I think,' he said finally, 'somewhere, somehow . . . I think somewhere, one of us, the bullet that killed your brother – it came from us.'

# GLOSSARY

**Acholi:** tribe in northern Uganda, renowned for their ritualistic traditional funeral songs.

**Afrikaans:** language of the Afrikaner people, a simplified version of old Dutch.

**Afrikaner:** Afrikaans-speaking white South African, descendent of Dutch, French and German colonists.

**AK-47:** Kalashnikov semi-automatic assault rifle, standard infantry weapon of East Bloc countries; most widely used guerrilla weapon.

**'All night, nyaga-nyaga with the fokken amaZulu':** (Tsotsitaal) 'There has been trouble with the fucking Zulus all night long.'

**amaButho:** (Zulu) group of Zulu warriors, traditional age-based system of military service.

**ANC:** African National Congress; black liberation movement founded in 1912, banned in 1960, unbanned on 2 February 1990. Oldest surviving political organization in South Africa, now has majority in Parliament.

**apartheid:** (Afrikaans) 'separateness'. Official government policy from 1948 to ensure racial separation at all levels of society.

**APLA:** Azanian People's Liberation Army. Armed wing of the radical black Pan-Africanist Congress, now disbanded.

**asigibeli:** (from gibela – Zulu for 'ride') call for a work stay-away, to not use transport to town.

**assegai:** (Zulu) short Zulu stabbing spear.

**AWB:** Afrikaans acronym for Afrikaner Weerstandsbeweging (Afrikaner Resistance Movement) Militant neo-Nazi organization.

**AWOL:** absent without leave.

**baas:** (Afrikaans) master, sir, boss. Former mode of address by non-whites to whites.

**big machines:** township slang for an assault rifle, usually an AK–47.

**black:** person whose skin colour is not white. Apartheid terminology referred to Bantu-speaking Africans, non-Bantu-speaking Africans and people of mixed race (coloureds) as non-whites.

**Black Maria:** police vehicle used as a mortuary van.

**black-on-black violence:** term used by authorities to describe violence between black political groupings. Also 'faction fighting' in attempt to tribalize and de-politicize the conflict.

**Boer:** literally 'farmer'. Afrikaans-speaking white, used by Afrikaners as a self-defining term, referring to pioneering farmer or descendant of early Dutch or French Huguenot settlers.

**boers:** derogatory reference to white ruling class, especially security forces and Afrikaners.

**Boer Wars:** the Transvaal Boers won the right to partial independence from imperial Britain as the Zuid Afrikaanse Republick (ZAR) after the first Boer war of 1880–81. The second Boer war (1899–1902) saw the ZAR and the Orange Free State re-colonized by Britain.

**boerewors:** (Afrikaans) highly spiced pork and beef sausage, almost the national dish crossing ethnic and racial lines.

**Bophuthatswana:** until 1994, a nominally independent national state for Tswana people, consisting of seven unconnected pieces of land. One of the ten apartheid homelands.

**boytjie:** (Afrikaans) small boy, Afrikaans term of endearment.

**braai:** (Afrikaans) barbecue.

**braaivleis:** (Afrikaans) social gathering at which meat is barbecued or grilled.

**button:** slang for Mandrax tablet.

**button-kop:** (kop – Afrikaans) 'button-head', habitual Mandrax user.

**bushveld:** countryside dominated by thorn trees; usually cattle or game area.

**Casspir:** armoured, mine-proofed SA military vehicle.

**CBS:** US television network.

**Charterist:** follower of the Freedom Charter, the ANC's original manifesto.

**CNN:** US television network.

**Coloured:** apartheid terminology for a person of mixed race, alternatively non-Bantu African.

**comrade:** young militant activist affiliated to one of the liberation movements.

**com:** abbreviation of comrade.

**comtsotsi:** comrade + tsotsi – thug masquerading as comrade.

**dagga:** slang for marijuana, *Cannabis sativa*.

**dead zone:** no-man's-land in township during Hostel War.

**'Die Stem':** 'The Voice' – Afrikaans poem by C.J. Langenhoven, set to music, became the South African national anthem. Strongly Afrikaner nationalist. Now one of two with 'Nkosi Sikeleli' iAfrika'.

**dompas:** slang for the detested reference or pass book, which Africans were required by law to carry to prove they had permission to be in an urban or white area. Repealed in 1986.

**Durban Poison:** potent marijuana that is grown in KwaZulu-Natal.

**Emergency Regulations:** rules under which a temporary State of Emergency is governed.

**f5.6:** lens aperture setting, to control light and/or depth of field.

**Fokoff:** (Afrikaans, slang) fuck off.

**Freedom Charter:** document written and adopted in 1955 by the Congress of the People at Kliptown. It propounded a non-racial society, liberty and individual rights. Those liberation movements that followed its guidelines were called Charterist as opposed to the Black Consciousness movements such as the PAC.

**ganja:** (Caribbean slang) marijuana, *Cannabis sativa*.

**group areas:** areas set aside for exclusive occupation by a particular race group in terms of the Group Areas Act, 1950.

**Heytada:** (Tsotsitaal) township greeting, short for heytadaso.

**highveld:** high-altitude grassland on inland plateau where Johannesburg and the Reef are sited.

**hola:** (Spanish) greeting previously used only by those supporting the liberation movements, now almost depoliticized.

**homeland:** one of ten areas set aside under apartheid for particular African tribes or language groups, earlier known as Bantustans, to ensure black South Africans were citizens of nominally self-governing or independent territories and thus leave South Africa with a white majority. Four opted for full independence in the 70s – Bophuthatswana, Ciskei, Transkei and Venda. All were reincorporated into SA in 1994.

**IFP:** Inkatha Freedom Party.

**impi:** (Nguni) band of armed men, regiment, often with tribal connections, especially Zulu.

**impimpi:** police informer, spy, sell-out. Possibly from 'pimp', as in 'to pimp on someone'.

**induna:** (Nguni) headman.

**influx control:** regulations controlling the movement of Africans out of the homelands and into white SA.

**inkatha:** (Zulu) woven grass ring, cloth or clay used for carrying heavy loads on head, also the name given to the Zulu movement that became the Inkatha Freedom Party, abbreviated as IFP.

**Inkatha Freedom Party:** Zulu nationalist and royalist political party, founded 1990.

**inkosi:** (Nguni) mode of address to a male superior, chief or lord.

**intelezi:** (Nguni) war medicine, magic potion used to render one invulnerable to harm, often only effective if facing enemy. Most intelezi needs human ingredients, most potent are body parts from slain enemies.

**isazi:** (Zulu) slang for 'clevers' meaning urban sophisticates.

**joint:** marijuana cigarette.

**jackrolling:** abduction and gang-rape of girls, often over extended periods.

**klapping:** (Afrikaans) slapping.

**kaffir:** offensive term for black people, from Moslem term of abuse for non-Moslems.

**Kaffirboetie:** (Afrikaans) 'lit-kaffir-brother' – offensive term for white thought to be a 'kaffir-lover'.

**kaffirskiet-piekniek:** (Afrikaans) 'Ons is op 'n kaffirskiet-piekniek' – 'We are on a kaffir-shooting picnic.'

**kafir:** archaic spelling of 'kaffir'.

**Kalashnikov:** (Russian) automatic Kalashnikov – see AK.

**khakibos:** weed, alleged to be brought in with British horse feed during Boer Wars.

**kommunis:** (Afrikaans) communist.

**kraal:** (Dutch) rural African homestead, also refers to cattle enclosure.

**kwash:** slang – home-made gun that usually only shoots one bullet at a time; from the sound it makes when fired.

**KwaZulu:** self-governing territory of the Zulu people in Natal; officially KwaZulu never accepted full independence, but had its own administration, police force and parliament and was controlled by Inkatha. Now part of KwaZulu-Natal province.

**Kwela:** (Nguni) music, played primarily on a penny-whistle, famously by Lemmy 'Special' Mabaso in the 50s.

**laager:** (Afrikaans) defensive encampment of wagons, historic, now used as 'laager mentality' to describe voluntary isolation or insular thinking.

**Lebowa:** former homeland of the north Sotho people, consisting of six pieces of land.

**Lungile, ai problem:** (pidgin Zulu) 'It's OK, no problem.'

**Mandrax:** tranquillizer, banned.

**matchbox:** sub-standard township house, mostly council built.

**mdlwembe:** (Zulu) wild dog, derogatory reference to Zulu hostel dwellers.

**mielie meal:** (Afrikaans) maize meal, staple food in SA.

**migrant labourer:** person who moves from one part of the country to another in search of employment, usually from homelands to industrial or mining regions of 'white' SA.

**mixed marriage:** union between a white and a person of another race, especially black or coloured, outlawed between 1949 and 1985.

**mjita:** urban black slang for 'one of the boys', friend.

**MK:** nickname of Umkhonte we Sizwe, the military wing of the ANC.

**mlungu:** (Nguni) mode of address to white man, whitey, can be derogatory.

**Molotov cocktail:** home-made petrol bomb. Fuel-filled glass bottle with cloth wick, named after Soviet Second World War general.

**Mshaya'zafe:** (Zulu) 'Beat him to death.'

**Nando's:** fast food franchise, slang for necklace.

**National Party, NP, Nats:** party formed in 1914 to represent Afrikaner interests. Went through various splits, fusions and name changes until it came to power in 1948. Introduced apartheid. Ruled until 1994. Now renamed the New National Party, and has opened its doors to race groups other than whites. Incorporated in the Democratic Party in June 2000.

**Nats:** sometimes derogatory abbreviation for National Party.

**necklace:** rubber tyre fitted with petrol, forced over a victim's head and then set alight.

**Nguni:** group of south-east Bantu people and languages, including Zulu, Xhosa, Pondo, Ndebele, Swazi.

**Nkosi Sikelel' iAfrika:** (Xhosa) 'God bless Africa', a hymn of which first verse was written by Enoch Sontonga in 1897. Adopted by the ANC in 1925 and now one of two national anthems with 'Die Stem', which was the white regime's anthem.

**non-white:** apartheid term for person falling into race classification other than white, i.e. black, coloured, Indian, etc.

**NPKF:** National Peace-Keeping Force, a transitional force made up of members of the SA Defence Force, the SA police force, former homeland armies and guerrillas from the liberation movements. Plagued by racial and political infighting. Was disbanded after Thokoza April 1994 fiasco. Most members now in renamed and reformed army, the SA National Defence Force.

**nyaga-nyaga:** Tsotsietaal slang for trouble, as in 'nyaga-nyaga with the fokken amaZulu' – 'trouble with the fucking Zulus'.

**ous:** (Afrikaans) slang for boys, in reference to colleagues or members.

**PAC:** Pan-Africanist Congress, established 1959 by break-away Africanist members of the ANC. Followers of Black Consciousness, an ideology that preaches psychological liberation from white racism and white liberalism. Non Charterist. Commonly perceived as a racist organization.

**paparazzi:** Italian term referring to overly-persistent celebrity photographers. After the death of Princess Diana in 1997, it became a byword for photographers as scavengers.

**pass book:** document that Africans were required to carry by law to prove they had permission to be in a white area. (See dompas.)

**pass laws:** restricting black people's movements. Repealed 1986.

**panga:** (poss. Nguni) machete, broad bladed slashing knife.

**peckies:** derogatory term for blacks, origin obscure.

**penny-whistle:** cheap flute used by shepherds and cowherds; made

famous as primary instrument in 50s kwela music. Used to cost one penny.

**people's court:** unofficial township court set up by activists to try criminals and political offenders, especially impimpis.

**petty apartheid:** enforced segregation of public and private amenities, buses, beaches, toilets. For example, architects designed banks to allow the separation of entrances and exits for blacks and whites.

**poyisa:** (Xhosa) police.

**Rain Queen:** queen of the BaLobedu tribe in the Northern Province of South Africa, whose great-grandmother had been the model for novelist Rider Haggard's heroine Ayesha. Widely believed to be able to control the rains.

**rand:** South African unit of currency. 100 cents in one rand.

**Rand:** common abbreviation of Witwatersrand, the gold bearing 'ridge of white waters', upon which Johannesburg and the other Reef towns were built.

**Reef, the:** South Africa's most highly industrialized region, from the reef of gold that followed the Witwatersrand.

**rinderpest:** (German + Latin) virulent, highly infectious cattle disease that swept through South Africa in 1896. Likened to the plague.

**RSA:** Republic of South Africa.

**SAP:** South African Police, former police force now called the SAPS.

**sangoma:** (Nguni) traditional African diviner/herbalist, 'witchdoctor'.

**self-defence unit (SDU):** neighbourhood-based underground liberation-movement-aligned vigilantes, often youths; some were members of MK, APLA.

**separate development:** euphemism for apartheid.

**shebeen:** (Irish) place where liquor is sold and often consumed; informal and/or illegal bar.

**shebeen queen:** owner of shebeen, often larger-than-life character referred to as magrizza, 'grandmother' in Tsotsitaal.

**shisanyama:** (Nguni) burnt or cooked meat, slang for necklace.

**'Shoota, baas, shoota us':** (pidgin Zulu) 'Take a picture of us, boss.'

**skip:** large open garbage container that can be picked up by truck.

**skuif:** (Afrikaans) joint, or a hit on a white pipe.

**slivovic:** potent Yugoslav plum brandy, often home-distilled.

**South West Africa:** former German colony that was given to SA by the UN as a protectorate after the First World War; gained independence as Namibia in 1990.

**State of Emergency:** suspension of certain civil liberties in order to strengthen the arm of the executive in controlling a perceived threat to the state. Also gives police and military extended powers which often contravene basic human rights.

**stoep:** veranda, stoop.

**stringer:** freelancer working regularly for publication or agency.

**Struggle, the:** opposition to apartheid, from the struggle to be free.

**SWAPO:** South West African People's Organization, now ruling party in Namibia.

**swartgevaar:** (Afrikaans) literally 'black peril' – rallying cry for white South Africans fearing majority rule.

**takkies:** rubber-soled laced canvas shoes (sneakers/tennis shoe).

**terr:** abbreviation of 'terrorist', refers to guerrilla in liberation movement armies. White SA slang.

**third force:** shadowy elements of the intelligence community, as well as the security forces and government officials, who colluded with Inkatha and right-wing white extremists to undermine the transition to democratic rule.

**three cents:** at one time the price of a box of matches, slang for necklace.

**Total Onslaught:** term used by SA government under P.W. Botha to describe an international conspiracy to force one-person, one-vote on white South Africa. His regime devised a Total Strategy to counteract this.

**toyi-toyi:** high-stepping militant dance used at protest rallies and funerals, allegedly started by exiles in the military training camps outside SA.

**Transkei:** former homeland, the first to take independence. One of two for the Xhosa people. The other was Ciskei.

**tsotsis:** petty street thugs, small-time township criminals. Perhaps refers to the stove-pipe trousers fashionable in the 40s.

**Tsotsitaal:** The constantly changing informal but ubiquitous township language that is a mixture of Afrikaans, English and several African languages, with different languages predominating from place to place.

**Transvaal & Free State Boer Republics:** short-lived independent Afrikaner republics, now an ideal that a minority of secessionist Afrikaners yearn for – see Boer Wars.

**UN:** United Nations.

**United Democratic Front (UDF):** umbrella organization of anti-apartheid movements, many of which were, in practice, internal organs of the then-banned ANC. Disbanded after ANC legalized in 1990.

**United Democratic Movement (UDM):** Political party formed and led by former NP minister Roelf Meyer and former Transkei military dictator General Bantu Holomisa. Meyer resigned his leadership position in 2000.

**Umkhonto we Sizwe:** (Nguni) 'spear of the nation' – ANC's military wing, abbreviated as MK.

**'Umlunghu shoota':** (pidgin Zulu) 'The white man is shooting.'

**usuthu:** traditional Zulu war cry.

**Vaal Triangle:** a roughly triangular grouping of towns and townships in the industrial area some 60 kilometres south of Johannesburg; from the Vaal River.

**veld:** (Afrikaans) rural South African countryside or landscape; grazing land.

**vierkleur:** (Afrikaans) 'four-colour' flag of the South African Republic and the Transvaal, symbol of Afrikaner yearning for a homeland. Still occasionally waved at rugby and cricket matches by racist white fans.

**Volk:** (Afrikaans) people, nation, usually Afrikaner nationalists.

**volkstaat:** (Afrikaans) homeland for white Afrikaners.

**vula:** (Nguni) open.

**white pipe:** mixture of Mandrax and dagga in a broken-off bottle neck.

**Witwatersrand:** the gold-bearing 'ridge of white waters' (Afrikaans) upon which Johannesburg and the other Reef towns were built – see Rand, Reef.

**young lions:** youthful ANC supporting militants, upon whom the duty fell to make the townships ungovernable in the 80s as part of the ANC's strategy to topple the apartheid regime.

**Zaïre:** large central African state now Democratic Republic of Congo, formerly the Congo – a Belgian colony.

**Zionist:** separatist African churches or cults. No affiliation to Judaism or Israel. The name is from the desire to find a promised land, usually spiritual.

**zol:** marijuana cigarette, or reference to the marijuana itself.

**zombie:** undead, believed to be a person under the spell of a sorcerer.

**Zulu:** collective name for the northern Nguni who were forged into a militaristic tribe by Shaka Zulu in the 19th century.

# SOUTH AFRICAN
# TIMELINE

‖

**1910** Union of South Africa formed.

**1912** SANNC, later ANC, founded.

**1913** Natives' Land Act passed.

**1914** NP founded.

**1920** Native Affairs Act creates separate administration for blacks living in Native Reserves.

**1923** Natives (Urban Areas) Act extends segregation to towns.

**1925** Afrikaans becomes an official language alongside English.

**1948** (Reunited) National Party (HNP) wins election.

**1949** Prohibition of mixed marriages.

**1950** Population registration (to determine a person's race), Immorality and Group Areas Acts; Suppression of Communism Act.

**1951** Separate Representation of Voters Bill enacted.

**1952** Native Laws Amendment Act, Abolition of Passes Act starts reference book (dompas) for Africans. ANC launched Defiance Campaign.

**1953** Government wins election with mandate to remove coloureds from common voters' roll in the Cape. Bantu Education Act passed. Reservation of Separate Amenities Act.

**1955** Forced removals from Johannesburg's non-white Sofiatown suburb continues through to 1958 from other suburbs. Freedom Charter adopted.

**1956** Coloureds removed from common voters' roll. Treason Trial of 156 anti-apartheid activists.

**1958** Hendrik Verwoerd becomes Prime Minister.

**1959** PAC breaks away from ANC.

**1960** Anti Pass Law campaign; Sharpeville shootings. ANC and PAC banned, both set up military wings. State of Emergency declared. White referendum of forming a Republic.

**1961** Mandela proposes the adoption of an armed struggle.

**1962** Mandela arrested.

**1966** Verwoerd assassinated in parliament, B.J. Vorster takes over.

**1975–6** South Africa invades Angola, then withdraws, but SA continues to side with UNITA in civil war until 1989.

**1976** Soweto riots. Many teenagers flee the country for military training. Internal Security Act passed.

**1977** Seventeen organizations and two newspapers banned.

**1978** P.W. Botha succeeds Vorster after he resigns over funding scandal.

**1980** Zimbabwe wins independence. ANC breaks with Chief Mangosuthu Buthelezi and Inkatha.

**1984** Tricameral parliaments formed, no representation for blacks. Widespread rioting begins.

**1985** State of Emergency in 36 magisterial districts declared.

**1986** Pass Laws abolished.

**1988** Seventeen anti-apartheid organizations banned, including UDF.

**1989** P.W. Botha has stroke, resigns, succeeded by F.W. de Klerk. NP wins general election. Anti-apartheid demonstrations permitted in major cities.

**1990** Mandela released from prison. ANC, PAC, SACP unbanned. Namibia gains independence. Separate Amenities Act repealed. Fighting between Inkatha and ANC spreads to the Transvaal. NP allows all races to join.

**1991** National Peace accord signed. Talks on relinquishing white hold on power begin. Group Areas Act, Population Registration Act, Native Land and Trust Act repealed.

**1992** Forty-five people killed in Boipatong massacre.

**1993** Chris Hani assassinated by white right-winger. Election date announced.

**1994** ANC wins first democratic election by massive majority. Homelands reincorporated.

**1998** October: Truth and Reconciliation report published.

**2000** June: The New National Party (formerly the National Party) incorporated in the Democratic Party.

# BIBLIOGRAPHY

Bauer, Charlotte, *Weekly Mail* (now *Mail & Guardian*). (1994)

Bradford, Jean, *A Dictionary of South African English.* (Oxford University Press Southern Africa, 1987)

Carter, Kevin, *Weekly Mail* (now *Mail & Guardian*). (1992)

*Illustrated History of South Africa – The Real Story.* (The Reader's Digest Association South Africa, 1992)

Lorch, Donatella, *The New York Times.* (1993)

MacLeod, Scott, *Time Magazine.* (1994)

Marchese, John, *Village Voice.* (1994)

Marinovich, Greg, 'The Dead Zone: The Confined Space of Political Conflict, Tokoza Township' in *Architecture, Apartheid and After* Hilton Judin & Ivan Vladislavic (editors). (NAI Publications, 1999)

Nichol, Mike, *The Invisible line: The Life and Photography of Ken Oosterbroek.* (Kwela Books in association with Random House, 1998)

Silva, Joao, *The Star.* (1992)

Squires, Carol, *American Photo Magazine.* (1994)

*The Star*

Truth and Reconciliation Commission of South Africa Report. (1998)

# INDEX

‖